Girls
and
Their
Cats

Girls and Their Cats

BY BRIANNE WILLS

with Elyse Moody

CHRONICLE BOOKS

SAN FRANCISCO

Library of Congress Cataloging-in-Publication Data available.

ISBN 978-1-4521-7679-6

Manufactured in China.

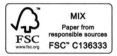

Design by **LIZZIE VAUGHAN**.
Typesetting by **JARED GENTZ**.
Typeset in FreightBig, Grenale, Kabarett, Mission Script, Noe, Proxima Nova, Radiant and Recoleta.

10 9 8 7 6 5 4 3 2 1

Chronicle books and gifts are available at special quantity discounts to corporations, professional associations, literacy programs, and other organizations. For details and discount information, please contact our corporate/premiums department at corporatesales@chroniclebooks.com or at 1-800-759-0190.

Chronicle Books LLC
680 Second Street
San Francisco, CA 94107
www.chroniclebooks.com

For the loves of my life:

Chris, Liza, and Tuck

Contents

Foreword by Molly Young **8** ———————————— Introduction by BriAnne Wills **11**

Cat Lady, Redefined **14**

Aisha Awadallah 17
Alela Diane 20
Nicole Lee 23
Christene Barberich 24
Cassandra Slack 29

Jamilah King 30
Gabrielle Silverlight 33
Jayde Fish 36
Liz Carey 41

How to Catproof Your Home **42**

Monica Choy 45
Shona McAndrew 48
JiaJia Fei 51
Cherie Jellison 52
Sandra Martocchia 55

CJ Miller 58
Michelle Lee 61
Jaime Lee 64
Gretchen Jones 67

Cat Tail Language, Explained **70**

Marissa Jane Oswald 73
Viridiana Cervantes 74
Preeti Mistry 79
Alexandra King-Lyles 80

Hannah Shaw 83
Erica Chidi Cohen 86
Anka Lavriv 89
Pia Panaligan 90

The Chorus of Cat Sounds **92**

Holly Samuelsen 95
Bianca Christensen 96
Bethany Watson 101
Imaan Khan 102

Ariana Bindman 107
Holly Andres 108
Athena Wisotsky 113
Channing McKindra 114

Things You Get Better at Because You Have a Cat **118**

Éva Goicochea 121
Christina Loff 122
Rikkí Wright 127
Alyssa Mastromonaco 128

Sophi Reaptress 133
Bonney Johnson 134
Jacqueline Mansky 139
Laura O'Neill 140

You Know You're a Cat Lady When… **144**

Maria Hinojosa 147
Nikki Garcia 148
Emily Katz 153
Sam Ushiro 154

Lauren Leavell 159
Jess Hannah 160
Sara Anderson 165
Puno 166

——————— What to Expect When You're Expecting a New Cat **170** ———————

Rescue Organizations We Love **174** ——————— Acknowledgments **175**

Foreword

by Molly Young

I'm standing in the kitchen, watching my cat prowl the floor for dinner crumbs. It's early autumn in Brooklyn, too late for ice cream and too early for hot chocolate.

"Maybe I'll dress up as a cat lady for Halloween," I am saying to my husband.

"So," he replies. "No costume?"

Cue laugh track. But also, he's not wrong. Dressing up as a cat lady for Halloween would mean putting on my regularly scheduled clothing and going about my regularly scheduled day. No alterations in presentation or temperament required. After all, the modern cat lady has evolved.

In decades past, cat ladies were a minor but pungent pop culture archetype. There were Little Edie and Big Edie of *Grey Gardens* fame, who had between twelve and three hundred cats at their East Hampton manse (the exact number is unclear). There was Patricia Highsmith, the famously prickly novelist who prepared gourmet meals for her Siamese cats and spoke to them in a made-up language. There was the actress Vivien Leigh, who collected cats, cat books, and portraits of herself with various cats. There was Eleanor Abernathy from *The Simpsons*, a disheveled hoarder in purple cardigans, screaming gibberish at Lisa Simpson.

There was once a pervasive sense that a (run-of-the-mill, nonfamous) cat lady was someone who likely smelled of mothballs and old soup. Perhaps she was a fan of Barbara Pym novels. Perhaps acquaintances would describe her with the old-fashioned epithet "spinster." There was something unwholesome about her attachment to felines, possibly a suggestion that her communion with cats resulted from a distaste of fellow humans, or an inability to interact with them.

But as our access to a dizzying universe of people and lives has increased—thanks, Internet!—a new landscape of cat ownership has emerged. (A phrase, by the way, that feels totally wrong. You can never really own a cat. All cat people know this.) The new vision includes cat companions of every age, hue, and fancy, with corresponding cats of every shape, size, nomenclature, and personality, from meltingly mild to diabolically sneaky.

BriAnne's portraits are sparkling visions in this cosmos, with their depictions of women at work and at play in cat-dappled habitats. The women come from different backgrounds and work in different fields, but they all have one thing in common: a healthy obsession with felines. Which brings us to the question: What *is* it about cats that tickles a certain kind of imagination? Of all the furry quadrupeds that roam the earth, why is this the animal that Egyptians deified and Chinese calligraphers immortalized and Balthus painted and T. S. Eliot wrote poems about?

Something about cats inspires worship, and I have hypotheses. Let's start with the physical similarities to their wild kin. Domestic dogs no longer closely resemble members of the larger *Canidae* family—you'd never mistake a yellow Lab for a jackal or a standard poodle for a maned wolf. Cats are another story. With domestic cats, the distinctions are of scale rather than kind: A black cat looks just like a tiny panther; a spotted one like a miniature cheetah. Domestic cats hunt, prowl, and leap just like their wild brethren. A dog may blend seamlessly into the household, but when you're contending with a cat, it's impossible to forget the uncanny strangeness of housing a foreign animal under your roof.

There's also a cat's temperament. No two are alike, but all are profoundly unpredictable. The cat is a creature of quixotic preference and habits. Do you ever truly know what your cat is thinking? Do you know why she supervises you in the bathroom or sleeps on your head? No, you don't. None of us do. Just when we think we have a handle on our little darling, she stops eating her favorite food and starts sleeping exclusively in the dish rack. There is a logic at work, but it's not for humans to transcribe. Having a cat in the house relegates you to the role of a permanently surprised audience member.

And that, in a sentence, is the gift of this book. *Girls and Their Cats* is a window into the intricacies of these wondrous creatures and the women who love them. The sweet truth of cat ownership is that we treasure our animals not despite their peculiarities but because of them—and that, perhaps, is as good a rubric for loving as any on earth.

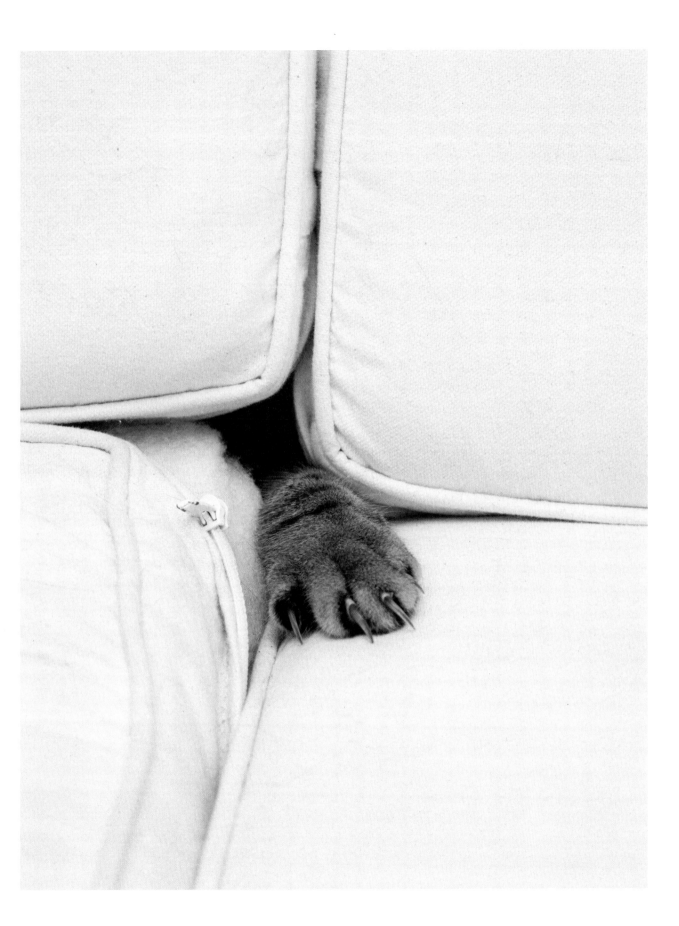

Introduction

by BriAnne Wills

September 3, 2013: my birthday. My husband, Chris, and I are living in Kiev, Ukraine. We had friends over for a party, but now, at almost three in the morning, everyone is gone. Chris is asleep, passed out. I'm fully awake, thanks to all the sugar in the drinks we had. That's when I hear it: tiny kitten cries.

No going to sleep for me. I've got some experience helping animals out of sticky situations in our adopted city, which happens to be full of cats. They're mostly well cared for, fed by babushkas, but this one is clearly in trouble. I go to investigate. In Kiev, the city blocks are long, lined by tall trees with white-painted trunks and something that would soon be a problem—no low limbs.

In one of those tall, bare trees, I see two glowing eyes. I hear two meeps. There she is, way above the first branch, itself at least seven feet high. I leave and come back with half-asleep Chris, who tries to shimmy up the trunk. We try hoisting each other. No luck. Then, lo and behold, comes a very tall man, walking his dog. He hoists Chris up into the branches. Chris climbs. The kitten climbs. He climbs, and she climbs, onto the tiniest limb, and then she falls. I scoop her up and put her in my jacket, and we take her to the emergency vet. She's okay, just filthy, with ear mites, tapeworms, fleas, ringworm—every ailment a month-old kitten could possibly have. But she's ours. Mine. She immediately bonds to me.

A few months later, when Liza is clean and healthy and we've almost gotten rid of the fleas in our place, I'm walking home from my job and see a black ball on the ground. It's screaming in the most pitiful way. Everyone is passing it by. It's impossible to believe it's a kitten. His whiskers are all crooked and he looks like a goner, but I think I can at least make him comfortable. So I put him in my sweatshirt and take him home. Food and water turn him into a totally different creature. Eventually he lets me bathe him, and we take him to the vet, and we de-everything him, and finally Tucker (aka Tuck) looks like a regular kitten. By now, it's December, and the revolution is starting. I go home to Oregon, without Chris and Liza and Tuck. Six months later, I move to Brooklyn. Chris gets the cats their shots and their kitty passports (yep, they issue those), and he flies with them for twelve hours to meet me.

In Ukraine, Liza and Tuck were timid and afraid. When we had friends over, they hid under the bathtub. Now they're spoiled American cats, and they love people. Liza is like a sweet, very patient mom. We call her Mama—and Sissy, and Liza Minnelli Belly. Tuck is our bratty, needy toddler. He just lost his last crooked whisker. We call him Tuck Fuck, Nu Nu, and Buddy. They're both passionate about bonito flakes.

These two save my sanity on a daily basis. Their fuzzy cuddles keep me from being lonely when Chris goes back to Ukraine for work. On mornings when I'm feeling down about my career (the usual ups and downs of freelance life and fashion photography) and don't want to get out of bed, I feel a fuzzy nuzzle on my arm. I know it's Tuck, standing on the basket by my bed where he stands every morning, purring for me to get up and feed him. And when I'm in a bad mood, Tuck and Liza make me laugh. Cats truly are good for the soul.

That's my story. Since 2015, I've been taking photographs of women like me and cats like Liza and Tuck, and asking them to share their stories. I started this

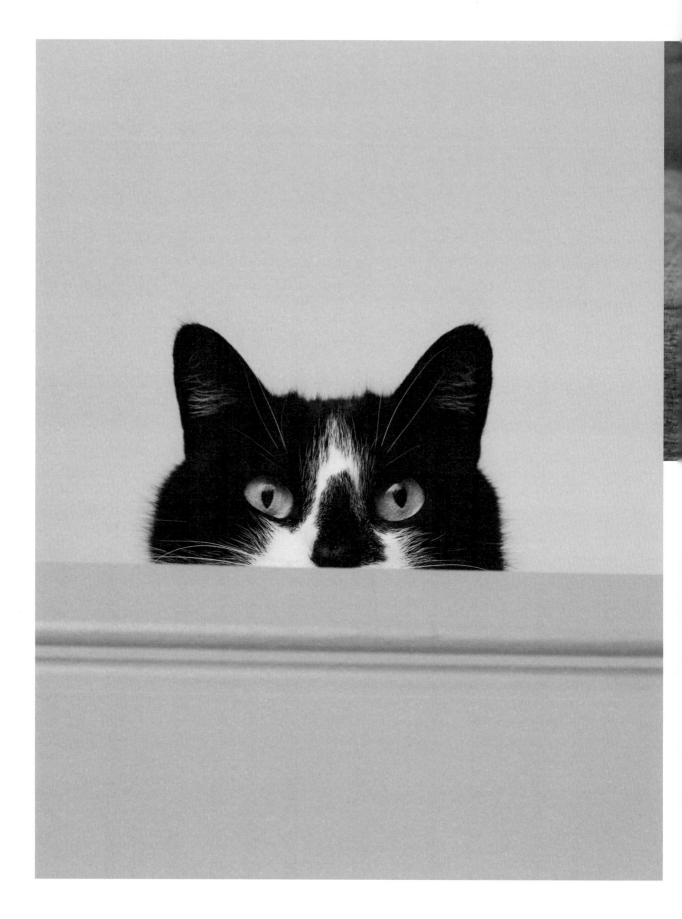

series thinking it would be a good way to meet people in my new city, network, and focus on my art; I thought I wanted to do a series of nudes. But while photographing my first nude model in her home, George, a beautiful Maine coon, popped into frame and stole the show—the way cats always do. I got an idea. I decided to change the direction of the series completely, and *Girls and Their Cats* was born.

In my photographs, I set out to modernize the "cat lady" stereotype. The women in these pages are artists, entrepreneurs, writers, activists—no Big or Little Edies here. I've received hundreds of applications from women who want to take part, and these are just a few of them.

Yes, these women and I may be obsessed with our cats (we can't help it; just look at them, they're adorable), but that's not what defines us. Instead, our cats are our partners and supporters as we hustle to define ourselves. They're there for us when we need them— on mornings when we have a hard day's work ahead of us, and at night when we come home afterward. They're comforting, entertaining, and sometimes flat-

out ridiculous. But most of all, they're our best friends, and life wouldn't be the same without them. I know mine wouldn't.

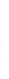

Cat Lady,

REDEFINED

Cat Lady

noun

An older *or younger—doesn't matter—* woman who *is cool, compassionate, and creative, and* lives *her best life* ~~alone~~ with *her cat or* ~~a large number of~~ cats, to which she is thought to be ~~obsessively~~ *totally, understandably* devoted.

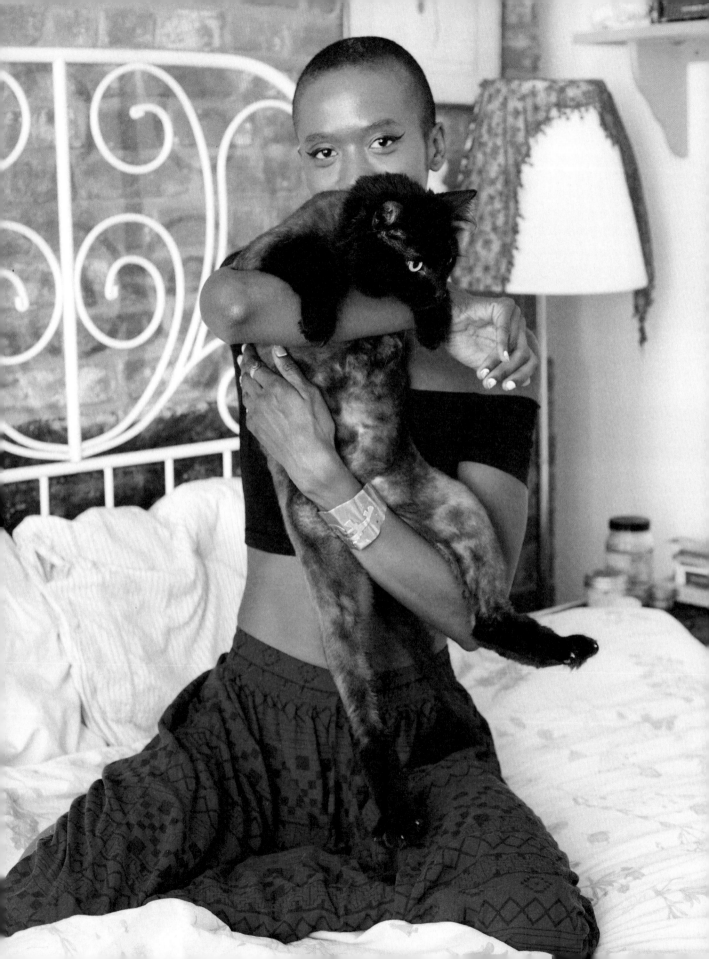

"Magical, sensitive, patient, adaptable, exceptional people."

Aisha Awadallah

ARTIST AND DOULA
BROOKLYN, NEW YORK

My three cats are all reflections of me and represent the full spectrum of my personality and phases of my life. I'm a natural introvert, and love creating a comforting and colorful home environment. These three eccentric fur balls with their superfluous names and strong personalities are essential to it.

I adopted Tigger (full name Tigger Oscar Wilde) in 2010, which makes my relationship with him probably the longest male relationship of my life. I was in my early twenties, had just moved out of my mom's place to live with an ex, and was ready for the responsibility of a pet. It had to be a cat. Tigger was up for adoption at the ASPCA, and while I initially had my eye on another cat, Tigger seized the opportunity to lock eyes with me and let out one of his loud, high-pitched, feminine meows that make your heart melt. He's been with me through multiple apartments, deaths, toxic romances, crazy roommates, and my own past struggles with depression and anxiety. He can be a grumpy guy and is prone to random acts of violence, but he loves being the center of attention and follows you everywhere, especially the bathroom. And when he decides to be loving it's some of the sweetest and most demanding love and cuddle time you can get from a cat.

Xena Warrior Princess is definitely my baby princess, but she's the queen of the household and psychologically dominates her much larger "brothers." I like to call her Queen Sheba, the Man Eater. I got her in 2014 through a Facebook group; someone had put up a post saying they found a tiny stray chasing after some children. I saw a pic and immediately fell in love. I had been thinking of getting a companion for Tigger, and knew that a kitten would bring a lot of joy and life to the household. She literally fit in the palm of my hand when the rescuer handed her to me, and was so young that I had to bottle-feed her for a few weeks. With that we bonded in a way I had never bonded with a pet before—she actually is my furry child. She taught me so much about what it means to care for another living being and

Tigger, Xena & Alex

TYPE

Tigger »	Tiger-striped brown tabby
Xena »	Black domestic shorthair
Alex »	Maybe a Chantilly mix

FAVORITE SNACK

Tigger »	Frozen broccoli
Xena »	Licking empty sardine cans
Alex »	Important papers

LIKES

Tigger »	Intense eye contact, sleeping on my face, humping blankets
Xena »	Food, slapping her archnemesis Alex
Alex »	Lounging in the building's hallway, belly rubs, doing sick backflips

DISLIKES

Tigger »	The cat carrier, being told what to do
Xena »	Being adventurous, loud noises
Alex »	Being cooped up in the apartment, hissing (he never hisses)

HUMAN ALTER EGO

Tigger »	A young Marlon Brando
Xena »	Edith Piaf
Alex »	Daniel Day-Lewis in *The Last of the Mohicans*

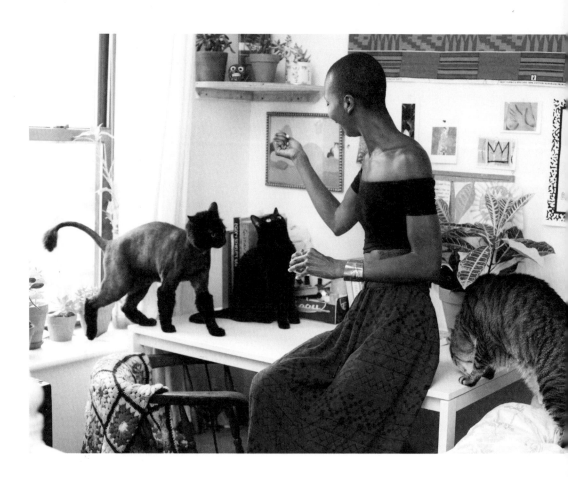

exceptionally vulnerable creature. While she can be aloof and does her own thing most of the time, she loves to find time alone with me and lie on my chest and stare into my eyes, purring deeply while drooling like a kitten as I pet her.

Alexander the Great is a funny one. He's usually a gorgeous, long-haired, black furry fluff ball, but in this photo he has just been groomed for the summer heat and looks like a lion. I found him on the streets of Red Hook, Brooklyn, in 2015, hanging with some feral cats at an abandoned car lot. I passed him on my way home from work over the course of a few weeks, and he was always unusually friendly and eager for attention—and way too beautiful to have been on the streets for long. A feeder of the local cat colony eventually told me that she saw his previous owner abandon him and encouraged me to take him home, which I promptly did. Alex is a constant source of laughter and confusion. He has a long, deep meow and the funniest awkward stride, and he lets me pick him up and carry him like a baby. One moment you look into his eyes and it doesn't seem like much is there,

but the next he'll surprise you with genius methods of getting into cabinets and choosing the heaviest books to knock off of the shelf to wake you up for breakfast. His cat siblings have a love-hate relationship with him and seem to still not completely have a grasp on him. Alex isn't always one to seek affection but doesn't mind when you force it on him, and he likes to sleep right on top of my feet at night. I like to think of him as a "dog cat." I love this unique little man so much.

Alela Diane

SINGER-SONGWRITER
PORTLAND, OREGON

Back in the summer of 2005, I lived in a log cabin in my hometown of Nevada City, California. In desperate need of a companion, I drove out to the Nevada County Animal Shelter. It was there that I met a tiny, orange-faced kitten. I filled out the paperwork and left after they told me she was not yet ready for adoption. I tried to put her out of my mind, thinking she'd go to a different home.

I was very surprised when I received a phone call about a month later, asking if I was still interested in the kitten. I was, very. I drove out the winding country road and picked her up, heart full. I named her Bramble Rose, after the blackberries that grew outside my cabin window. Her spirit calmed my nerves, and she purred wildly and kissed my face every time I picked her up. We lived together in the woods for a few months, and then we packed up a U-Haul, bound for Portland, Oregon.

That trip was Bramble's initiation to travel. She sat on my lap for most of the drive, and loved looking out the window at the highway. Shortly after we settled in Portland, I began touring with my music. Not knowing what to do with my dear kitty while I was gone, I decided to bring her with me. We played shows mostly down In California, so the trips weren't too long. Bramble curled up on the passenger seat while I drove, always up for exploring new surroundings. We stayed with friends or got a cheap motel. I remember hiding her from a motel proprietor, not wanting to pay the $10 pet fee, which was out of my budget in those days. When I began touring in Europe, Bramble stayed home with a series of kitty sitters. It's never been difficult to find a companion for her, since she's so affectionate.

Over the past few years, I've watched her become a sweet old lady cat. She's moving more slowly these days, and sleeping more. Her playfulness has been replaced by a serene calm. When my husband and I had our older daughter, Bramble embraced her, and has been tolerant of the curiosity that children bring. She lets our two girls tug at her tail, and sometimes sleeps in their dolls' bed. We still take her traveling when we visit my husband's family. She snoozes between the car seats, and when we arrive, she jumps out and walks the perimeter of the house before lying down near the window to watch the rise and fall of the tide on Puget Sound.

Bramble Rose has been the constant in my life through many chapters, and has brought me so much peace. She still kisses my face every time I pick her up, and at the end of the day she climbs onto my chest to say goodnight. It will be a sad day when her time comes. I wish we could grow old together.

Bramble Rose

TYPE
Calico-tortoiseshell mix

NICKNAMES
Miss Rose, Rosie, Rosenthal, Old Lady Cat, Brambs, Miss Mouse

FAVORITE SNACK
Tuna

LIKES
Snuggling

DISLIKES
Being bothered

HUMAN ALTER EGO
A wise, gentle grandmother

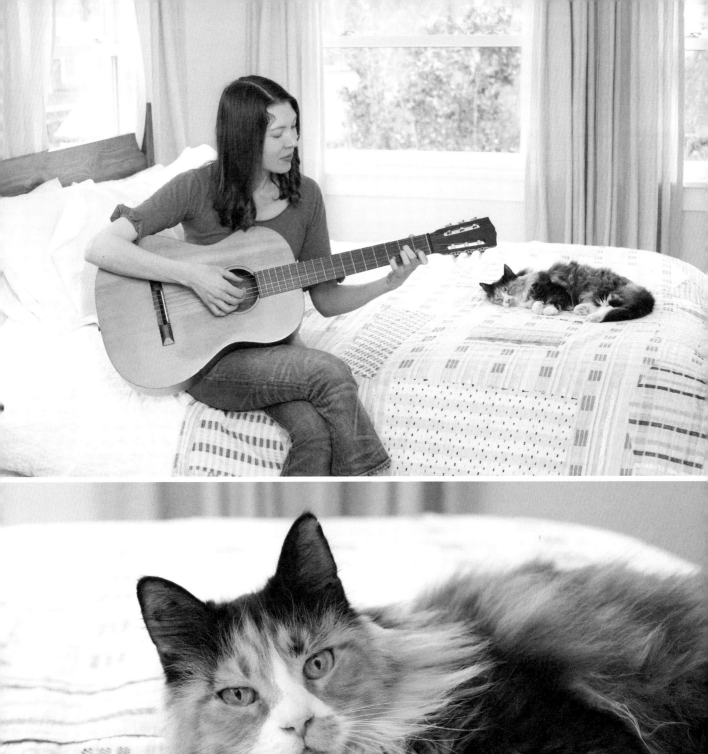
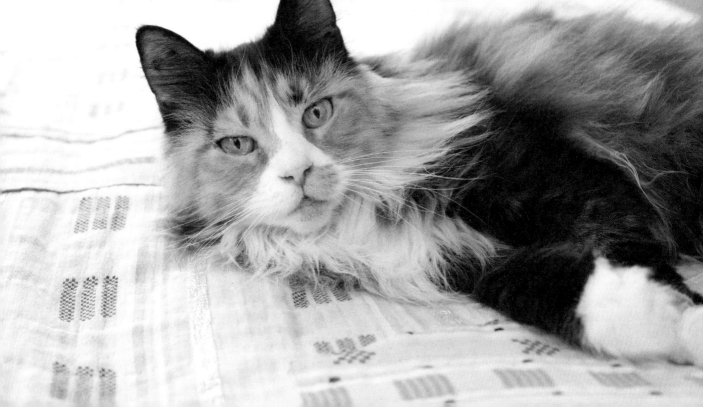

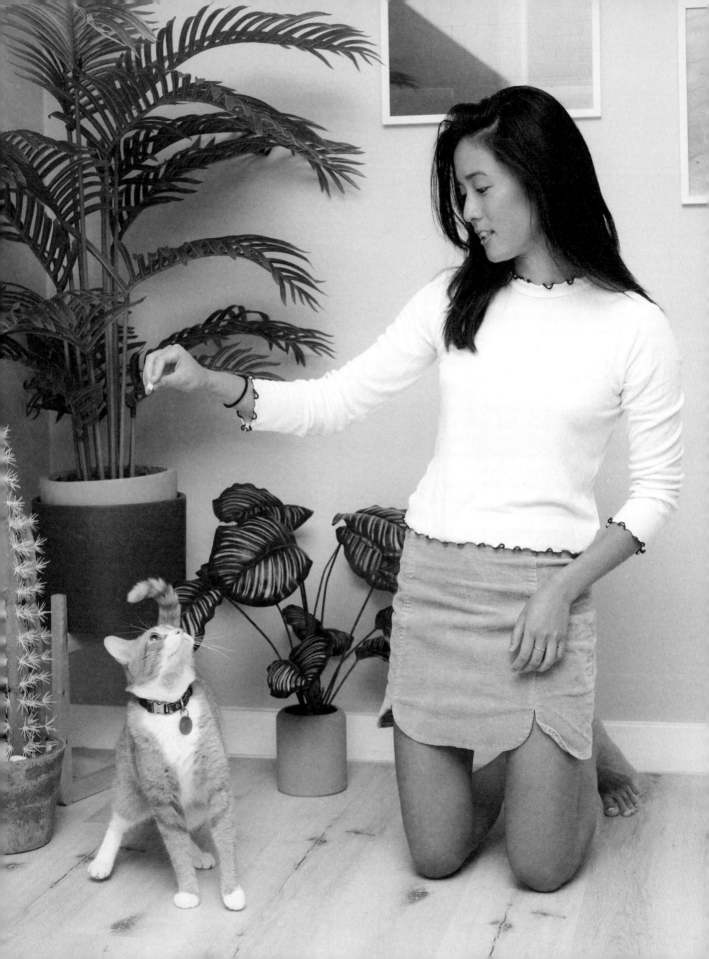

Nicole Lee

CREATIVE MANAGER AT TINDER
LOS ANGELES, CALIFORNIA

Like many couples nowadays, Nemo and I met on the Internet. A friend sent me a post about an orphaned kitty who needed a foster home. I picked him up when he was four days old—no bigger than an avocado. His eyes had not opened yet, and he bore a strong resemblance to a naked mole rat. Like his namesake Pixar character, Nemo was orange-and-white striped, motherless at too early an age, and terrified of sharks.

While I had an affinity for cats, I am a self-proclaimed dog person (see my first screen name for evidence: nicoledogs2003). I had every intention of fostering Nemo for only a few months until he was ready to be adopted. But after bottle-feeding him and watching him fall asleep against my chest multiple times a day, I was beginning to develop attachment issues that quickly foiled my plans to find him another home. We have been joined at the hip ever since.

Due to his orphaned-kitty upbringing, Nemo is much more affectionate and cuddly than the average cat. He transforms into a happy, drooly puppy when you give him a belly rub. At times I wonder if he is a cat-dog hybrid, à la the late-'90s Nickelodeon animated series *Cat-Dog*. I somehow managed to train Nemo to sit for treats and prance over to me when I call his name. His canine tendencies truly shine in a game of fetch. Toss a stuffed animal across the room, and Nemo will sprint over to retrieve it, eager to please (classic Virgo).

Nemo is a stage-five clinger, perhaps because of our unusually tight bond. He follows me around from room to room. He likes to keep me in plain sight and prefers to get as close as physically possible. When I come home, I check my personal space at the door. Nemo has claimed my face and neck as his napping headquarters since he was a kitten. While it was cute when he was a tiny nugget, a ten-pound fuzzy, purring mass plopped on top of your face can prove to be a source of slight discomfort.

This behavior became problematic when I discovered I was severely allergic to cats. The sneezing and itchy eyes that I attributed to spring allergies were in fact due to Nemo. The allergist asked if rehoming him was possible, to which I responded with extreme disgust and shock—what a terrible thing to even propose! I now take two different kinds of allergy medication daily: a true testament to my love for Nemo.

Nemo is an Olympic gold medalist in midnight zoomies and spider eating. He also happens to be the best little spoon. I'm eternally grateful for the endless cuddles and free wake-up call services he provides.

Nemo

TYPE
Tabby

NICKNAMES
McNugget, Bubbo, Neems

FAVORITE SNACKS
Spiders, dehydrated chicken treats

LIKES
Belly rubs, drooling, knocking over La Croix cans

DISLIKES
The outdoors

HUMAN ALTER EGO
Bad-boy Prince Harry
(his pre-Meghan Markle days)

"Beautiful, loving, highly evolved creatures, just like their muses."

Christene Barberich

COFOUNDER OF REFINERY29
BROOKLYN, NEW YORK

About five years ago, on New Year's Day, I was finishing up my annual ritual: bringing my journal from the previous year to a special place and taking stock of all its highlights and accomplishments. This time around, I chose the Mondrian hotel in New York. As I sat there detailing the events past, I began to feel very low, reflecting on another year gone by without having a child. Not that I hadn't tried—I had, and failed, no fewer than four or five times. Amid all the wonderful things blossoming in my life, that one defeat never seemed to stop lingering, casting a shadow over every small happiness. But always, on this day, for the four years that my husband, Kevin, and I had been trying, it hurt the most.

On my way home from the Mondrian, I passed a local animal hospital in my neighborhood. I saw a fluffy white cat named Chalky in the window, up for adoption, and went inside. I asked to meet Chalky without even checking with Kevin about the prospect of fostering him. The attendant seemed delighted by my interest, but kept suggesting that I meet another cat instead. This cat's name was Cora, and she was deemed "special needs" because she'd lost her back leg in a car accident the year prior. For some reason, I felt determined it was Chalky who should come home with me that day. I was in kind of a daze and didn't even know what I was doing, but felt strangely guided to do it anyway. I called Kevin and asked him to come over and meet Chalky. But Kevin insisted we meet Cora since she'd bounced around in foster care for months and was just shy of a year old.

The attendant took us into a small room for potential pet parent meet-and-greets. A few moments later, the door cracked open, and in popped this tiny, tiger-striped head—her big eyes were so wide and curious. She was so small but so elegant. She hopped in, and

Phoebe

TYPE

Domestic shorthair, probably mixed with Maine coon

NICKNAME

Pheebs

FAVORITE SNACK

Dehydrated chicken

LIKES

Balls with bells on them, any small stuffed thing with a tail, the hems of dresses, dreaming about birds, bedtime, staging new and ever-more-elaborate/covert ways to stalk ankles and feet

DISLIKES

Being brushed, having her nails trimmed, packed bags, bag packing in general

HUMAN ALTER EGO

Chloë Sevigny
(There is no limit to her coolness)

I watched her look up at both of us pensively and then curl around Kevin's ankle. He scooped her up with one hand and just looked at me, like, *Let's get out of here*. And that was it. We decided to bring her home. When I went back to officially adopt her, Chalky was gone, too.

Phoebe—that's her name now—hid out in her furry little cat house from the

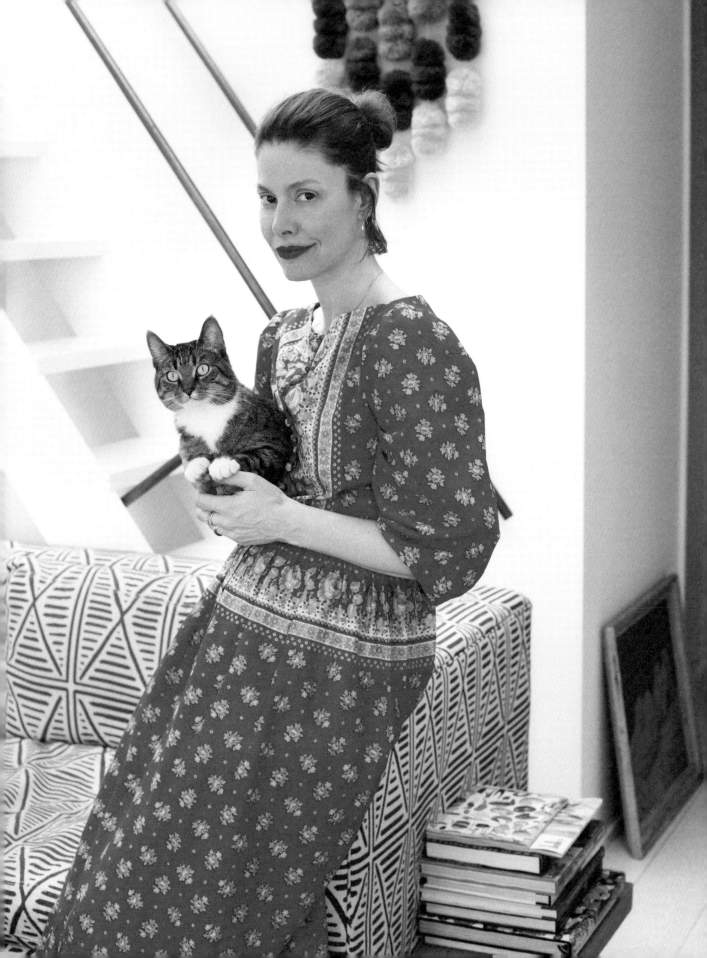

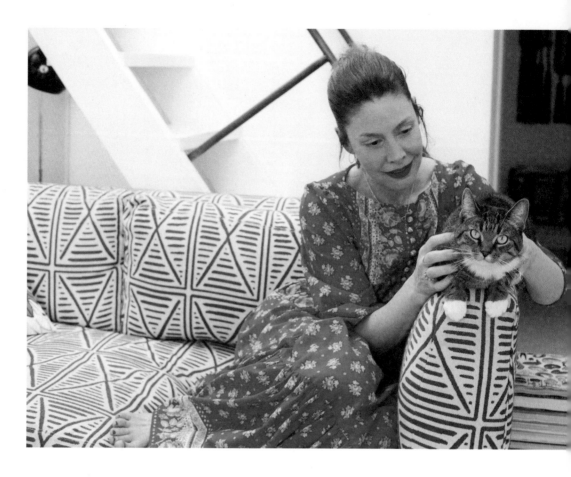

animal hospital as she gradually got used to roaming the apartment and found new spots to claim as her own. It's obvious that she's deeply devoted to Kevin. She likes to hide around corners and pounce on his feet and ankles. But with me, she's more soulful and sturdy. She sleeps between my legs and then, at some point during the night, sneaks up alongside my chest and purrs until we both fall asleep again.

I never expected that Phoebe would or could take the pain of all our loss away, but in many ways she did. And she helped us clear a path to another new beginning—bringing our daughter Rafaela "Raffi" Rose Baxter into the world last October. Rafaela has historically been The Healer, but really it was Phoebe who helped bring us back to life first. And she helped us prepare for a new one—a life we never really thought was possible. Before Raffi arrived, Phoebe reminded me how good it feels to love something, to really care for it and need that simple love in return. To feel like destiny had intervened and she had found her rightful home. She taught me that it

wasn't all my fault I struggled so much to have a child, and helped me find the courage to write about what all that loss was like. The constant love and presence of a soul like Phoebe reminded me that life does go on. That through heartbreak and failure and so much regret come other kinds of love and nurturing that you're not always expecting, but that feeds and heals you just the same. Phoebe opened my heart and gave me hope again. But most of all, she made me believe in myself, maybe in a way I never had before.

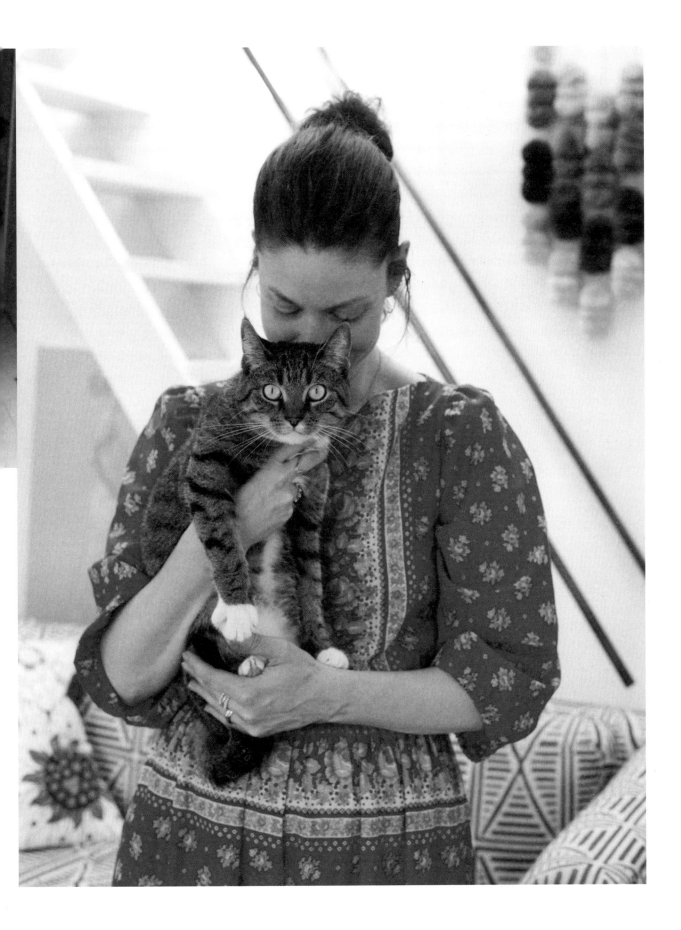

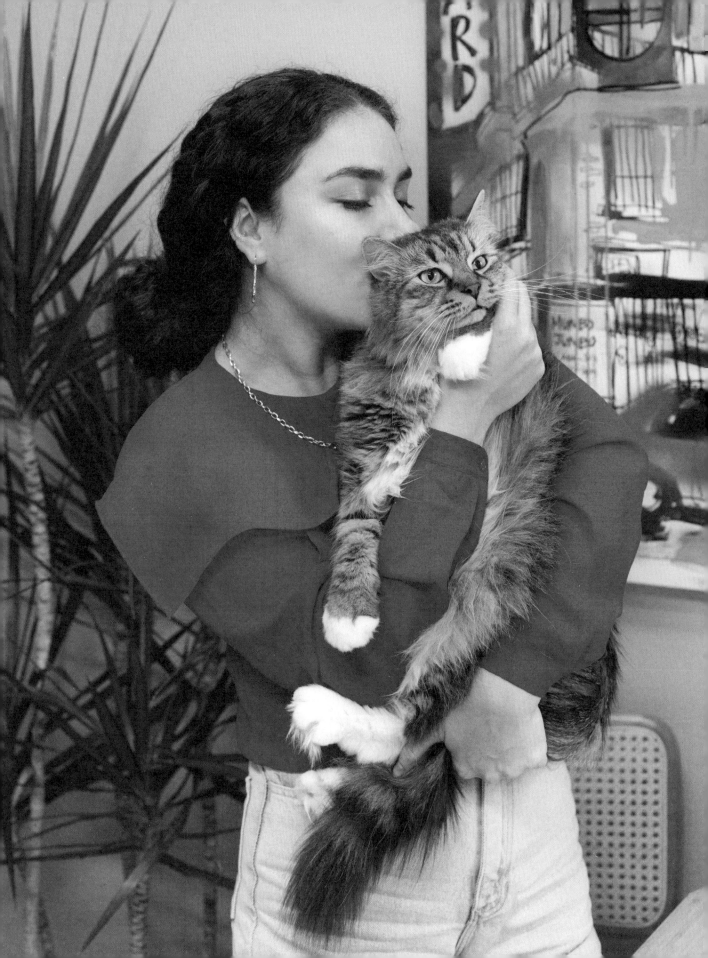

"Not what you've seen on *The Simpsons* but also
not *not* what you've seen on *The Simpsons*."

Cassandra Slack

EXHIBITION AND GRAPHIC DESIGNER
WASHINGTON, DC

I adopted Moshe in October 2016. After a couple months of research, I reached out to a woman who runs a nonprofit in Maryland and had posted several kittens she rescued from a kill shelter in West Virginia. When I visited, Moshe was hanging upside down in his crate, meowing loudly for a snack.

Before Moshe, I did not really like cats. They seemed uninterested and kind of scary. But Moshe has opened me up to the weird eccentricities of cat behavior. I find everything he does to be so sweet and charming, even when he weakly tries to chase a toy or clumsily jumps onto a table, barely making it on top and knocking several things in the process.

Moshe has white socks, three small ones and a large one. He has the sweetest pink paw pads and a bit of a wandering left eye. Sometimes he just looks at me with his big eyes and I am so overcome by his cuteness that I compulsively pick him up and squeeze him until he moos in my ear a couple of times. Sometimes I sing him a song that goes like this: "Moshe! You're my cat!" And that's it. He loves it.

His favorite place in my 550-square-foot apartment is either on top of my blanket basket or in his brown chair, where he can supervise me.

One of my favorite things Moshe does is flirt with my friends when they drop by. He interrupts them while they are talking by patting them lightly on the butt with his paw, then pulling away.

Recently, I woke up to Moshe scratching my rug. I reached underneath it and found a small toy, so I gave it to him and tried to go back to sleep. He kept tugging at the rug, distracting me, so I pulled it back to see what he was playing with. I found several pieces of gold jewelry I had been looking for for months. I should have known based on the way he looks at my chain necklaces that he would be capable of squirreling them away. What can I say? The guy loves gold.

In the morning I usually find him somewhere on my bed beside me. I rub his head and under his chin until it's really time for me to get ready. Sometimes I catch his eye from across the room or in the mirror while I'm putting on makeup, and he's just staring at me and I have no idea how long he's been standing there. It's spooky, and I love it. I tell him that he's obsessed with me and that the feeling is mutual.

Moshe

TYPE

Maine coon mix

NICKNAMES

Moshimoto, Mush, Fluffy Face, Fluffy Butt, Pumpkin, Son, Squishy Boy, Sweet Baby Angel, Prince, Grumpy Pants (when he's not happy with me)

FAVORITE SNACK

Eggs

LIKES

Soft blankets, stretching, birdwatching, running into the hallway and then changing his mind and running back inside, a stick that I brought from the park

DISLIKES

Flushing toilets, being brushed, pens on top of tables, the attention I give to my laptop

HUMAN ALTER EGO

Moses, from the Bible. It's why I named him Moshe! I think Maine coons have a Charlton-Heston-in-*The-Ten-Commandments* vibe.

Jamilah King

WRITER AND REPORTER AT *MOTHER JONES*
BROOKLYN, NEW YORK

I've had Smarty since 2012. He's a rescue whose previous owner got sick and couldn't care for him anymore. At the time I met him, I was pretty neutral about cats, but my roommates were eager to get one. I wound up going to an animal shelter in East Harlem with my roommate to adopt *another* cat (Leo, Smarty's adopted brother), but the minute I saw Smarty, I fell in love with him. He looked at me with his huge eyes from a cardboard box that was in a small cage, and I just knew.

He was one of the biggest cats in the place—I think he weighed about sixteen pounds—and at four years old, he was also one of the oldest. It was a kill shelter, and he had been there for weeks, so the staff decided to discount his adoption fee to $25. He was so playful and so sweet. He rubbed up against my hand when I went in to pet him. And he kept staring at me. It will always be the best $25 I've ever spent.

I joke that his paws have never touched pavement. Despite that rough patch at the shelter, he's been a pretty well-kept cat. He's a gentleman of leisure who loves to curl up on his cat tree and rest undisturbed in my living room's bright spot in the afternoon.

Smarty and I spent our first few years together living with my roommates and two other cats. We were all in cat heaven. Now it's just me, Smarty, and his adopted dog sister, Zora, who's six years younger. He's incredibly patient with her, and even likes to wrestle with her sometimes. There's about an hour-long stretch every evening when they both go kinda wild, running at top speed after each other around the apartment. I call it crunk hour.

Smarty is the most communicative little being I've ever known, and while it's not great that he purrs in my face at five in the morning, I try to look at it as him just being very open about his needs. And I can learn from that!

Smarty

TYPE
Tabby mix

NICKNAMES
Smeet, My Little Guy, Smooches

FAVORITE SNACKS
Milk, potato chips

LIKES
Lasers, cat trees, scratching (mostly sofas, but sometimes people—by accident!)

DISLIKES
Belly rubs

HUMAN ALTER EGO
Kyle Barker from *Living Single*

We both love milk. Every night, I make myself a little snack of graham crackers and milk and sit on my sofa and try to zone out from the day. And every night, Smarty sits on my coffee table, eyeing my cup, waiting for the perfect moment to fling his little head in there and steal my milk. Sometimes he wins. But my reflexes are getting a lot better.

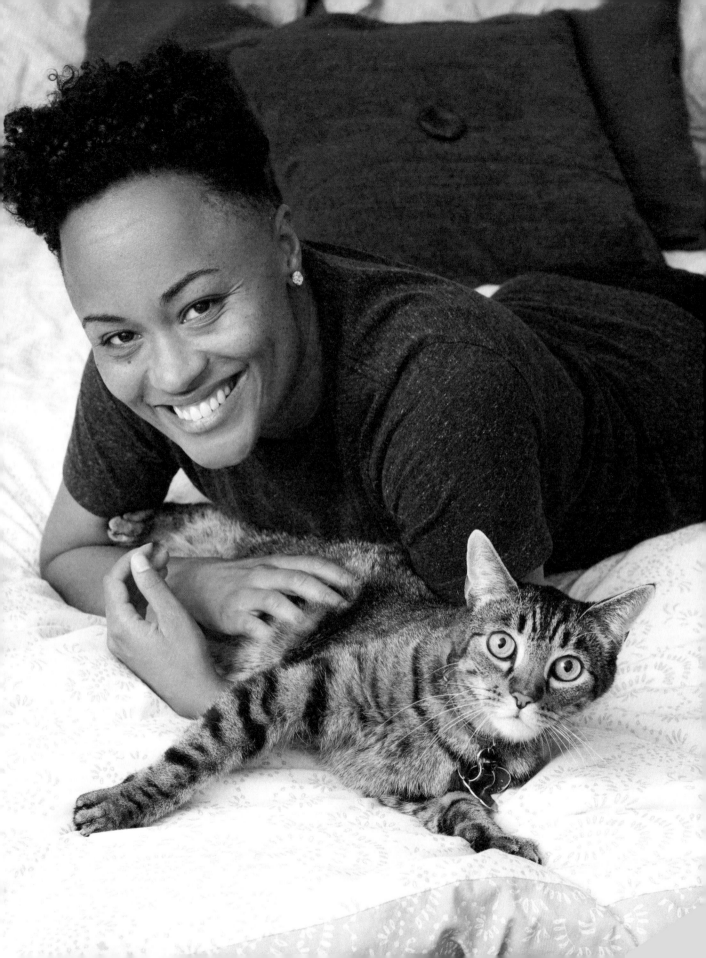

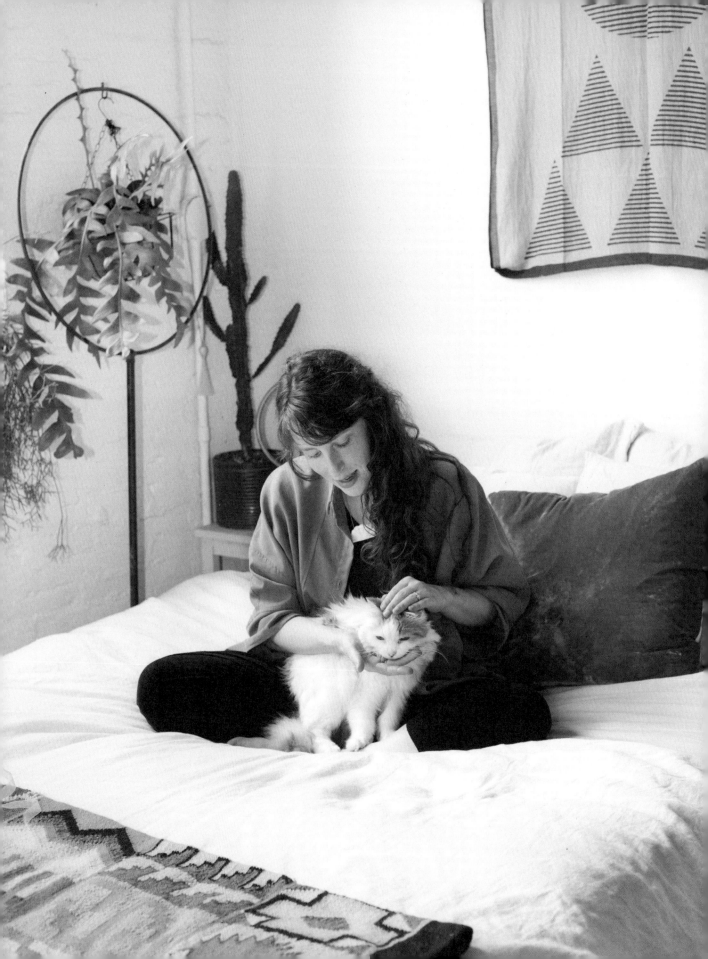

Gabrielle Silverlight

CERAMICIST AND JEWELRY DESIGNER
PHILADELPHIA, PENNSYLVANIA

The story of Miss Mabel and me begins with my first cat, Zolaska (aka Zoli), a beautiful Turkish Van with rabbit-like orange-and-white fur, big emerald eyes, and giant-mitten polydactyl paws. I adopted Zoli from a shelter in Boston in 2003, when he was about a year old and I was in college. The shelter staff called him Mr. Personality, because he was beloved by everyone, humans and animals alike. I asked to hold him and knew I could never let him go. For the next fifteen years, he was the best cat-panion a gal could ask for.

Zoli lived happily with my roommates' cats in Boston, so after I moved to Philadelphia I decided that he could use a furry friend. I like to joke about Miss Mabel's creation story and tell people she came into being from the loose fluff that floated off Zoli when I brushed him, but the truth is she's from a shelter in south Philadelphia. When I first saw her, I couldn't believe this mini Zoli look-alike. Here was another year-old Turkish Van with the same orange-and-white coat, but she had black patches on her paw pads and tail and orange jack-o'-lantern eyes, and was less than half his size. I have to admit I made my initial decision to adopt her based on looks, because although she was (and is) very sweet, I didn't quite know the full extent of her personality; she was still drugged and recovering from the situation the shelter rescued her from. She was malnourished and sickly (she eventually even had to have most of her teeth removed), but I brought her home and nursed her back to health. Since then she has blossomed into the weirdest and most awesome cat, sweet and petite as a forever kitten.

In 2016, when Zoli was fourteen, he was diagnosed with inflammatory bowel disease and small cell lymphoma of the intestines. After two years of treatment, he was doing much better, but then he developed a very aggressive bladder cancer, which is rare in cats. My husband, Brian, and I did everything we could to help him, including traditional and alternative treatments like acupuncture. We both work from our home studio, so we were able to tend to him with his medications, treatments, and weekly vet visits. After a few months of caring for him around the clock, I had to say goodbye to my Zoli. Recognizing that it was time to let him go was one of the hardest decisions I've ever had to make. He fought very hard but was not responding to his treatments. I'm so

Miss Mabel

TYPE
Turkish Van

NICKNAMES
Missy Mae, Bitsy Tippins, Mitzey, Missy, miss miss, Bitzen, Mitzey von Bitzey Crackers

FAVORITE SNACK
Tuna

LIKES
Smelling shoes, rolling in just-worn shirts, cuddling in laps, licking water from the bathtub faucet, sitting in her teepee house overlooking the rest of the apartment, getting brushed, being patted on her back right above her tail

DISLIKES
Plastic bags, fur-to-skin contact (e.g., she prefers pants to shorts)

HUMAN ALTER EGO
Not a human, but Mogwai from *Gremlins*

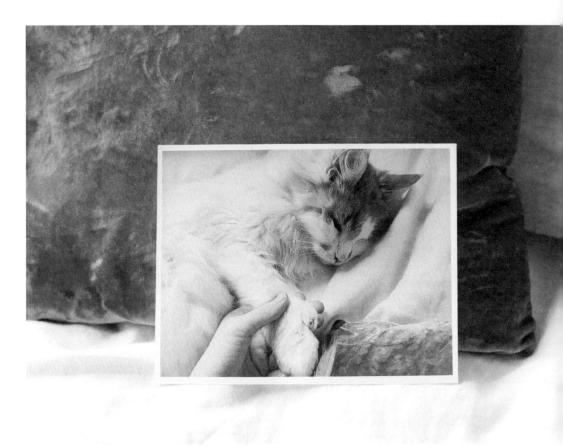

incredibly grateful to our veterinarian, who came to our home and made Zoli's transition as peaceful as I ever could have hoped. Brian and I lay on the bed with him, and just as he passed, the bells from a nearby church rang. The moment was completely beautiful.

My love for Zoli (pictured above) was always enormous, but my heart opened up to make space for Miss Mabel as soon as she came into our home. They made a dynamic duo with their very different yet complementary personalities. They both loved cuddles and kisses, but Zoli always wanted you to hold him, while Miss Mabel prefers a lap. He had an adventurous palate (chips, popcorn, cookies, whitefish, even his own loose fur), while she prefers a simple diet of cat food and tuna treats. He loved to spoon in bed; Miss Mabel prefers to sleep on top of me. He would jump on every surface you didn't want him on, bulldozing anything in his path; she daintily creeps around each object. She runs away when the bed is being made, but Zoli loved dashing between the sheets as I tried to make it up. I liked to describe his long meows as his lovely singing voice,

while she makes an array of chirps, squeaks, grunts, and varied-tone meows—I'm always trying to figure out her code. Zoli always looked perfectly handsome (I dare say he was the most handsome cat ever). Miss Mabel makes me laugh because sometimes I catch a glimpse of her looking like a little gremlin.

While we were adjusting and mourning, Miss Mabel and I gave each other so much comfort. Cats show (or rather don't show) pain in very different ways than people do. The space Zoli left behind felt immense. Of course, our cats had different spots in the house that they claimed as their own. A week or so after Zoli passed, Miss Mabel made herself comfortable for the first time ever in a Zoli-only zone: a rattan butterfly chair that I called his throne. Maybe she had always had her eye on it, but I like to think that sitting there made her feel close to him.

Jayde Fish

ILLUSTRATOR AND DESIGNER
SAN FRANCISCO, CALIFORNIA

In 2014, my partner, Jeremy, and I watched the movie *St. Vincent*, starring a grumpy Bill Murray who bonds with a fluffy white Persian. We fell in love with their relationship and decided we really wanted a cat. I had wanted one ever since I was a kid (my dad was allergic). After some searching, we found a woman who had several chocolate British Shorthair show cats. Their squished, hilariously angry-looking little faces and short legs won us over. A very special re- tired one named Irbis had a snaggletooth. The show- cat community considered it a flaw, but it made us like her even more. The woman really liked our artwork, so I gave her a drawing—a portrait of a lady with hair made up entirely of brown cats—in exchange for gifting us Irbis.

We now call her Mrs. Brown, or MB for short. (Her full name is Mrs. Irbis Brown Cat Fish.) The name Mrs. Brown comes from my grand- mother, who I was very close to. It was the name she used when we played house. We used to pretend to be young working women with silly little dramas, and dressed up in funny outfits, costume jewelry, and hair extensions made out of nylons. It was a pretty funny sight. I went by Mrs. Jones. My grandmother passed away right around the time I got MB, and because she was a brown cat, the name fit perfectly.

As soon as MB set foot in our house, she was friendly, out and about, and looking for a scratch—not the kind of cat to hide. It took some time for her to get really cuddly, but now she's like my shadow.

Her one eye looks a bit cloudy because she had to have surgery on it, to repair a wound she got playing with a toy; it wouldn't heal on its own. The damaged outer layer had to be removed. It's a common issue in flat-faced, or brachycephalic, cats due to the large size of their eyeballs and the fact that they don't have a long nose to protect

them from debris and scratches. We like to pretend that she got into an alley-cat fight over a piece of tuna, though—you should have seen the other guy.

MB had some other health problems a couple of years ago. She went into stage-four kidney failure when she was given Meloxicam (a nonsteroidal anti- inflammatory drug, like human Advil, that has been linked to renal failure in cats) after a surgery. We thought she

Mrs. Brown

TYPE
British Shorthair

NICKNAMES
Kitteee, Mrs. B, MB, Muffin Cat, Booboo Kitty, Little Bear, Tiny Face, Triangle Face, Brown Cat, Brown Garfield

FAVORITE SNACK
Inaba Churu salmon purée

LIKES
Water, chin scratches, belly rubs, kitty grass

DISLIKES
When I oversleep

HUMAN ALTER EGO
Billie Holiday, especially when listening to the song "Miss Brown to You"

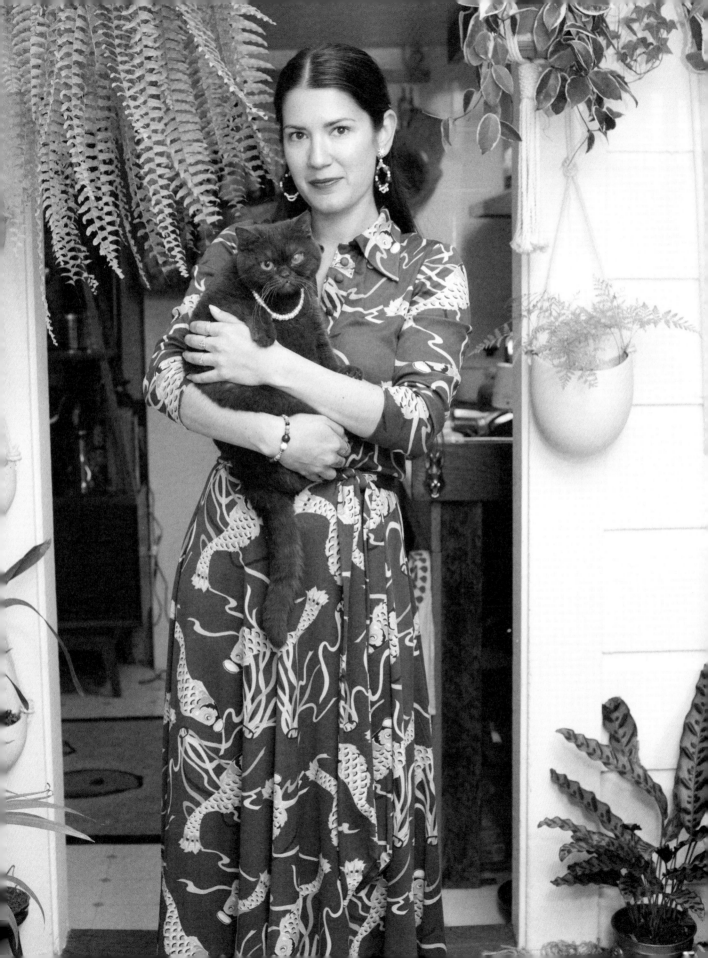

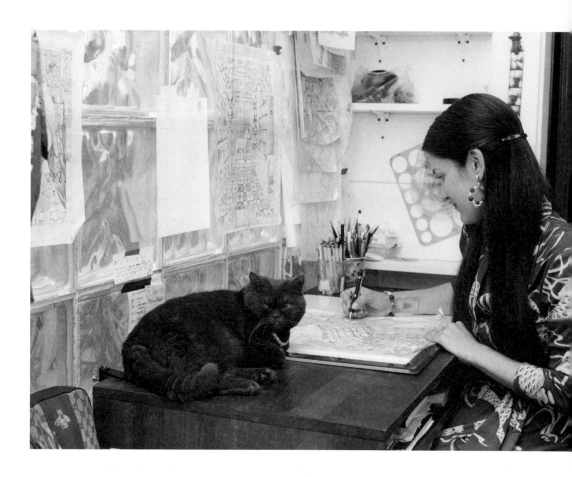

wasn't going to make it, but with the San Francisco SPCA's help she quickly turned around. I'm happy to say that her kidneys are back to normal, but for a while there she had to have IV drips. I can't recommend pet insurance enough.

Ever since the scare with her kidneys, MB has been infatuated with water. Staying hydrated with compromised kidneys makes sense—she's a smart cat. She loves to jump in the shower, bathe her paws and face in her water fountain, and get sprayed with a spritzer bottle. Every day when I wake up I make my coffee and spritz my plants and my cat. It's a ritual.

She also loves to lie in the warmth of the LED light on my drawing table and can often be found there, belly up, partially covering the very drawing I'm working on, like a furry assistant.

There are so many things I love about MB: how soft she is (she often gets compliments on her bunny-like fur), the way she head-butts almost everything, her big orange eyes. She's really integrated into our little family, always cuddling with us on the bed and eating

with us when we have lunch or dinner. And she's very social when we have friends over—she just naturally looks pissed off, especially with her tooth sticking out. Her personality is hilarious. There's a lot more laughter in the house with her around.

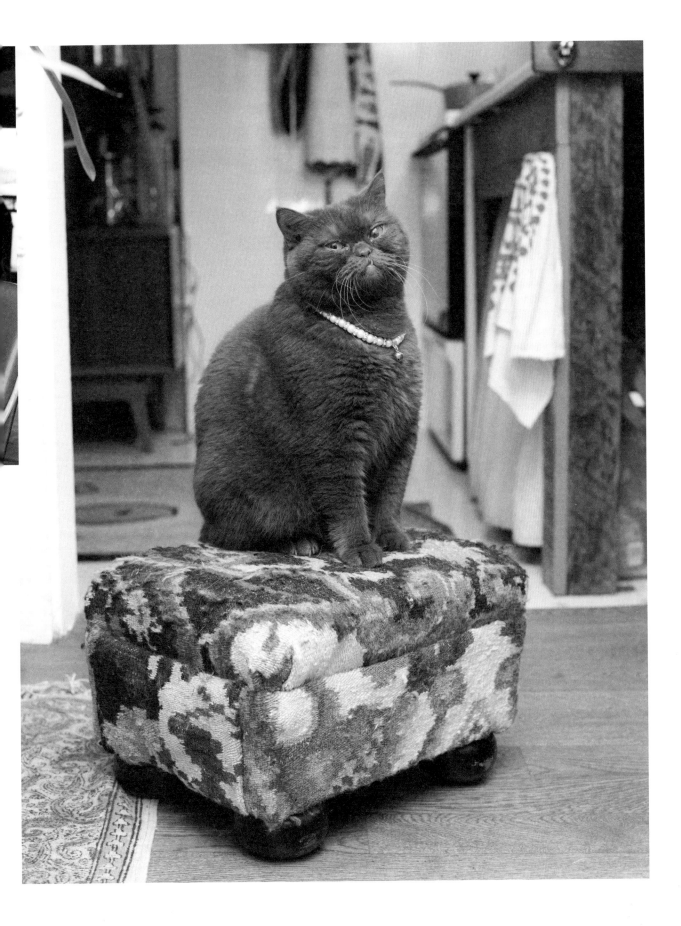

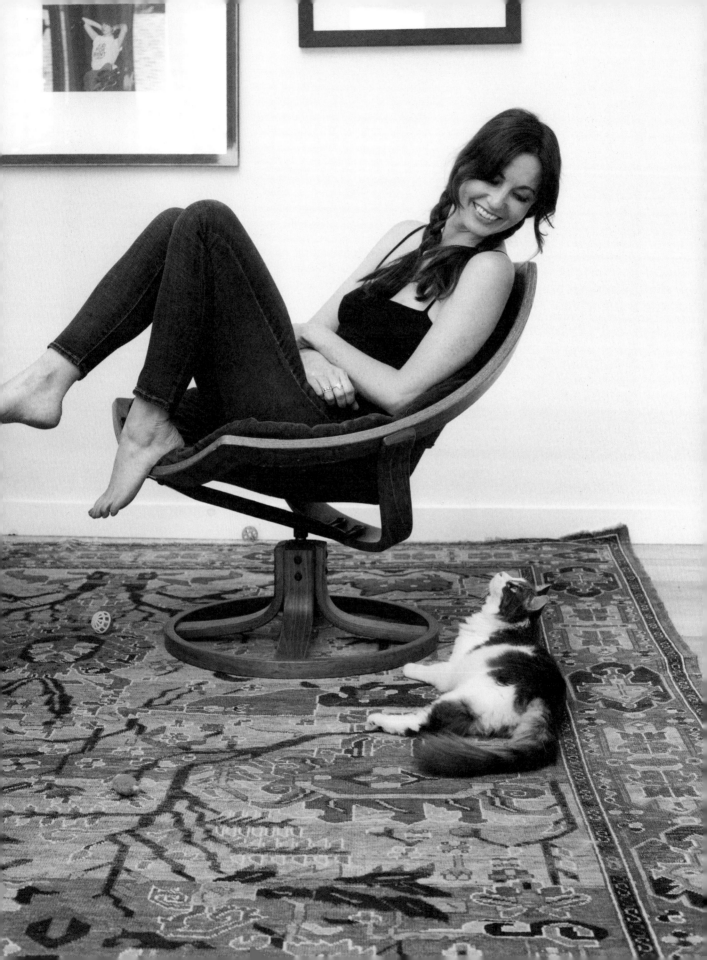

Liz Carey

COMEDY WRITER/ACTOR
LOS ANGELES, CALIFORNIA

I have had a deep love for cats for as long as I can remember. My grandfather had a farm in Michigan where there was almost always a pile of kittens. He even had a little cathouse for them. I spent hours out there, taking care of them and carrying them around in my overalls. If I could go through life with kittens in my pockets, I feel like it would be so much easier.

Captain joined my family—me; my son, Waylon, who is now thirteen; and our pet lizard, Pokie—in October 2017, when he was about four months old. Waylon and I were both drawn to his lopsided walk, crossed eyes, and squirrel-like tail, which continues to be strangely longer than his entire body.

Captain is really more of a dog in a cat's body. He lives to play fetch. When the doorbell rings, he runs to greet our guest and throws himself at his or her feet. He is a real talker, happy to interrupt any conversation to give his two cents. He loves taking hot baths and cries to get in the shower. His main job is securing the bathroom area in general. If he is not busy in the bathroom, he is trying to get inside the refrigerator. (So we are basically the same person.) If I am getting a treat, then he is getting a treat. He made that clear when he moved in, and I respect this.

He has some kind of crazy hearing that I have never known from a cat. If I so much as open an eyelid in the morning, it is time to wake up. He sits on my face until that happens. I do not know how—does having crossed eyes amp up his hearing?—but he could work in a special ops unit. That being said, he slides all over our wood floors and is not the most skilled when it comes to balance or high jumps. Leaping up on furniture or counters is not his forte—unless there are flowers that need destroying, and then he really comes alive.

Captain is not the easiest cat I have ever had. I said it. He has tufts of hair growing out of his paws that need some tending, and white fur that is always on me. He is loud, constantly under my feet, determined

Captain

TYPE
Siamese/calico mix

NICKNAMES
Mr. Bites (because he nips a lot), Bushie

FAVORITE SNACKS
All the snacks!

LIKES
Eye massages

DISLIKES
Any funny business on his stomach, loud noises

HUMAN ALTER EGO
Michael Scott from *The Office*

to walk on the stairs when I do, and dying to go outside (we keep going over the same subject). He loves to lie on my best silk dresses. His other favorite pastime is sitting on my bedside table and slowly knocking each item off. Still, I cannot imagine not having him or his insane crossed eyes staring at me every day. He is a snuggler when he feels like it, and one of the best feelings is when he settles his little head onto mine.

Catproof Your Home

Entryway

Put everything you bring in on a rimmed tray or in a drawer. Drop your keys or the heavy pair of earrings you can't wait to take off on the console table unsecured, and the next time you see them will be when you roll up the rug to move. (Tell your friends about this when they come over.) **NOTE:** This is a nice place for a scratching post, so she can claw it when she's coming down from the excitement of meeting you at the door.

Bedroom

Leave an open space on a deep, sunny windowsill. Spread a comfy throw across the foot of the bed for her. (Cats love chenille.) Clear your nightstand of anything break- or spillable. This will be her launching point for jumping onto your pillow, where she'll curl up around your head while you sleep. You may wake up to find you're occupying approximately 10 percent of the pillow, and she has taken over the rest.

Closet

Leave a little space in the back of your closet, behind a shoe rack or shelf—this will be her favorite hiding place. **NOTE:** Know that if you leave a drawer full of neatly folded clothes open and turn your back, you may find it more disheveled and slightly furrier the next time you reach in.

Dining Room

Embrace glass furniture. Glass is a mystery to cats. Instead of setting a no-paws-on-the-table rule and asking her to obey it, go with glass.

Kitchen

Clear—or contain—the counters and whatever's on top of the fridge. Yes, she can jump up there. No, she won't mind if she knocks over the granola. **NOTE:** This is a good, out-of-the-way place to serve dinner and/or snacks.

Bathroom

Remember to shut the toilet lid. Dogs aren't the only ones who will stick their snouts in for a drink. **NOTE:** This is where she'll sit to keep you company while you do your eyeliner.

BAD-NEWS BLOOMS

Set a vase of fresh flowers on your dresser or coffee table and your cat will want to have a sniff (and maybe a bite). We don't blame her a bit: You've brought home a new, irresistible outside smell. But when you're choosing a bunch, keep in mind that some flowers aren't safe for cats.

The ones we want to call out in particular are LILIES. In interviews for this book, we heard about tons of close calls involving cats and lilies. Every part of every kind of lily—Easter lilies, tiger lilies, stargazer lilies, you name it—can be fatal to cats if ingested, even the water in the vase, per the U.S. Food and Drug Administration. Ingesting even a small amount can cause kidney failure. Close relatives, like lily-of-the-valley, can be dangerous, too. Keep them out!

To learn about all the plants that are toxic to cats, see the ASPCA's full list: aspca.org/pet-care/animal-poison-control/cats-plant-list.

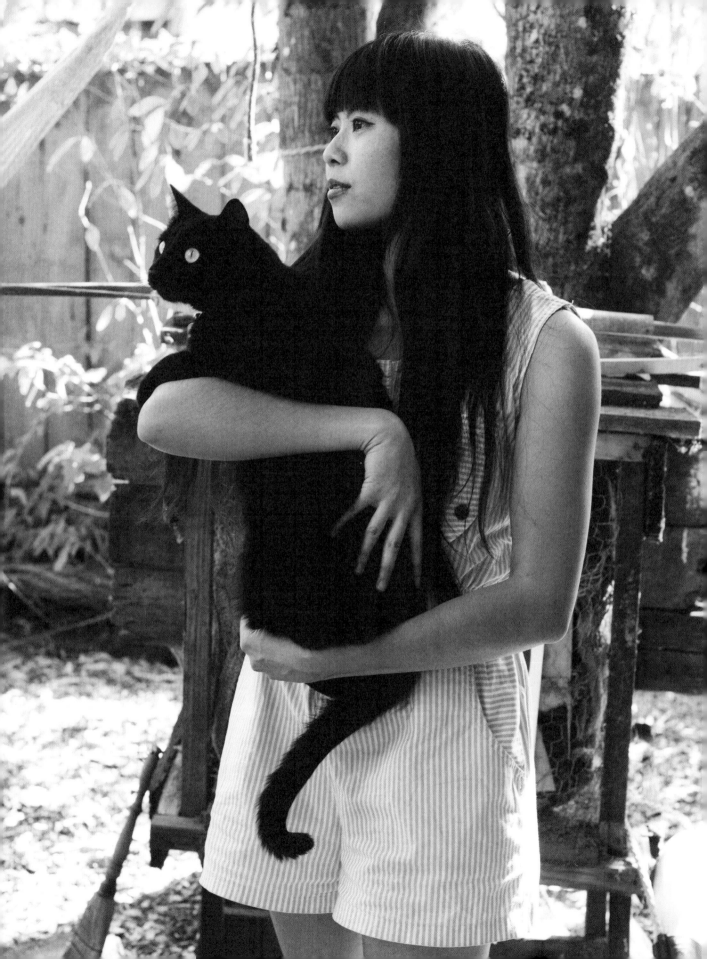

CAT LADIES ARE...

"Intuitive, kind, and a bit mischievous."

Monica Choy

**ARTIST AND COFOUNDER OF THE
CREATIVE WORKSPACE ACTION STUDIOS**
PORTLAND, OREGON

Early in our relationship, my partner, Souther Salazar, and I moved from Los Angeles to a house on a river in rural central California. We found a feral kitten in our backyard and named him Popcorn. We felt like a little family of hermits. Popcorn started appearing in Souther's art, and Souther even made a stop-motion short with him. We had a home studio, so we spent a lot of time with him every day. Just over a year later, we suddenly lost Popcorn to feline infectious peritonitis, a rare and fatal disease. We were completely heartbroken.

Souther said he wouldn't be able to adopt another cat for a while. Before Popcorn, he lost his cat Morrison to cancer, and it really hurt to lose another friend so soon. I missed Popcorn so much that I would go to Petco just to pet the cats in the adoption area, knowing I couldn't take any of them home with me.

A month later, a friend of ours messaged Souther about two kittens he'd found on his property in Grass Valley. We were going to San Francisco for my birthday, and he said he could meet us there with the kittens. Souther secretly drew a coupon for "One Free Kitten of Choice" to give me as a surprise if we connected with either one.

When I met the kittens, I didn't know we could adopt them, and I was so envious of them. They were such love bugs. The two eight-month-old black kitties were twins in every way; they mirrored each other's movements and seemed to share one energy. There were only subtle differences between them: One purred immediately when you petted him or picked him up; the other loved to wrestle. They would lie so close together that you couldn't tell where one cat ended and the other began.

When Souther gave me the coupon, I was so surprised and happy. But which one would I choose? After sleeping on it, we agreed that we had to adopt both of them, and started calling them the Cat Bros.

Linus & Zorro

	TYPE
Both »	Unknown

	NICKNAMES
Linus »	Linocut, Tinus, Linie
Zorro »	Zorro-man, Z-bo, Personal Panther
Both »	The Cat Bros

	FAVORITE SNACKS
Linus »	Roommate Matilda's cat food
Zorro »	Feline Greenies, water from the tuna can

	LIKES
Linus »	Sitting in laps, sun patches, being held like a baby, drooling with joy
Zorro »	Being brushed, wrestling, catnip, cuddling in bed in the morning

	DISLIKES
Linus »	Being kept indoors
Zorro »	Too much petting, being held

	HUMAN ALTER EGO
Linus »	Linus van Pelt, from *Peanuts*
Zorro »	Gordon Patio, a private eye who goes from door to door, surveying the neighbors about their cat-treat situation

45

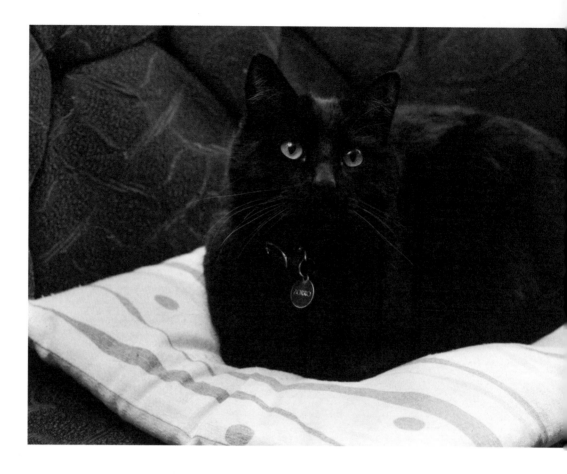

The Cat Bros have lived with us for eight years, in central California, San Francisco, and now Portland. Zorro, who's named after the masked vigilante, is built like a jungle cat. He's burly, with a swagger in his step, and his tiny fangs stick out a bit. Linus, who's named after the Zen *Peanuts* character, has a lot of poise, and I often think of him as a cat model. He's always posing with his paws and tail positioned just so. As they've grown up, they act less like twins and do their own thing. But I love it when they slip back into their kitten selves and cuddle together in a pile or eat meals side by side, synchronized tails twitching.

Linus still purrs right away. And he makes friends wherever he goes. In our old neighborhood by Belmont Street, he went out at night sometimes and came home smelling like cigarettes or perfume. He was getting pets from the barflies on the corner. One of our neighbors even offered to adopt Linus because he started coming to his house every day to visit his cat, Mouse—she and Linus were having a love affair. Mouse is an indoor cat, but she would sit by the sliding glass door while Linus sat outside, and they would gaze into each other's eyes. One time she ran out to protect him from a giant raccoon. He is easy to love.

Zorro is more standoffish with strangers, but he is loyal and tender to those he's chosen as his people. He throws his whole body into head-butting you for pets. He talks more than Linus, but instead of meows, he makes a sound that is more like "*MAAAH*"; it's his usual greeting. He has a certain route he likes to patrol in our neighborhood.

I love the little things about our life together: how Linus sits on the edge of the kitchen counter watching me, how Zorro touches his forehead to mine, how they gallop to the car when we come home from the studio.

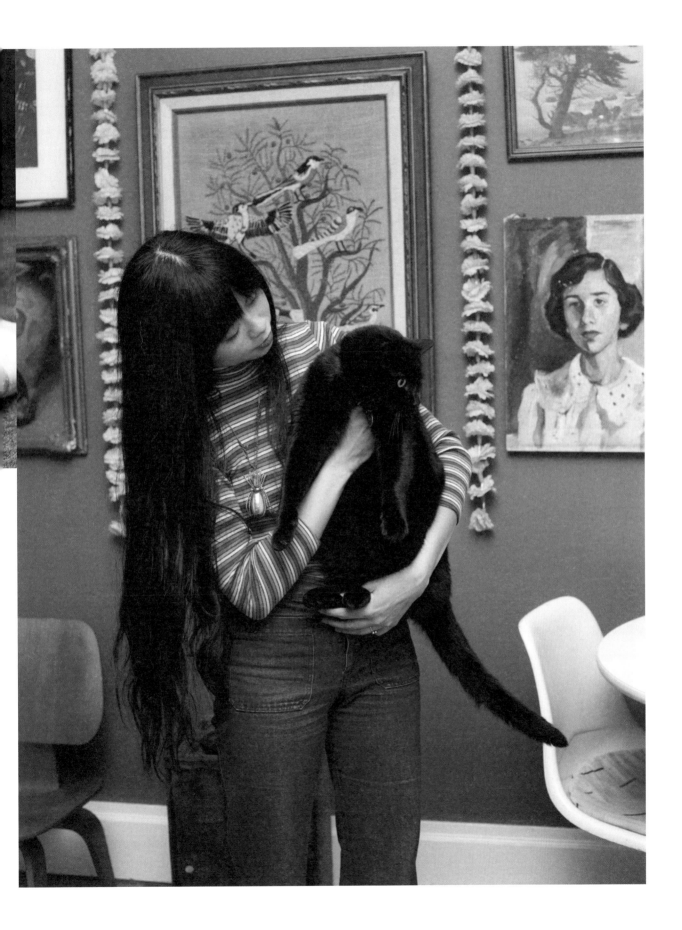

"Just ladies with cats, dealing with life one kitty-litter scoop at a time."

Shona McAndrew

ARTIST

PHILADELPHIA, PENNSYLVANIA

Bo is my absolutely favorite soul in the world. From the moment I adopted my little scrawny ball of uneven fluff, he has been my happy place. It was a week before I started my master's in fine arts at the Rhode Island School of Design, an important and scary moment in my life. I knew I would need something to ground me, and Bo became that rock.

I looked for rescued kittens in the Providence area. His profile picture immediately stole my heart away—in it, he was sleeping like a contorted, fluffy pretzel, and looked so very small and precious. When I realized he had the same birthday as my mom, it felt like the world telling me to make it happen.

Walking into the rescue center, I was warned that Bo was not particularly social. As the runt of his litter with what seemed like only fifteen hairs coming out of his tail, he was a scrawny, funny-looking cat. But none of that mattered: He had already taken a kitten-size chunk of my heart.

Fast-forward four years, and Bo has grown into a large, kind, handsome, fluffy tuxedo cat. Though he wasn't fluffy for one of those years. Let's just say his tail was a late bloomer and went from patchy (and I'm being polite) to the bushiest tail that rivals any raccoon's or squirrel's. He has three main passions in life outside his rigorous nap schedule: chasing bugs, cuddling, and competing in long-distance staring contests. At times he is goofy and a little bit crazy, and at others he is sensual and elegant. One minute, Bo will be nestled between me and my boyfriend, spooning him as he caresses my face with his li'l paws. The next, his eyes will widen and his ears will perk up and you know that Bo is about to sprint pell-mell out of the room and under the couch—his favorite hiding spot—because of the impending terror of a car he might have heard turning a corner five blocks away.

He's my best friend, always by my side. My art studio is a separate but connected space in my home. Bo has slowly become an amazing studio cat, always perched on a shelf or lounging on my table, watching my every move. I like to say he's my little guardian angel, always keeping an eye on me. (It's either that or a staring competition . . . I'm still not sure.) I don't think he has missed a single one of my bathroom breaks in the past year.

I am completely enamored with Bo and utterly incapable of capturing all of the quirks that make him special. He is my little man, and I am so grateful to have found him and to be able to share my life with him.

Bo

TYPE
Domestic longhair tuxedo

NICKNAMES
Bobo, Bobo the Oboe, Bo Daniels, Little Chicken, Lovebug

FAVORITE SNACK
Popsicles

LIKES
Belly rubs

DISLIKES
Anything remotely startling

HUMAN ALTER EGO
James Bond

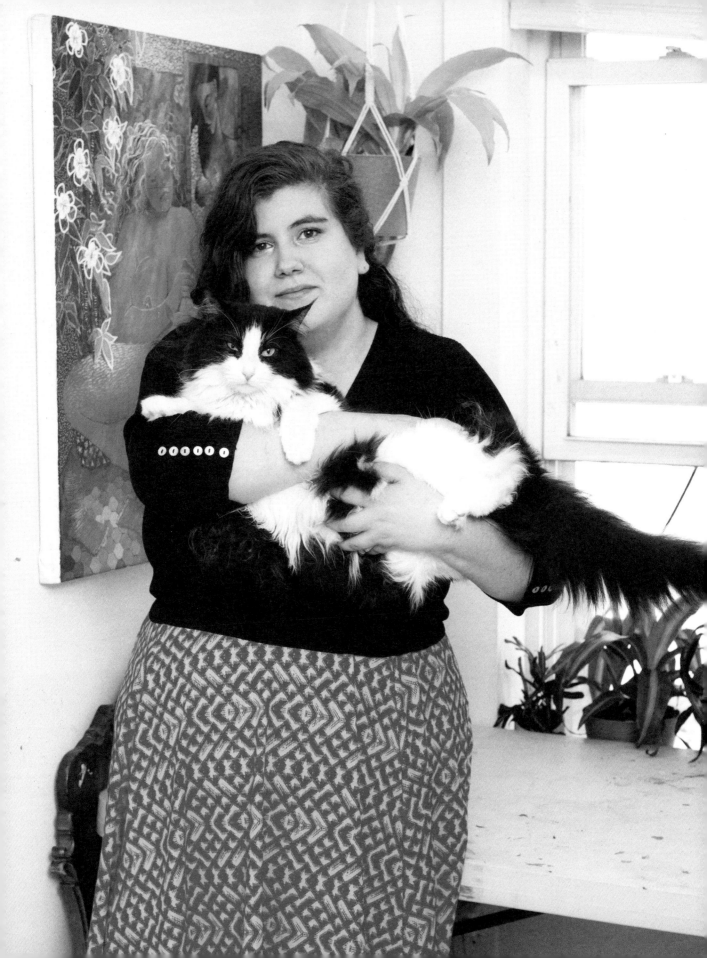

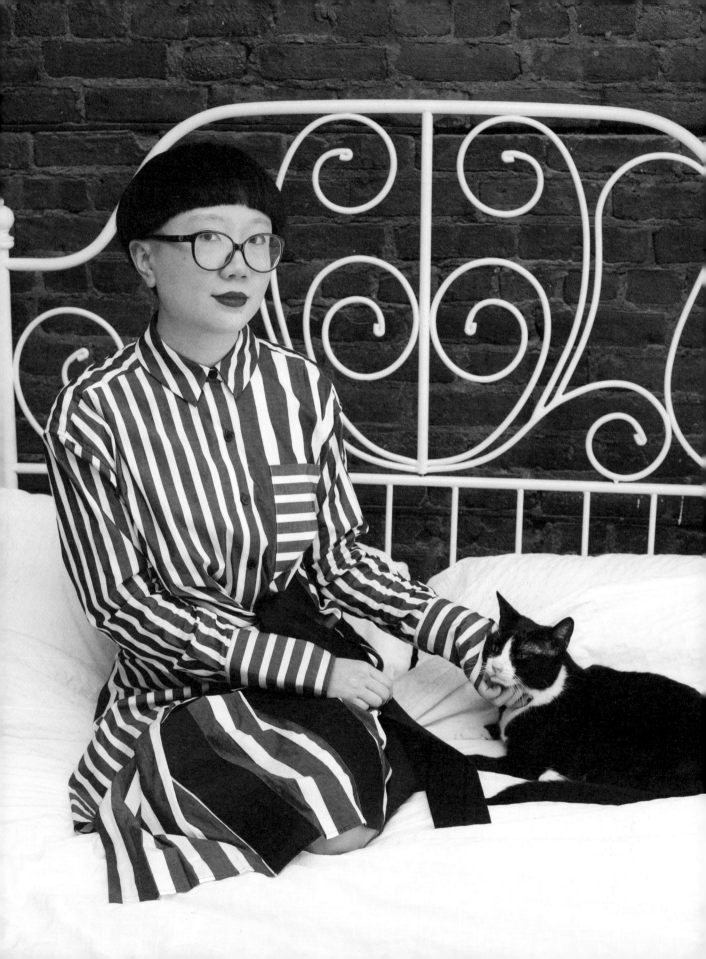

JiaJia Fei

DIGITAL DIRECTOR AT THE JEWISH MUSEUM
BROOKLYN, NEW YORK

Coco was an impulse purchase. I walked into an animal shelter in Brooklyn almost nine years ago, just to "look," and knew it was going to be impossible to leave without adopting a cat. I spent several hours that afternoon meeting and interacting with every single cat to make sure I went home with the right one. When I first met her, Coco was rather shy, and then she began to aggressively head-butt her face into my hand with affection. From there, I knew she was the one.

To this day, Coco (full name Coco Chanel Fei) remains a loving head-butter. Since she was only four months old, Coco has grown up in my Carroll Gardens apartment, living a cozy life of naps and deep cuddling. In many ways she's also grown to fit the stereotype of pets who resemble their owners. Her black-and-white look pairs perfectly with my deliberately monochromatic wardrobe and bedroom, where she spends about 90 percent of her time.

Coco was 100 percent a dog in another life. She frequently runs to the door when someone knocks, follows my every step around the apartment, and sometimes even chases after toys and brings them back to me as if we were playing fetch. Unlike dogs, cats train *you*. I'm no stranger to the early morning wake-up call for breakfast (in the form of knocking-down-everything-in-sight terrorism). But Coco is also a creature of habit. In the morning she follows me through every step of my routine as I get ready for work, from the bathroom, where she stares at me patiently while I brush my teeth, to the Nespresso machine, where I make my coffee, all the way back to my room, where she squats on my clothes while I get dressed.

Coco is famous for her bed squat. Anytime I place a piece of clothing on my bed, she somehow always ends up sitting on it, which, during winter months, is an ideal way of preheating my look for the cold weather. In the evening, her squishy bundle of fur conveniently doubles as a foot warmer. Every night, she knows it's time for bed

when I put away my laptop and turn off the lights. She gently crawls onto my pillow, spoons the top of my head like a little hat, and purrs herself to sleep on my face. It's the best.

Coco

TYPE
Domestic shorthair tuxedo

FAVORITE SNACK
Dried seaweed

LIKES
Sleeping, dogs

DISLIKES
Thunderstorms, loud noises, other cats

HUMAN ALTER EGO
Coco Chanel

Cherie Jellison

INTERIOR DESIGNER AND FOUNDER
OF BLINK INTERIORS
PORTLAND, OREGON

Charlie and Susan are my fluffy princesses. I honestly don't think they'd last a day outside. They were both surprise gifts from my ex-boyfriend, about a year apart.

Charlie came from the Humane Society as the tiniest white fluff-ball kitten ever, and now she's the most gorgeous—and temperamental—creature. She loves to talk and has the loudest meow, especially when mealtime rolls around. She's even been known to bite a toe sticking out of bed in the morning to let you know it's time to eat. And she drinks only fresh water out of the bathroom sink. (I told you she's a princess.) She's a total sweetheart who wants to be on your shoulders like a live, furry stole, getting scritches at all times. You can tell she's really into it when she starts sneezing and drooling.

Susan is quite literally the cutest cat you will ever see. Her little face makes me want to burst out laughing or crying every time I look at her. She's a little jumpy/neurotic and takes a while to warm up to strangers, but once she does she won't leave you alone. I work from home, and Sue sits on my lap at my desk all day. If I have to get up, I just pick her up like a flat kitty pancake and put her back when I sit down again. Her favorite spot in the house is the kitchen rug, and when you stand there she does figure eights through your legs. I say she's "buttering me up," because it's kind of like she's spreading butter on toast. Her meow is barely a squeak, her tongue sticks out 80 percent of the time, and even though Charlie torments her, she loves her and looks up to her the way any little sister would.

Charlie & Susan

TYPE

Charlie »	Longhair, possibly Maine coon
Susan »	Longhair mix

NICKNAMES

Charlie »	Chuck, Chuckie, Smog, Charlene Princess Payday
Susan »	Sue, Susy, Bug, Buggy

FAVORITE SNACKS

Charlie »	Tortilla chips, ice cream
Susan »	Raw kale

LIKES

Charlie »	Harassing Susan, sleeping, eating
Susan »	Sitting on laps, sticking her tongue out

DISLIKES

Charlie »	Unwanted petting
Susan »	The vacuum

HUMAN ALTER EGO

Charlie »	Marie Antoinette
Susan »	Phoebe Buffay

Sandra Martocchia

PRODUCT DESIGNER, ANIMAL ADVOCACY
ACTIVIST, AND HERBALIST
SAN FRANCISCO, CALIFORNIA

When people hear that I have three cats, the next thing they usually say has the phrase "cat lady" in it, and I'm perfectly okay with that. Prudence, Jojo, and Chia came to me in various ways—none of which included me deciding it was the right time to get a cat—but I'm perfectly okay with that, too.

Prudence was the first of the three. She was a surprise birthday gift from my boyfriend at the time. My previous cat had died unexpectedly, and he thought a new cat would help me out of my grief. But it was soon evident it wasn't going to work that way. New pets become new loves, not replacements. I was living with my three rats at the time (that's a whole other story), and I'd gotten used to letting them run freely. But I didn't hesitate to move them into cat-free quarters for playtime, because there was no way I was going to send Prudence back to the shelter. Prudence is the friendliest of my three cats, especially with new people. Sometimes I feel bad that the other two came along because I have a suspicion she'd rather be the only cat. She's the one who is always there next to me, wanting a kiss, often blocking me from whatever it is I'm trying to do. We compromise.

Jojo joined us after my mother made me promise to adopt another cat to keep Prudence company. I happily complied. Jojo is the most vocal of the bunch. All I have to do is look into his eyes to get him to say something. He's also the biggest. By biggest, I mean fat. He always wants to eat. Sometimes I think he has Maine coon in his bloodline because of how big and affectionate he is. We don't end a day without having a snuggle session.

Chia is the most independent and the youngest. She originally belonged to my mother, but when my mother fell ill a few years ago, I promised her I would take care of Chia. It's difficult to put into words what those moments were like. We were planning for a possible future, but it was as if we were going through the motions without believing that future would actually come. When you're

Prudence, Jojo & Chia

TYPE

Prudence » Black-and-gray tabby domestic shorthair with some orange

Jojo » Black-and-gray tabby domestic medium-hair

Chia » Gray-and-white longhair

NICKNAMES

Prudence » Prudy

Jojo » I don't really have one for Jojo—maybe because his name already sounds like a nickname

Chia » Chi Chi

FAVORITE SNACKS

Prudence » Fruitables Wildly Natural Cat Treats

Jojo » Tuna

Chia » Freeze-dried chicken bites from Crumps' Naturals

LIKES

Prudence » Drinking out of faucets, drinking out of glasses, chasing laser pointers, head butting

Jojo » Sprawling out, purring, snuggling

Chia » Jumping onto kitchen cabinets, licking hands and feet

55

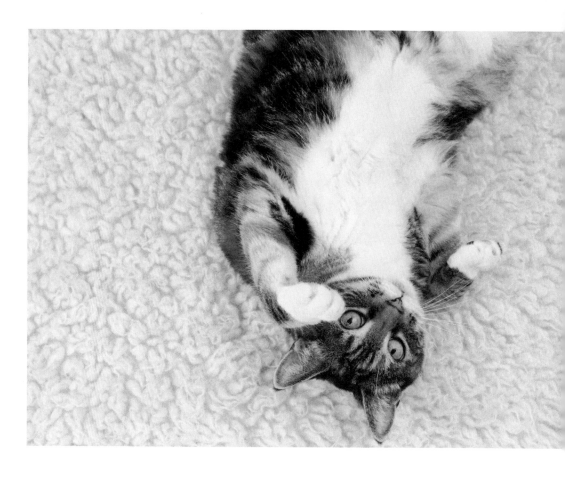

faced with a situation like that, you have to acknowledge things you never want to think about, and you do it so that the person you love can feel relieved and at peace. As my life shifts and turns, I'm always looking to make arrangements for how my cats will be taken care of if something suddenly happens to me. I suppose I do this in light of what happened with my mother, who ended up passing soon after. I think it was a relief for her to know Chia would be with me. And it's been meaningful for me to know I could do that for my mom. As for Chia, she is a tiny pile of fluff who has added nothing but joy to my life. Whatever she is doing, when I turn to look at her, my heart just melts. Unfortunately, as a latecomer to the group, she has to defend herself from the other two. But she's a tough girl and a total sweetheart in light of it all.

I sometimes think of us as this funny little awkward family that gives and takes like any other family. In the end, I'm just a grateful cat mama who's happy to have them in my life.

DISLIKES

Prudence »	The outdoor cat who occasionally visits the window
Jojo »	Loud noises, vacuums
Chia »	Prudence and Jojo when they gang up on her

HUMAN ALTER EGO

Prudence »	Emma Stone
Jojo »	Jack Black
Chia »	Gwen Stefani

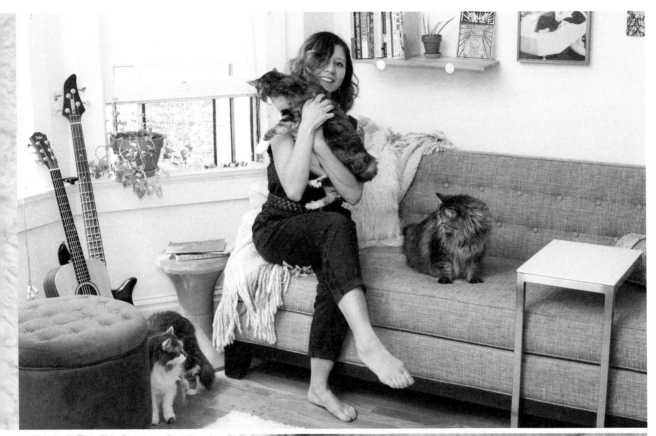

CJ Miller

MUSICIAN, DANCE AEROBICS INSTRUCTOR, AND BARMAID
LOS ANGELES, CALIFORNIA

My ex-partner/current dear friend volunteered at an animal shelter in Santa Monica, and among the many rescue kittens who came through the doors was Lydia, a wiry puff of gray, white, and black with a charming, impish face. We two young and moody goth punk girls fell in love with the little goblin, and it was decided that we would adopt her.

Lydia is equal parts tender and sweet and wild and ferocious. Infinitely unpredictable. She and I have a very special partnership, and I love her on a deeper level than any other animal I've spent time with. (As a girl who loves animals, this profundity I do not take lightly.) Lydia is a bit wary of strangers—any knowing street cat learns to be, I imagine—but she is also affectionate when trust is developed and people approach her softly.

She is also a proficient huntress and shape-shifter that, I believe, is at least part Norwegian Forest cat—and that's not just me projecting as a fangirl of Norwegian black metal and a practicing witch. She channels different animals and objects, and reflects them with her body from moment to moment: panther, dragon, loaf of bread, wolf. She has also shifted from a scraggly, tiny, gray, goblinesque adolescent into a beautiful, elegant, black-and-crimson furred goth lady with long fangs, completely fulfilling her cinematic namesake, Winona Ryder's character in *Beetlejuice*.

Lydia has taught me a lot about my own trauma and developing boundaries, and helped me understand that all creatures have different terms on which you may meet them. She has also shown me how it can take different amounts of time for everyone in a relationship to feel comfortable opening up.

She's a supremely intelligent friend and strong psychic communicator, able to emote and communicate with a very expressive face and wide range of meows. She seems to understand a great deal of what I say and returns to me from wherever she is with a call of her name or promise of a treat. In recent years, she has developed a serious obsession with cheese pizza and will aggressively bite into any available slice. Her gaze, which she holds on people for long periods of time, speaks volumes. Lydia has helped me through the most difficult times in my life. I am forever grateful for her and all her eccentricities.

Lydia

TYPE
Norwegian Forest cat mix

NICKNAMES
Black Bean, Coffee Bean, sometimes just The Bean

FAVORITE SNACKS
Cheese pizza, cereal milk

LIKES
Bottle caps, stalking lizards and mice, sleeping under the covers when it's cold

DISLIKES
Getting a claw stuck in clothing, having her paws touched (dislikes #1 and #2 compound each other), black plastic bags

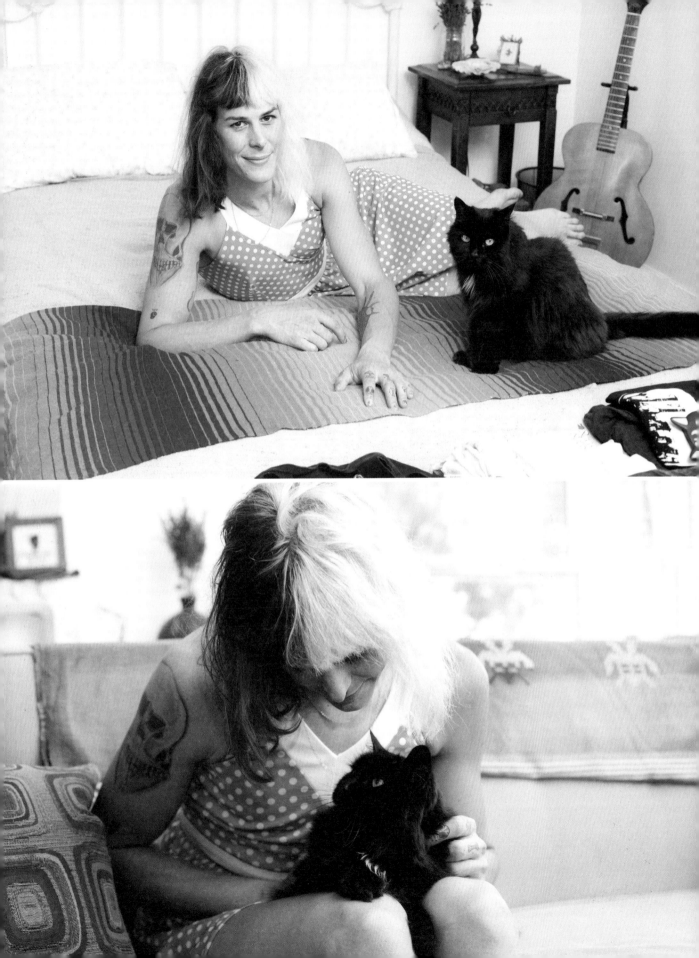

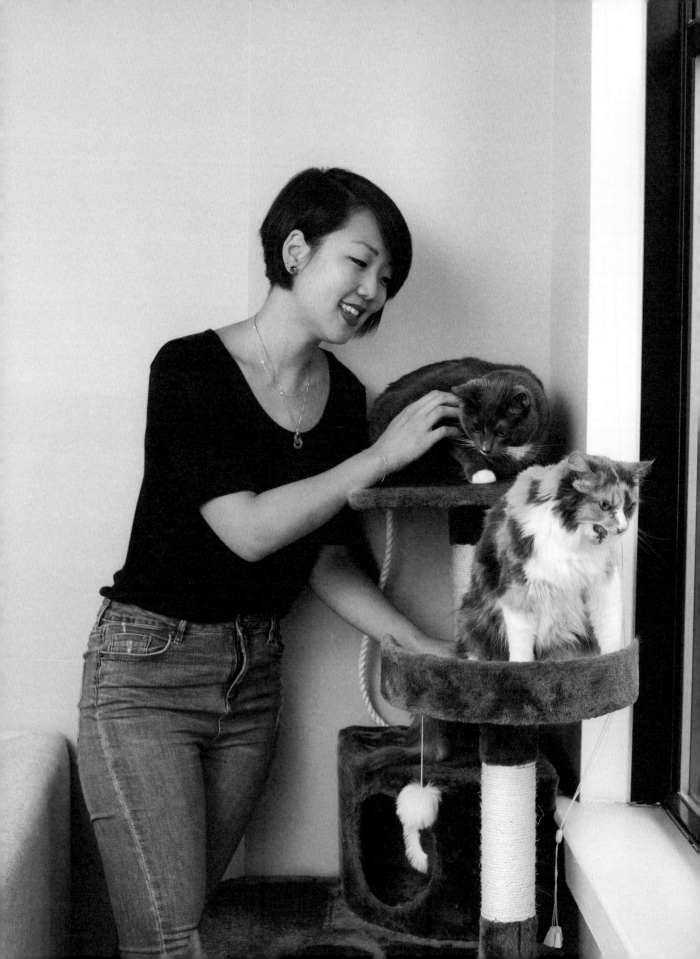

"Women who know that embracing a loved one's quirks and respecting their space is the key to lasting companionship."

Michelle Lee

REPORTER FOR *THE WASHINGTON POST*
WASHINGTON, DC

I started my first full-time job as a news reporter when I was twenty-two in Phoenix—a city I had never been to and where I knew no one. I worked long hours and wanted a friend to come home to after a hectic day of deadlines. My work schedule was unpredictable and I traveled a lot, so I knew a cat would fit my lifestyle best. When a local shelter had a Valentine's Day special for cats, I decided to adopt one.

When I brought home my new one-year-old longhair calico friend, she hid under the couch for hours. But after she finally came out, she wouldn't leave my side. And she has been by my side since then—through eight apartments, various roommates, and a cross-country road trip to Washington, DC, where I now live.

Penny (full name Pennilyn Lott Lee) is a diva with a big heart. She views my personal space as her own; she rests her chin on my hand when I'm typing on my laptop and likes to place her paw on my hand when I fall asleep. She's talkative, and shushing her makes her meow even louder. She's extremely affectionate and needy, and takes the best naps: She passes out and snores like she has worked the graveyard shift two days in a row.

In 2017, after I moved into an apartment big enough for more than one pet, I adopted a gray tuxedo, Liddy (Liddy Donaghy Lee). I met her at a pet-supply store, whose owners had rescued her from a nearby county and hoped to find her a new home. She was just eight months old and got along well with an older cat living in the store. I felt like she would be a great fit.

I'm convinced Liddy thinks she's a dog—much like the tuxedo cat stereotype, due to their social and energetic personalities. She greets me at the door when I come home, then follows me around the apartment. Her favorite place to sit is on my lap, and she climbs on my chest so she can be held like a baby. She loves Penny and tries to play with her all the time. Penny the queen isn't sold on Liddy yet and begrudgingly coexists with her.

Penny & Liddy

TYPE

Penny » Calico
Liddy » Gray tuxedo

NICKNAMES

Penny » Pen Hee, Pens
Liddy » Lid Hee, Baby

My family and I call them Pen Hee and Lid Hee because they rhyme with my Korean name, Ye Hee, and my sister's Korean name, Jun Hee. The rhyme is a part of a Korean family naming tradition.

FAVORITE SNACKS

Both » Dried shredded squid, dried mini anchovies

LIKES

Both » Sitting next to the warm bedbug heater while my luggage is heating after a trip, watching Netflix in bed, hanging out in the closet

DISLIKES

Penny » Liddy
Liddy » Belly rubs

HUMAN ALTER EGO

Penny » Kelly Bishop in *Gilmore Girls*
Liddy » A young Julia Roberts circa *Pretty Woman*

They are both named after characters who spend little time on screen but whose roles made an outsize impact on the plot lines of two of my favorite shows: Pennilyn Lott from *Gilmore Girls* and Liddy Donaghy from *30 Rock*. It's fitting, because their companionship has made an outsize impact on my sanity and general happiness.

Raising a cat requires a lot of patience and a thick skin. A cat's love is earned, not given. That's what makes it all so rewarding. I'm not sure exactly how it happened, but in recent years I've come to fully embrace my love for my feline pals. My human friends and family have recognized this, and now send me cat-themed gifts for every birthday and holiday. So I'm under budget and ahead of schedule in amassing the appropriate accoutrements for my cat lady destiny. And I wouldn't have it any other way.

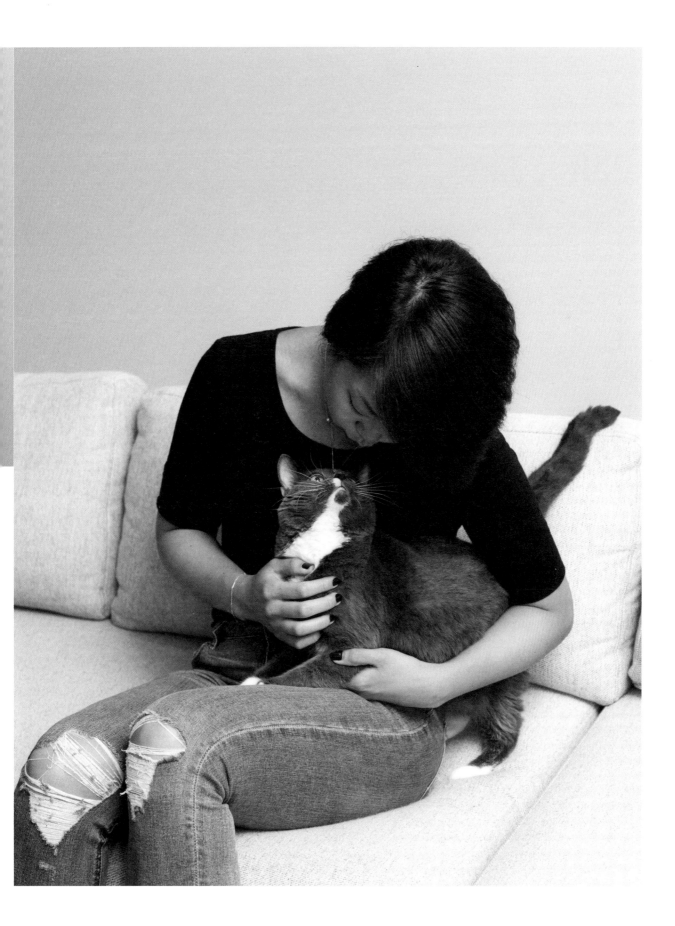

"Daring. They make bold steps for love, and trust
that everything else will fall into place."

Jaime Lee

ARTIST AND PERFORMER
PORTLAND, OREGON

For as shy and skittish as SheShe is, she has magical
powers, and she used all of them to enter my life.
One day in 2009, I was driving around aimlessly and
decided to pop into the Oregon Humane Society to
say hi to some animals. The very first cat I came upon
was SheShe.

I could see only her eyes in the little box in her cage where she
was hiding. I was shocked by how much I felt for her in that moment.
The other intense thing was the sign on her cage that said she had
been rescued on the very same day as Michael Jackson's passing.
Let's just say I'm a huge fan. (I was an MJ impersonator for years. For
reals.) I tried to shake it off by walking around the entire cat wing, but
seemed to be pulled back to this cat who was basically invisible with
the exception of those eyes.

It turned out that I was the only person who requested to see
SheShe in the long month she had been there. I had not stopped in
with the ambition of bringing a cat home with me. I had never been
a mother to any type of furry creature. The apartment I was living
in didn't even allow pets. But suddenly I was ready for a change. I
wanted to be independent, but wanted a companion to keep me
rooted. I didn't know that until I met SheShe.

We moved to the edge of a forest, and life became clearer. She slowly
warmed up to me over the first two months, and now even lets me hold
her. Over the years we've developed a made-up language, and have
at least one deep talk a day. Her "mow-wow" response is uncanny. Some-
where in the middle of our chat I revert back to my native tongue and
discuss my day, and ask her about her day and her needs. All the while,
she gives me more "mow-wows" of varying pitch and drive. If there are no
disagreements, she'll top the conversation off with her endless purring.
She loves to talk. She's the queen of talk-show hosts.

SheShe is powerful, yet dangerously shy. Her presence is huge, and
she doesn't boast to show it's there. It just is. I love to think I take after her.

SheShe

TYPE
Russian Blue mix

NICKNAMES
Mushka, Monkey, Boochi, Stinky Baby,
Chat Chat, D'sha, Cho Cho, Chunky

FAVORITE SNACK
Trader Joe's Feline Treats

LIKES
My husband, talking, meditating on
things deep and not-so-deep

DISLIKES
Other humans, other cats, squirrels

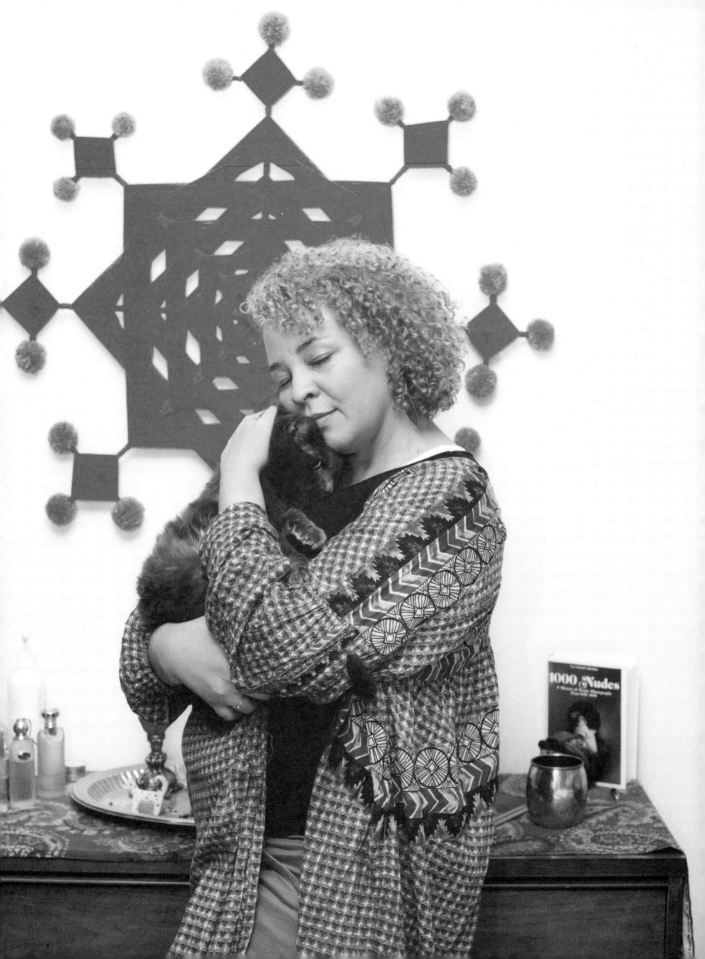

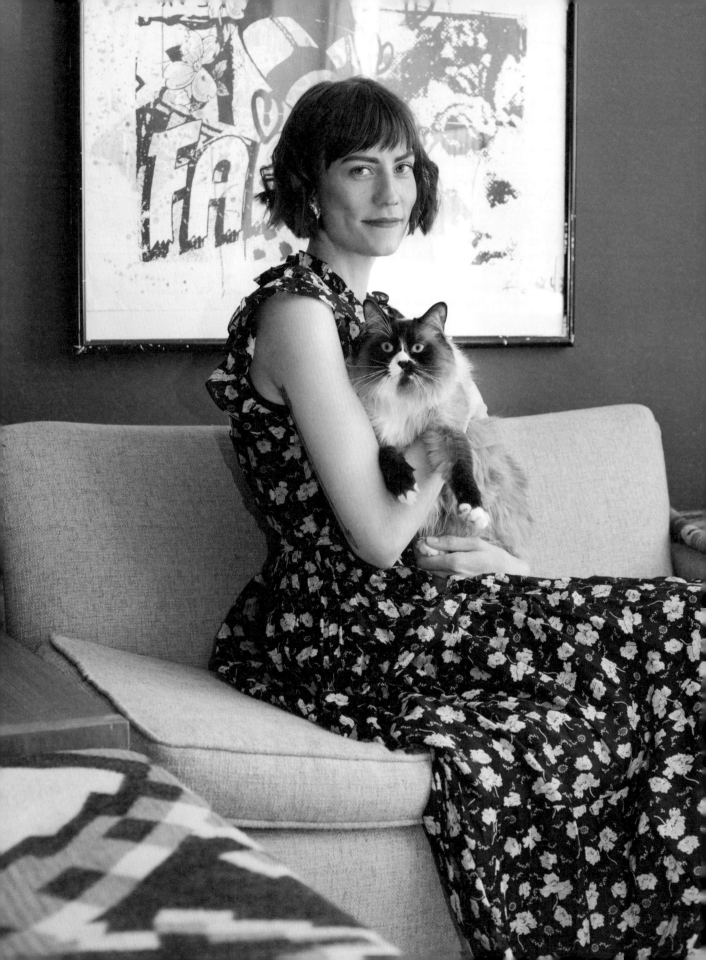

CAT LADIES ARE...

"Like a good novel—they get better the more you engross yourself."

Gretchen Jones

INTUITIVE BUSINESS COACH FOR CREATIVES
BROOKLYN, NEW YORK

I have one discount-designer beauty of a Baby Kitty who looks as good with my décor as she does with my outfits. My husband and I had wanted to introduce a cat to our household for two years but hadn't found the right little fur baby, until a friend snapped a shot of one at the Pixie Project—a nonprofit animal rescue and adoption center in Portland, Oregon—and texted it to me. She's half Siamese, half tabby, but she looks like a Ragdoll mixed with a Seal Point and has an incredible hook of white fur on her nose that makes her *jolie laide* in the most dynamic of ways. We knew she was the one! I love her.

Baby Kitty was the tiny runt of a three-kitten litter. The Pixie Project folks weren't sure she would make it; her brothers had bogarted nourishment from their mama to the point that it caused Baby Kitty some neurological and nutritional damage. But we knew she would—she had fire in her eyes.

At first, she was so small that we were a bit perplexed as to what to offer her for a bed. I rummaged through my accessories and picked out a vintage fur hat because I'd heard that fur coats are used at shelters when baby animals are taken from their mothers. We placed it on one of our end tables by the couch, behind a table lamp. It took her a minute, but once she found it she made it her little nest and safe space. That being said, we didn't realize she'd taken to the hat and location so quickly, and ran around the house hysterically searching for her only to discover she had curled up and was sleeping exactly where we wanted her to. Now she sleeps in her travel carrier in my closet under my dresses, and it's cute as hell.

I like to joke that I got her for my dog Harry (who has sinced passed), which is a lie. We got her because I needed a kitty cat in my life, because cats are not dogs. You make dogs think. Cats make *you* think.

Baby Kitty

TYPE
Half Siamese, half tabby

NICKNAMES
Bebe Kee, Bubba Cooz, Cuzie, Bae, Bae Bae Gurl, Babeee Gurrr, KiiKii Poose, Luce

FAVORITE SNACK
Half and half

LIKES
The open road, a warm lap

DISLIKES
Our dog stealing her toys, being stuck inside, broken pieces of dry cat food

HUMAN ALTER EGO
Björk

Baby Kitty's real name is William, because I thought it would be funny to have a member of the royal family in our household. Unfortunately, that didn't last long. We tried to call her Billie for short. I always love a girl with a boy's name, like the reverse of the Johnny Cash song "A Boy Named Sue." Because she was so tiny, we also called her Baby Kitty, though, and that stuck.

Baby Kitty and I have an ongoing conversation about the meaning of life. She has some ideas about it all. I sing to

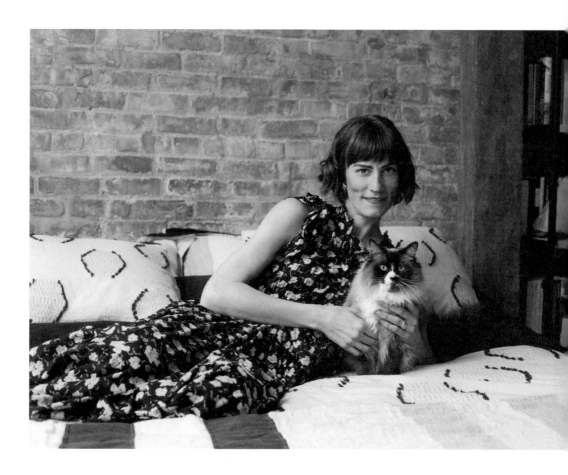

her in ways that she replicates, like a mockingbird calling back to me. It's part of a game of hide-and-seek we've developed that's cute and a workout. She sometimes calls me by that sound late at night, wanting to play. I don't get out of bed, but I often think about it. We're a certain kind of crazy together, and I like it. I think she does too.

We recently got our Baby Kitty a new dog. (The cycle of life in a no-children household continues.) They play together, truly. We are entertained by the wrestling and chasing that takes over our home daily. It's like nothing I've ever seen before. They are close to being snuggle buddies. She is definitely in charge. The dog abides.

We want her to live long and fuck shit up (but not our couches). She's that cool, that stylish, that engaging, and that real.

She bites, but she's not a bitch. She needs affection and intimacy, but often pushes it away. She's high-low maintenance. (Just like me.) She's perfect, because she's not perfect. I'm better for having her. She is me in cat form, which gives me permission to just do me.

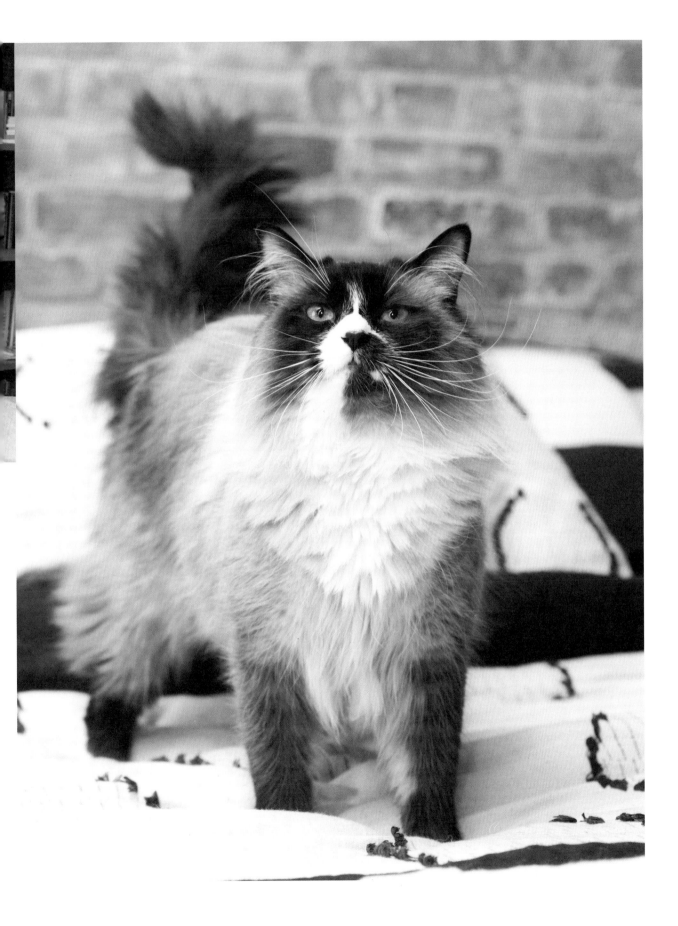

Cat Tail Language,

EXPLAINED

Because the difference between "I've never been happier to see you" and an incoming ankle bite is subtle—and the tail is the telltale sign.

The Jazz Hand

A straight-up, intermittently quivering tail

SCENARIO: She's greeting you at the door or waiting for you to prep her dinner; often accompanied by chirps, chirrups, and mews.

TRANSLATION: Super excited, angling for a snack

The Flagpole

A tail held happily aloft at 12 o'clock

SCENARIO: She's following you around the house or saying hello to a friend. Mama cats do this to encourage their kittens to keep up with them, and kittens mimic it when they run to their mama (or to their pet parent).

TRANSLATION: Confident, playful, friendly

The Question Mark

A buoyant tail with a crook at the end, like Pepé Le Pew's

SCENARIO: She's watching you from across the room, deciding if she wants to come over and hang out.

TRANSLATION: Curious, open-minded

The Statuette

A demure tail curled neatly around her seated hind quarters and front paws

SCENARIO: She's observing some commotion from a safe distance (say you have guests over), and maybe feeling a little overwhelmed.

TRANSLATION: Reserved, quiet, watchful

The Mood Swing

A tail held high, but waving from side to side

SCENARIO: She's tired of your lame attempts to entertain her and is acting as aloof and prickly as an angsty teen.

TRANSLATION: "Just leave me alone, Mom."

The Downward Dog

A tail literally tucked between the legs

SCENARIO: She's upset about a sudden change in the house, like a noisy new toy or appliance (fans could not be more terrifying), and pretty on edge.

TRANSLATION: Fearful, exposed

The Kink

A tail with a U-shape hook near the butt

SCENARIO: She's about to do an arched-back hop or a frantic loop around the house.

TRANSLATION: Feisty, zoomy

The Metronome

A tail angled down, swaying slowly

SCENARIO: She's eyeballing birds outside the window, a toy, or your bare toes.

TRANSLATION: Focused, excited, on the hunt

The Live Wire

A tail that's down and whipping around fast

SCENARIO: She's been playing too rough, or doing something else that overstimulates her and ruffles her feathers.

TRANSLATION: Territorial, aggressive

The Bottle Brush

A tail that's up and totally fuzzed out, like a squirrel's

SCENARIO: She's upset about something you've done; she may throw in an arched back and a hiss for pyrotechnics.

TRANSLATION: Outraged, hostile

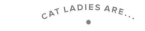
"Ancient Egyptian goddesses, essentially."

Marissa Jane Oswald

WRITER AND JEWELRY DESIGNER
PHILADELPHIA, PENNSYLVANIA

"My cat has herpes, and so do I" might be a track name from the very bad indie record I'm glad I never released. It's easy to joke about now, but when I was diagnosed with herpes simplex virus (HSV) a few summers ago, not only did I feel really terrible physically, but also depressed and isolated. Although the disease is referenced in many middle school jokes, I had never actually met anyone who had it—or so I thought. Feeling brave, I confided in a few of my closest friends and was surprised when many of them told me they'd had it for a while but were too ashamed to tell anyone. It wouldn't be until that fall that I'd meet, adopt, and nurse back to health a sick little kitten named Gandalf the Grey who, coincidentally, has it too.

Although the feline variety of HSV is quite different, it also attacks the immune system, thus making cats who have it sick a lot. When I first brought Grey home with me, he was very ill. Caring for him so closely is what healed me emotionally. Stress brings out the virus, so we take our lysine supplements together every night, which helps us both. And we make sure to spend plenty of time watching reruns of *Buffy*.

I adopted Grey from the Kawaii Kitty Cafe, a Japanese-style coffee house in Philly that is filled with cats for petting and adopting. All the cats come from the Philadelphia Animal Welfare Society (PAWS), an incredible no-kill shelter. What's so good about this concept is that you can really see if the dynamic between you and any particular cat is right before you take her home, something that's hard to do when they're confined to cages at a typical shelter.

Grey has fierce yellow-green eyes like a dragon, little fangs like Dracula, and a silvery—you guessed it—gray coat with extra fluff

Gandalf the Grey

TYPE
Russian Blue or Korat

NICKNAMES
Grey, GreyWolf, GreyBoy, Greyson, MoonBoy, MoonRat

FAVORITE SNACK
Pizza

LIKES
Birds, cheek pets

DISLIKES
My boyfriend—Grey's jealous

around his face that makes him look like an owl. He's a snuggler who follows me around everywhere and is scary smart: He sits on command and plays fetch like a pup. I've known for years that I wanted to adopt a Russian Blue baby, but was waiting for the right one. I'm so happy I waited for Grey. We needed and found each other at exactly the right time.

Viridiana Cervantes

HAIRSTYLIST
PORTLAND, OREGON

Seven years ago, one of the loves of my life—my loyal cat companion, Rubi—died. I really was reluctant to get another cat, but I finally decided it was time. My daughter, Valentina, who was two then, and I went to the Oregon Humane Society. We trolled the place, and she fell in love with a little calico kitten. The volunteers told us she was very attached to her brother, a shy orange kitten who was sick with an eye infection. They were found together; she was protecting him. They warned me they didn't want to separate them.

Valentina insisted we see the calico girl kitten, so we did—along with her brother. The two kittens were all over us, even the sweet, shy boy, who wasn't feeling very well. My daughter and the calico clicked right away. It was instant love. That was it. I decided we would take them both home. I had intended to come back with one kitten, and there I was getting two at once. But I knew I was lucky when all (and I mean ALL) of the staff came over to say goodbye to little orange Max. He nuzzled everyone, and they assured me he was gonna grow up to be a lover.

They couldn't have been more right. Every morning at 6:45, Max curls up to my pillow and starts to purr. As soon as I make any noise, he says, "Miiiiioowww!" and starts licking my face and biting my hair. This happens almost every morning, except for the rare times Max stays out all night—in which case I'll find him meowing at the door. I don't even know why I bother to have an alarm clock. When I come home, Max jumps up on the kitchen table and cries loudly until I either pet him or pick him up, and then he follows me everywhere I go in the house. When I shower, he always pushes the door open, as if he's saying, "No closed doors are allowed in this house!" Then he sits and guards the bathroom until I'm finished.

Mia may have been Max's protector when they were kittens, but that changed as Max outgrew her. I think the way he likes to play is

Max & Mia

TYPE

Max »	Orange domestic shorthair
Mia »	Calico

NICKNAMES

Max »	Maximilian Mustard, Maxipad, Maxi Rurru
Mia »	Mia Mayo, Mimi, *La Seria*

FAVORITE SNACK

Max »	Milk, especially Vale's leftover cereal milk
Mia »	Wet food

LIKES

Max »	Watching me clean the house
Mia »	The little cat forts we make for her

DISLIKES

Max »	Airplanes
Mia »	When people cough (she gets so offended)

HUMAN ALTER EGO

Max »	Fabio, a Latin lover, since he's so charming and loving—at any party he goes from one lady's lap to another
Mia »	A Kardashian, because she's so beautiful but so mean—everyone thinks she's cute, but she doesn't let you get close

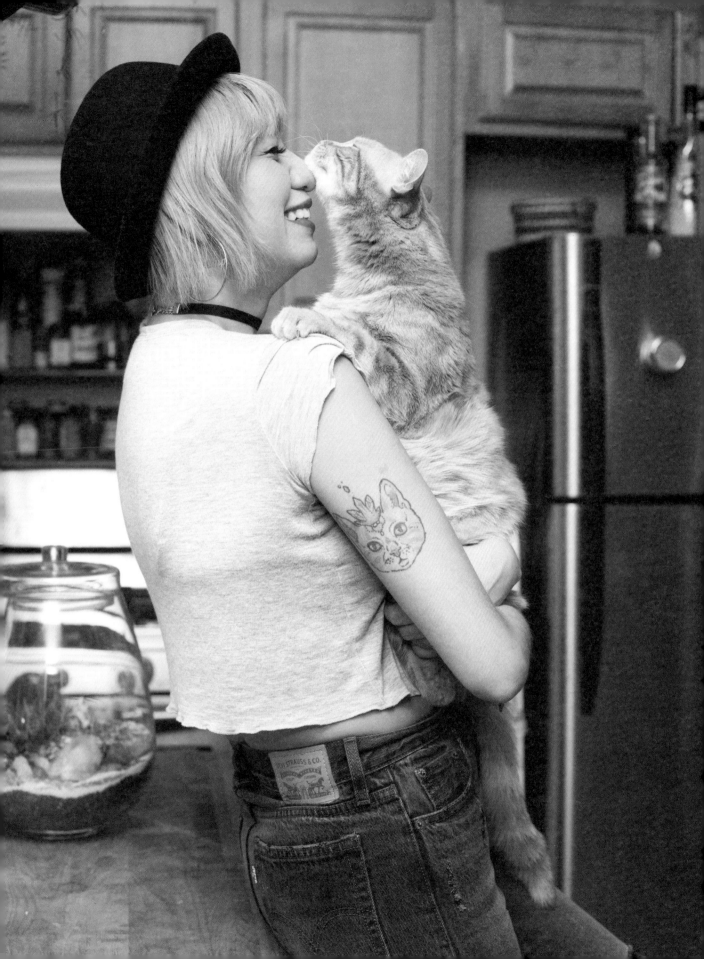

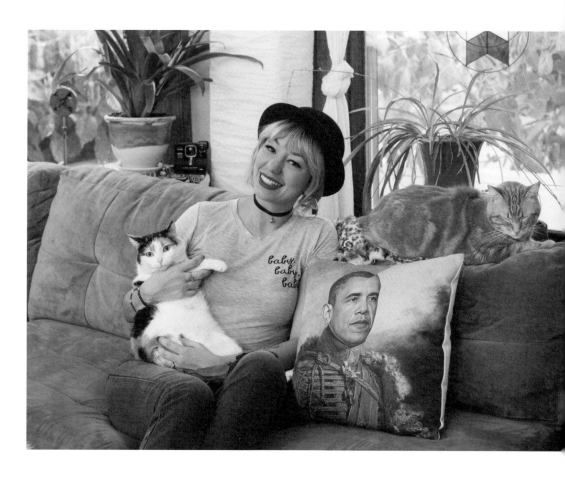

much too kittenish for her taste. She is dainty and seri-
ous and likes her alone time, though they both nap on
the couch when we sit there to watch TV or hang out.
Max's spot is on the back of the couch; Mia's is on the
cushions, normally on top of a blanket we leave there
for her.

Mia waits for Vale every day after school, just behind
the back door. And every night at bedtime, you can find
Mia curled up at the foot of Vale's bed. She cuddles
either under the blanket with Vale or next to her head
on the pillow while I tell them a story.

These cats have really made me believe in reincar-
nation. They are so magical. I have them tattooed on
me and take them with me everywhere I go. They even
came with us when we relocated to Spain. I love their
company so much.

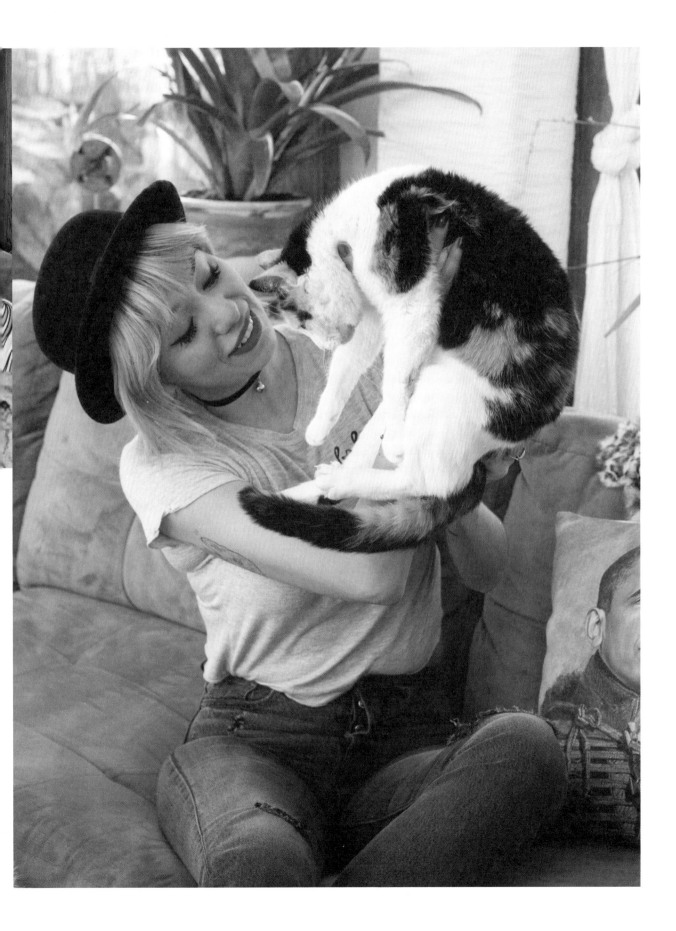

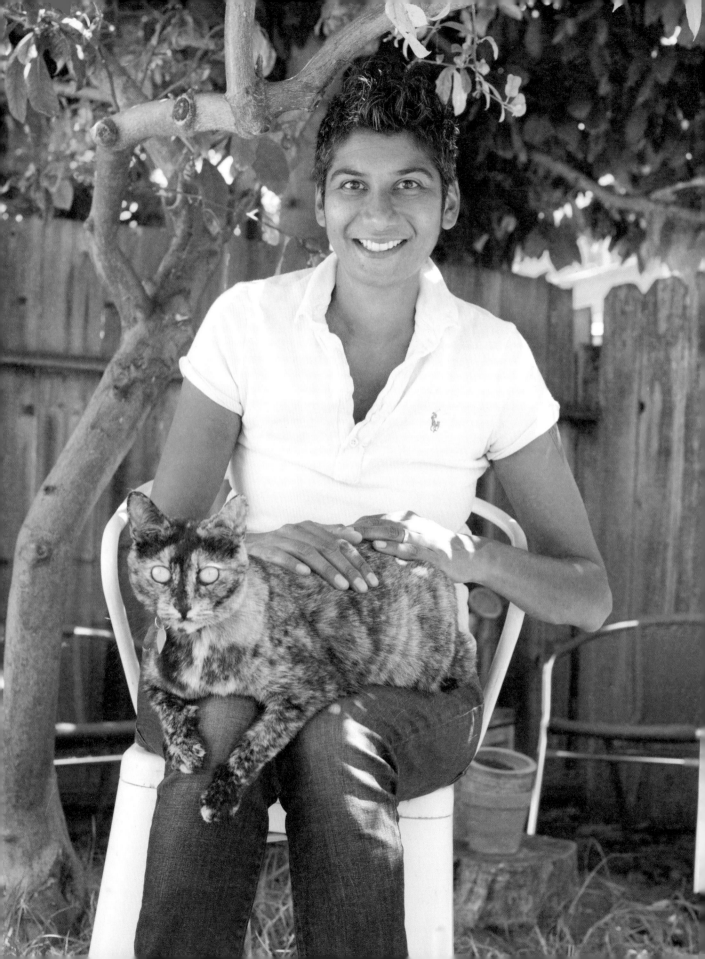

Preeti Mistry

CHEF, ENTREPRENEUR, AND AUTHOR
OAKLAND, CALIFORNIA

My wife and I adopted Peppercorn from the San Francisco SPCA when she was a year and a half old. We had been going there practically every other week, looking for the right cat, and then there she was waiting for us one Sunday afternoon.

We had wanted a kitten, but when we saw Peppercorn we knew she was the one. She is very playful but also very sweet and loving. She knows the difference between play and being aggressive, which means she has almost never bitten or intentionally scratched us or any other person.

My wife named her Peppercorn because, as she said, "She looks like she was rolling around in the pepper." And I work with a lot of spices, of course, so the name fit our family as well. We call Peppercorn the life changer, too, because she helped both of us make big decisions at a pivotal time in our lives. We moved from San Francisco to Oakland so that she could have a backyard to run around and explore instead of just a little apartment.

She's a hunter who has chased her share of squirrels and small dogs but can be a bit of a princess. She likes to be carried upstairs to bed at night. She is also very fastidious about grooming herself. She has even started grooming us—mainly the sides of my head where my hair is shorter. She loves to snuggle and get up in our faces, and kiss us and curl up cheek to cheek.

Peppercorn is a big part of our daily routine. She also gets a bit annoyed when things change. She wakes up my wife in the morning around 6 a.m. to feed her. Then she will be up and around all morning while we get ready. She likes to sit on my lap while I drink coffee on the sofa. By about 10 or 11, she usually settles in for a late morning nap. If I'm working from home, she really likes to sit in between me and my laptop, creating a Peppercorn barrier. In the evenings she starts meowing about her dinner a good hour before it is actually time.

If the weather is nice and Peppercorn is outside at what I call the "witching hour," around dusk, she is at her liveliest. She starts darting around the yard, and making trouble when we try to get her to come inside. That being said, she eventually comes in. She is not interested in staying out all night and meeting the other nocturnal creatures that may visit our backyard. She prefers to be told to come in and do it on her own instead of being picked up and brought in. She is very aware of how good she has it.

Peppercorn

TYPE
Tortoiseshell

NICKNAMES
Peppy the Corn, Pepe La Corn, Pepsi, Kittly-loo, Kits, Paprika Corn, Peps, Cornitas, Baby Corn, Kitty Corn

FAVORITE SNACKS
Bonito flakes, Annie's Organic Cheddar Bunnies, pizza crusts

LIKES
The Billie Holiday Pandora station, chasing birds and bees, getting her cheeks rubbed, being in a Peppercorn hug sandwich with her Moms

DISLIKES
Loud noises, loud people, erratic small children, being told what to do

HUMAN ALTER EGO
Me—we like to say that she looks like my furry Mini-Me

"Like their feline charges, loving and mysterious
creatures who are often misunderstood."

Alexandra King-Lyles

JOURNALIST AND WRITER
BROOKLYN, NEW YORK

Lois and Maxine are seven-year-old sisters. My
husband adopted them six years ago from a no-kill
shelter in Chicago and named them after local diner
waitresses. Even though they were the only kittens in
the shelter that day, my husband said everyone kept
stopping to look and then immediately walking past
their cage because it was clear they were not "nor-
mal" cats.

Which they are not. They both have a condition called cerebellar
hypoplasia (CH), sometimes affectionately known as wobbly cat syn-
drome. It's a brain condition that occurs when a kitten is born with an
underdeveloped cerebellum, the part of the brain that governs motor
skills. As a result, cats with CH don't have great balance or coordina-
tion. They walk like little drunks and lack that regular catlike ability to
jump. Very sadly, many kittens who show signs of CH when they are
born are destroyed because people think they won't get adopted.

But I can't recommend bringing one of these little weirdos home
enough. It may sound like a scary thing, but CH is nonprogressive
and noncontagious, and too few people know that it results in THE
CUTEST KITTIES IN THE WORLD. They don't do any of the asshole-
type things that normal cats can be prone to do, like scratching or
biting or leaping on countertops. Other than not being the shiniest
crayons in the pack, they are physiologically perfect. They don't
require any kind of treatment or meds or pricey trips to the vet.
They have a completely normal life span. They're not very bright,
bless them, but they're obsessed with people. And each other.
They just want to cuddle.

All you have to do is babyproof the house a bit (sharp corners can
be a hazard) and get ready to be adored. Every morning, I wake up
wearing a cat bikini: one snoozing across my chest, one on my hips.
They are the best.

Lois & Maxine

TYPE

Both » Domestic shorthair—
20 percent Beanie Baby,
100 percent street cat

NICKNAME

Lois » Lolo
Maxine » Bunny

FAVORITE SNACK

Lois » Greek yogurt
Maxine » Potato chips

LIKES

Both » Wobbly walks around the
garden every morning, 24/7
cuddles, clambering up on
Mama while she's doing her
yoga stretches

DISLIKES

Both » The vacuum cleaner

HUMAN ALTER EGO

Both » Ruth Bader Ginsburg (these
two are small but mighty)

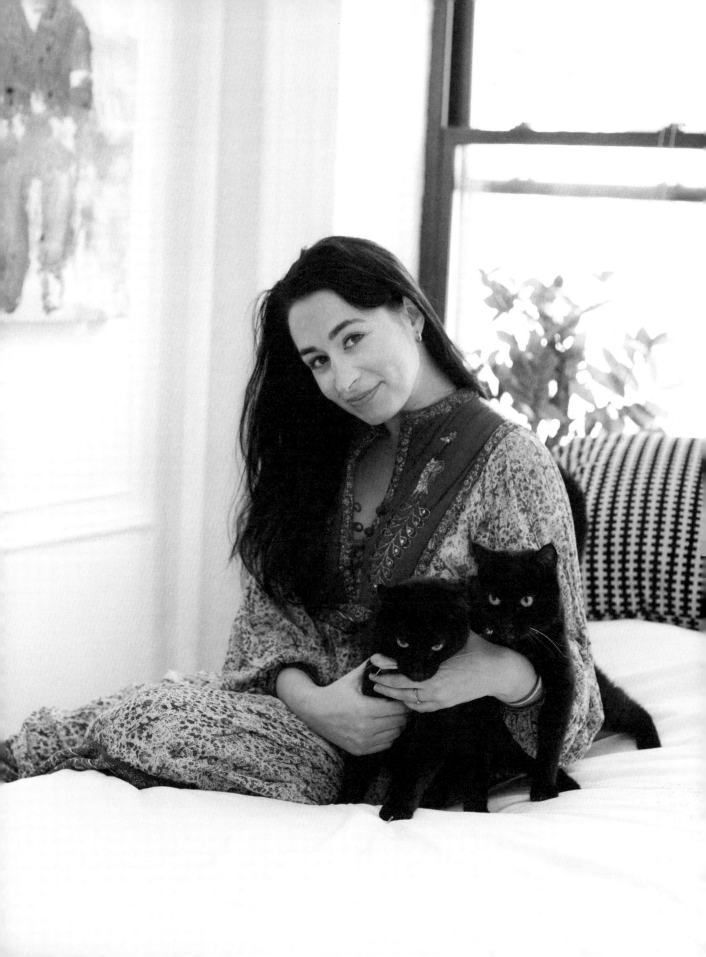

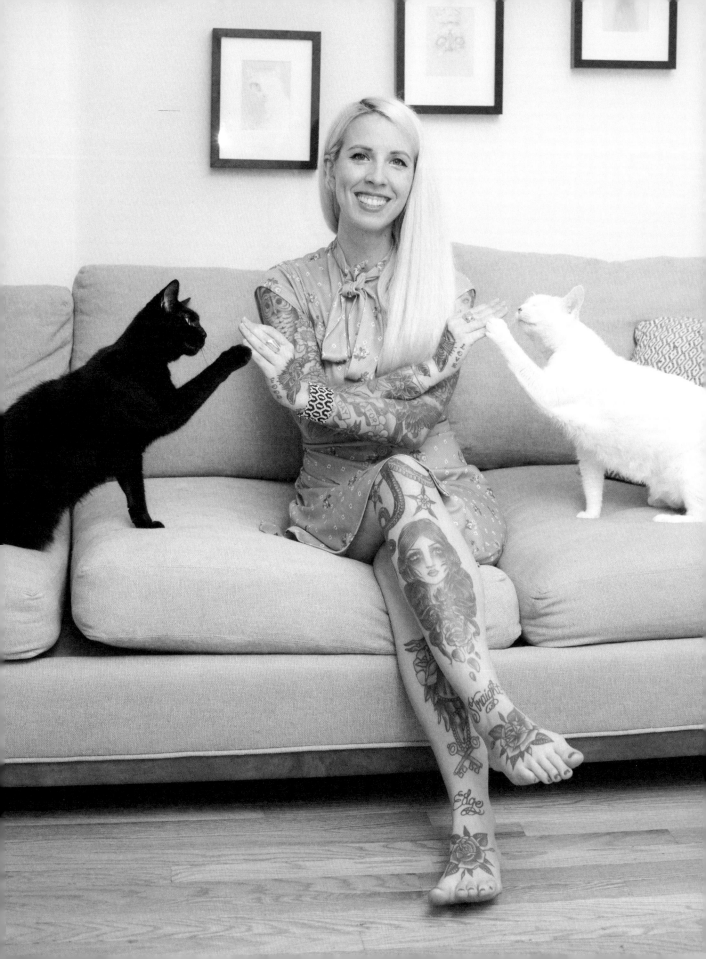

"More than just cat lovers—we should be cat activists."

Hannah Shaw

HUMANE EDUCATOR, ANIMAL ADVOCATE, AND FOUNDER OF THE NEONATAL KITTEN RESCUE PROJECT KITTEN LADY
WASHINGTON, DC

I've been an animal advocate my whole life, but I wasn't a cat lady until I found my first kitten, Coco. I was in a park in Philadelphia when I looked up into a tree and saw a tiny black kitten gazing down at me from a tall branch. I'd been a vegan for years by that point, but I'd never actually rescued an animal hands-on, so this was new for me. I climbed the tree, placed her in my shirt, shimmied back down, and thought, *Oh my God, what do I do now?*

Coco was my inspiration for getting involved in kitten rescue and shifting all of my advocacy efforts to focus on neonatal kittens and Trap-Neuter-Return (TNR). Raising her taught me how great a need there is for educational resources about kitten care. It opened my eyes to the reality of feline life on the streets, and I've been trapping and rescuing kittens, and educating my community, ever since.

Coco is my best friend, my ride-or-die. She sleeps with me at night, sits on my lap while I work, and greets me at the window when I come home. Coco is a smart girl who excels at tricks and even walks on a leash with a harness. She's the most likable cat you'll ever meet. She loves everyone and honestly thinks all of our houseguests are here just to see her. I always say that she'd make a great concierge or hostess because she loves checking on our guests and making sure they're tended to—or, really, that they're tending to her.

I found Eloise as a kitten, sitting in the middle of a country road, totally blind. Her eye infection was the worst one I'd ever seen, and she had such a bad upper respiratory infection that she could hardly breathe. I brought her home, cleaned her up, and watched her flourish with a little TLC. When she was healthy enough for adoption, she went home with a family, but after two months they decided she was too much work and returned her to my care. After all she'd been through, I was so upset for her. I decided she wouldn't leave my home again

Coco & Eloise

TYPE

Both »	Domestic shorthair

NICKNAMES

Coco »	Coconut, Cho-Cho, Kokomo, Ms. Nuts
Eloise »	Weezie, Cheesy, Ella Beez, Weezie Breezy Beautiful

FAVORITE SNACK

Coco »	Nutritional yeast
Eloise »	Crunchy treats

LIKES

Coco »	Toy frogs, walks in the grass
Eloise »	Spooning, birdwatching

DISLIKES

Coco »	Dogs
Eloise »	Surprises

because her next adopter would be me. Coco loved her, I loved her, and I knew she would fit right in with our little family.

Eloise is a shy girl. She's not keen on new people or new experiences, which makes our bond even more special. She is really, really close with me, and loves to give hugs and be held like a baby. She's so clingy that whenever I start getting dressed for the day or putting on makeup, she springs into action to try to distract me from leaving. Half the time,

I have to put on mascara with one hand while holding her with the other. Eloise usually can be found sitting in her favorite cozy spot near the window, chattering to the birds outside. She's obsessed with them, but absolutely petrified of the actual outdoors. Bless her sweet little heart.

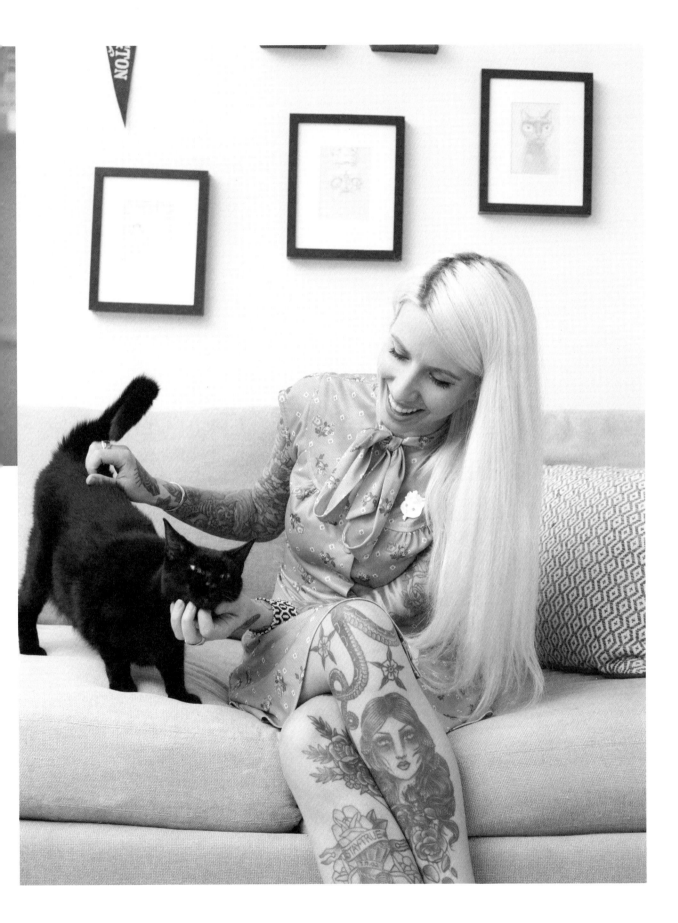

"A special breed. I think we deserve our own island filled with cat-friendly cafes."

Erica Chidi Cohen

DOULA, AUTHOR, AND COFOUNDER OF THE REPRODUCTIVE HEALTH EDUCATION COMPANY LOOM
LOS ANGELES, CALIFORNIA

Nima

TYPE
Manx

FAVORITE SNACK
Cured salmon

LIKES
Cuddling, eating butter off our plates

DISLIKES
Loud music, water being splashed on him when I'm in the bath

HUMAN ALTER EGO
Eddie Redmayne

Nima came into my life suddenly, but in retrospect it was perfect timing. I'd always wanted a cat but never could take the leap and get one. As a doula I never know when I'll have to leave the house or when I'll be coming back, and that made it hard for me to want a pet. I didn't think I would be able to give one the rhythm and consistency he'd need. Then, in the thick of the holidays in 2013, my husband went to a Christmas party at our friends' house without me. They told him that they had rescued a cat on the corner of Hollywood and Vine but couldn't keep him because their apartment had a strict no-pet policy. He came home and told me about it, and I agreed to a trial run—he said we could rehome him if it didn't work out. A few days later he picked Nima up.

At first, I resisted—I thought we were too busy to have a cat—but my defenses dropped pretty quickly. Nima was scared when he first got here. He sniffed around and smelled everything and eventually found himself a quiet corner to hang out in. Then he was just so cuddly, head-butting me for pets, that he won me over. Within forty-eight hours, I was hooked. Five years later I'm still smitten and scratched up. Let's call them love lines?

Nima is basically a dog cat. I don't think I've ever met a friendlier cat. Our friends are always surprised at how he runs right up to them, slinks through their legs, and finds his way onto their lap as soon as they sit down. He also likes to sit on my lap or on top of my computer and hang out when I'm working. We always have to keep a watchful eye on the front and back doors of our house because he loves to leap outdoors—not to run away, mind you, he just loves to roll around in the sand in circles. It's very goofy. Sometimes we put on *Planet Earth* just to see him swat and jump at the TV. He's totally stimulated by it.

His meows are humanlike. I swear he sounds like he's saying hello, and he comes when I call him, which is just the sweetest. He's a loud and clompy jumper, so I can always hear him coming.

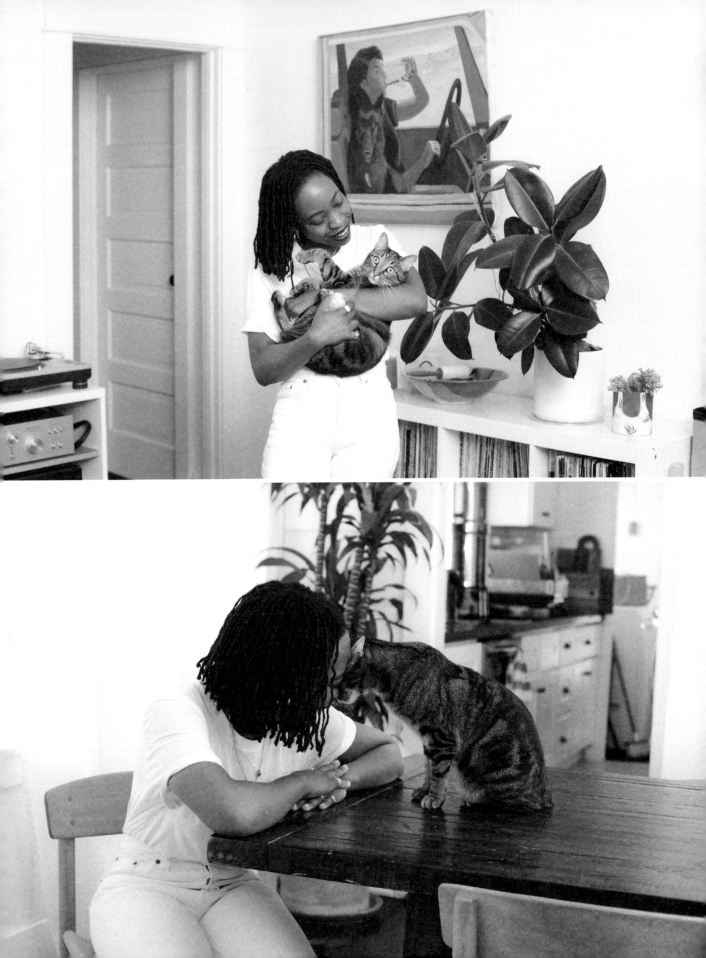

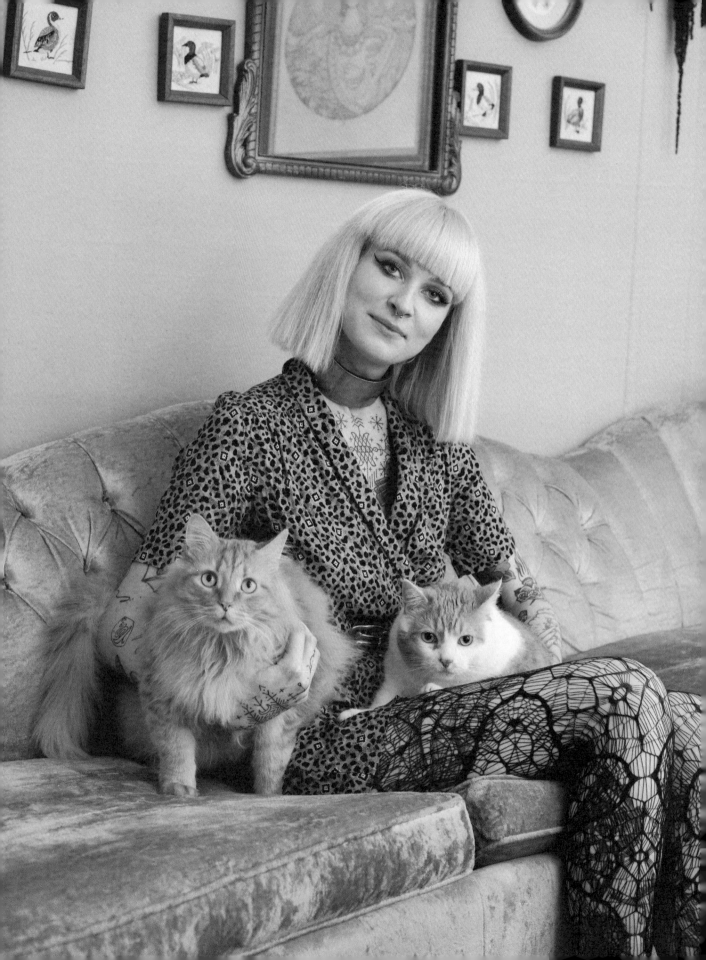

"The coolest, because there is something so special
about having a bond with such a mysterious creature."

Anka Lavriv

TATTOO ARTIST AND CO-OWNER OF BLACK IRIS TATTOO
BROOKLYN, NEW YORK

About six years ago, I got my very first studio apartment with no roommates and decided that I finally had my act together enough to get my own cat. A friend of mine worked at a pet-grooming place in New Jersey, and sometimes the people there rescued cats and found them homes. She sent me photos of multiple cats. As soon as I saw this tiny orange fluff ball, I immediately claimed him for myself.

Petey was a five-month-old Hurricane Sandy rescue, and the first thing he did when I put him on my lap was bite my hand. About a month after I got him, he ate a piece of string. I found out later that he had unraveled one of his toys and chewed the string off. It pierced his intestines and tangled them. When I brought Petey to the vet, they said he wouldn't survive the night without emergency surgery. I went for it with the help of my friend, who opened a credit line for me. (I literally had $300 to my name, and the surgery cost $8K.)

Even though it seemed like an unbelievable amount at the time, I have never regretted my decision. Petey is the light of my life. He is bossy, cranky, sassy, and courageous and takes no shit from anyone.

Our second cat, Hoomie (fka Henry), has been with us for a little over three years. We got him from my business partner; their living situation was giving him bad anxiety. Hoom is loving and gentle, and a really strange and special guy. My husband and I often joke that he is some kind of lizard, like an alien in a cat suit, pretending to "cat." He has a very special purr that is unlike any cat sound I've ever heard. People go wild when they hear it. His face is very expressive and sad; sometimes it feels like he's staring into your soul. He has a special corner behind my dresser where he likes to sleep on his back on his fuzzy rag and snore like a piglet.

Petey and Hoomie are complete opposites. They tolerate each other pretty well, though, and I love that they are opposites. Petey has a lion-like stature and manners; he's very proud and overly confident and curious. Hoomie is easily scared, overweight, adorably clumsy, and weird. Combined, they make a perfect cat.

Being a business owner, I don't get to stay home much, so my perfect day is just being lazy in bed, surrounded by my fuzzers.

Petey & Hoomie

TYPE

Petey » Maine coon/tabby mix
Hoomie » Shorthair tabby

NICKNAMES

Petey » Peeeetka, Fuzzy Pants, Mr. Peabody, Mr. Boy
Hoomie » Mr. Piglet, Biggie Boy, Lizardo, Seal, Hoomza

FAVORITE SNACK

Petey » Avocado
Hoomie » Feline Greenies

LIKES

Petey » Attention, sunlight, hanging in the backyard, smelling everything—especially my beauty products
Hoomie » IKEA faux-fur rugs, being petted, lying on someone's chest

DISLIKES

Petey » Being held, the smell of mint, water, the vacuum cleaner
Hoomie » Loud noises, guests, dogs

"Bad-ass ladies livin' in that good feline world."

Pia Panaligan

SENIOR PHOTO STUDIO STYLIST AT
DAVID'S BRIDAL AND CO-OWNER/DESIGNER
OF THE FASHION LABEL SENPAI + KOHAI
PHILADELPHIA, PENNSYLVANIA

I found Gunner on Chincoteague Island, off the coast of Virginia. I used to go there in the summer to see the wild horses. When I was visiting in 2007, I noticed that the house across from my hotel had a yard filled with cats and kittens and a huge sign running across it: "Free cats and kittens." I was told that Chincoteague has a cat-overpopulation problem and that at the end of the summer the cats and kittens are collected by a shelter and taken into Virginia; the shelter tries to find homes for the kittens, but some of the adult cats usually have to be euthanized. My heart immediately sank, and I realized I needed to adopt one.

After thinking about it for the whole trip, I decided to check out the scene. I looked around and picked up three gray cats—I thought I was going to take home a Russian Blue–looking kitty—but all of them kicked away from me. I got so frustrated that I started to leave. But on my way to the car, I saw a little black kitten sitting on a lawn chair, sunbathing and just enjoying his life. I walked right over to pick him up, he looked up at me, and, as corny as it sounds, it was totally love at first sight. I definitely heard music!

I remember how sweet Gunner was during the whole six-hour ride back to Philly. He just sat on my lap and farted his little butt off.

I got really lucky with this guy. Gunner is seriously the sweetest. I bring him up in conversation all the time, and, I have to admit, I brag about his temperament and tell everyone that when they meet him they'll fall in love. (Which is mostly true, except for people who are allergic.) He loves to come over to me on his own terms and sit on my lap or lie on me when he wants me to get out of bed to feed him. He also really loves it when you playfully blow air in his direction. He gets all excited and falls on the floor and rolls around like a weirdo. His stunner look is his hoodie. He is so cute wearing it and likes to show it off at his vet's office.

He is my get-ready buddy who follows me around most of the time. When he needs his alone chill time, you can find him in his favorite chair. When I'm on the couch at home, watching TV or working, he loves to be near me. When I'm in the studio, he loves to sit on my lap or by the window, or surprise me by napping in one of the storage bins. He brings me all the joy a mama cat needs. I take every chance I get to hold him in my arms and dance with him.

Gunner

TYPE

English Bombay

NICKNAMES

Gunn, Chicken, Gunnbean, BooBoo, Booba Face, Bubba, Black Bean, Velvet

FAVORITE SNACKS

Bonito flakes, chicken

LIKES

People, stoop hangs, being petted while he eats, face and butt scratches, his brush, when I clean his face with damp cloth

DISLIKES

When young children run for him

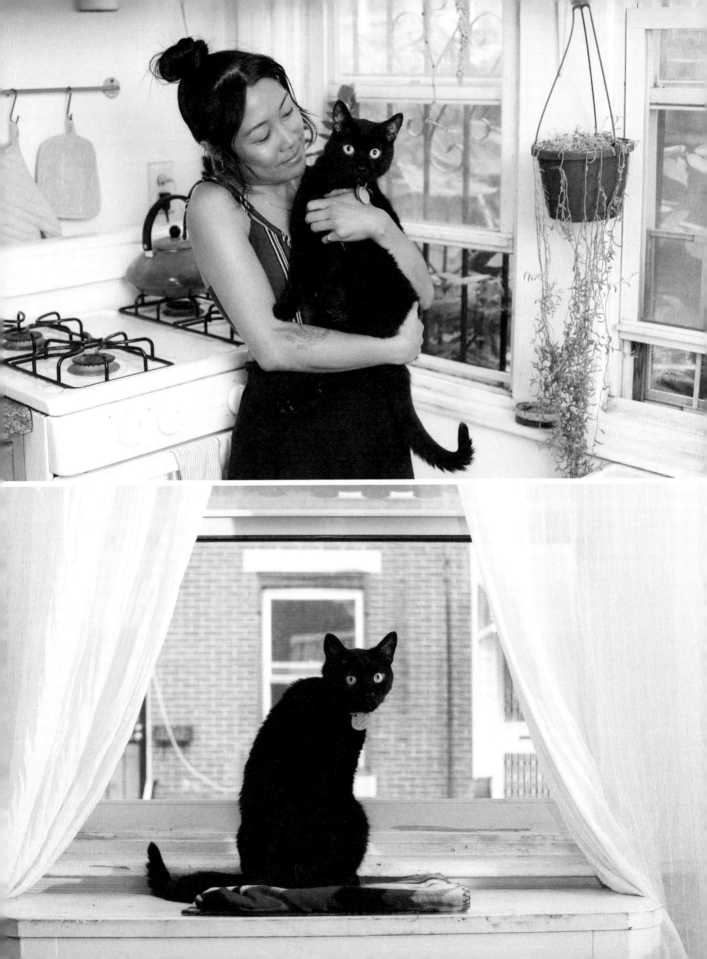

Cat Sounds

THE NOISE	HEARD WHEN
The cackle!	There's a bird in pouncing range (even if there's glass in the way)
The caterwaul!	You shut a door she doesn't want you to shut and leave her on the other side
The chatter!	Two old cat friends are gossiping and catching up
The chirp!	You walk near the fridge or cabinet where the cat food lives; or when you shake the treat bag
The chirrup!	You come in the door after work; when you play a really sporty game of fetch; or when you're having a friendly conversation
The chortle!	It's time to get up and give her breakfast
The gurgle!	She sits on your chest with her eyes closed and her paws tucked under, like a loaf of bread
The huff!	You try to get her out from under the bed or behind the TV stand; or when you pet her a little more than she'd like
The meep!	You're between her and somewhere she'd rather be or something she wants
The mew!	She's a kitten, or just acting like one
The moo!	You give her a good squeeze; or when you have a heart-to-heart
The mow!	You zip her into her carrier for a trip to the vet; or when you brush her so thoroughly that fuzzy tumbleweeds roll off
The percolator!	She stretches out next to you on the sofa and extends one of her paws to touch your leg
The sigh!	She settles into a bundle on top of your feet; when she nests in the center of a throw pillow

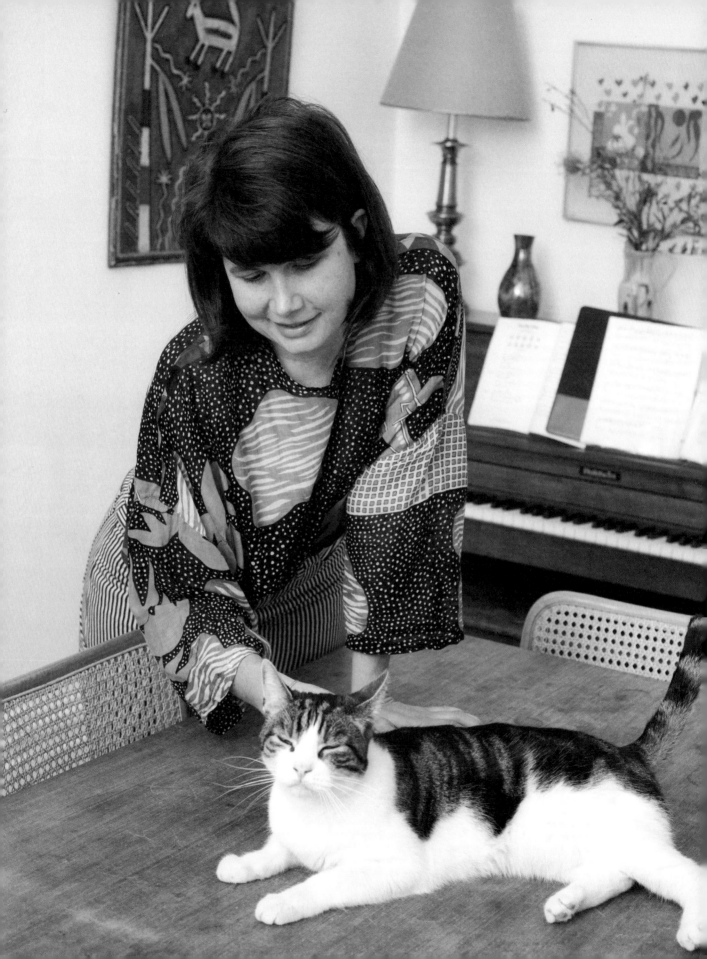

Holly Samuelsen

**FASHION DESIGNER AND CO-OWNER OF
THE SHOP AND CLOTHING LINE GRAVEL & GOLD**
SAN FRANCISCO, CALIFORNIA

Gomez

TYPE
Maybe domestic shorthair

NICKNAMES
Gomez Cat, Klaus, Gomies, Cuckoo,
Kookaburra, Kit Kit, Kit Cat

FAVORITE SNACKS
Bonito flakes, salty table scraps

LIKES
Ice, drinking water from the sink,
looking out the window

DISLIKES
Other cats and dogs, being
told to leave a room or surface

Gomez (full name Claude Gomez) joined my household around 2010. One of my former roommates found him wandering in Lucky Alley in the Mission District. He was slightly older than a kitten, a little rough around the edges, and pretty rambunctious to become a house cat, but he got socialized quickly living with eight humans. Now there are only three of us—Gomez and I live with my friend/business partner and her boyfriend—and things are calmer.

When I come home from working in my design studio or running errands, Gomez meets me at the top of the stairs and checks on me or just sits and watches while I cook. He also likes to leap up to the top of the kitchen cabinets, so he can keep an eye on the household's goings-on. We host a lot of dinner parties, and he'll pop into the dining room to say a quick hi to everyone. He has a clear preference for the male scent and makes a show of sniffing and rolling on visitors' jackets or backpacks.

Gomez used to be more of an eccentric—he'd steal and hoard corncobs and dish sponges in a little lair in our pantry—but he is letting go of some of his quirks as he matures. He's not too wild about most toys, but he will hunt ankles and calves if they are in his territory, as well as bugs and the rare mouse.

My former housemates and I were initially drawn to Gomez because he is remarkably handsome—well proportioned, with gorgeous markings, fur that is soft like a rabbit's, clear green eyes, and an expressive face. He still gets far on his good looks, and inspires fanatical crushes and compliments from cat people and non-cat-people alike. He's not overly generous with his affections, but he knows when to work his charms. Occasionally he curls up on my lap or gives me a gentle paw tap when I walk past him. He's also really good about holding eye contact and giving me slow blinks.

Gomez and I have a good connection based on mutual respect and appreciation. I couldn't call him "my cat" because that would be too possessive and ignore all the other people who have bonds with him. Even though I clean his litter box.

Bianca Christensen

CHEMICAL ENGINEER
LOS ANGELES, CALIFORNIA

I have two feisty male cats. The older one is a tuxedo named Mister who's three. I got him when I was in the process of being ghosted by my boyfriend of more than two years. I had moved east across the country to be closer to this man (stupid, I know), and I felt very isolated.

The ghosting was one of those things with a terribly slow buildup, which I now recognize as a period of him manipulating and gaslighting me. I was in bad shape due to all this; I wasn't eating or sleeping, and my performance at work was slipping rapidly. At the time I worked in research and development and made explosives, which is not something you want to do while sleep-deprived and distracted. One Saturday I met an older lady outside a mall in Rhode Island who had a litter of kittens up for adoption. Her unspayed cat had gotten outside and came home pregnant. I picked up a little black-and-white fluff, who immediately burrowed into my neck and meowed urgently when I tried to put him back down. Only my holding him kept him quiet. Obviously I fell in love then and there.

I knew that cats like to be in pairs, but I was terrified of raising two kittens at once, and clearly I wasn't at my most self-confident. So I took my little meower home and made some promises. (I'm a real sap.) I looked at his little face and promised him that he would be with me forever, that his home was with me, and that I would always do everything in my power to take the best care of him. And he needed a lot of care. It turned out the woman had lied or was mistaken about his age—he was too young to be away from his mama. So I had to be his mama. I fed him a gruel made of watered-down cat food and showed him how to use the litter box and clean himself.

Having a tiny creature who was dependent on me gave me something else to focus on besides self-pity, and I started making better choices. I left my job and relocated back home to Los Angeles, and focused on creating a safe and healthy environment for the two of us. It worked.

Mister & Weetzie Cat

TYPE

Mister » Domestic shorthair
Weetzie » Maine coon mix

NICKNAMES

Mister » Buddy, Mister Twister, Tuna Brain, *Katerchen* (which means "little tomcat" in German, but is generally just a term of endearment for cats), *Hübscher Kerl* ("cute guy")

Weetzie » *Schmutzig* (German for "dirty") or *Schmutzige Katze* ("dirty cat"), to tease him for his poor grooming habits

FAVORITE SNACKS

Mister » Freeze-dried duck liver, shrimp, egg yolks, whatever Mom is having

Weetzie » Just kibble, thanks

Almost exactly a year later, Mister got a brother. I was looking at pictures of shelter cats online while waiting in my dentist's office, and I saw a picture of a tiny, terrified-looking gray tabby. His eyes were so wide open and confused. I had an immediate, visceral reaction. I rushed home after my appointment, where my friend was waiting for me so we could begin a beach weekend we had planned, and immediately burst into tears trying to explain about this poor cat I had to rescue. We went down to the shelter

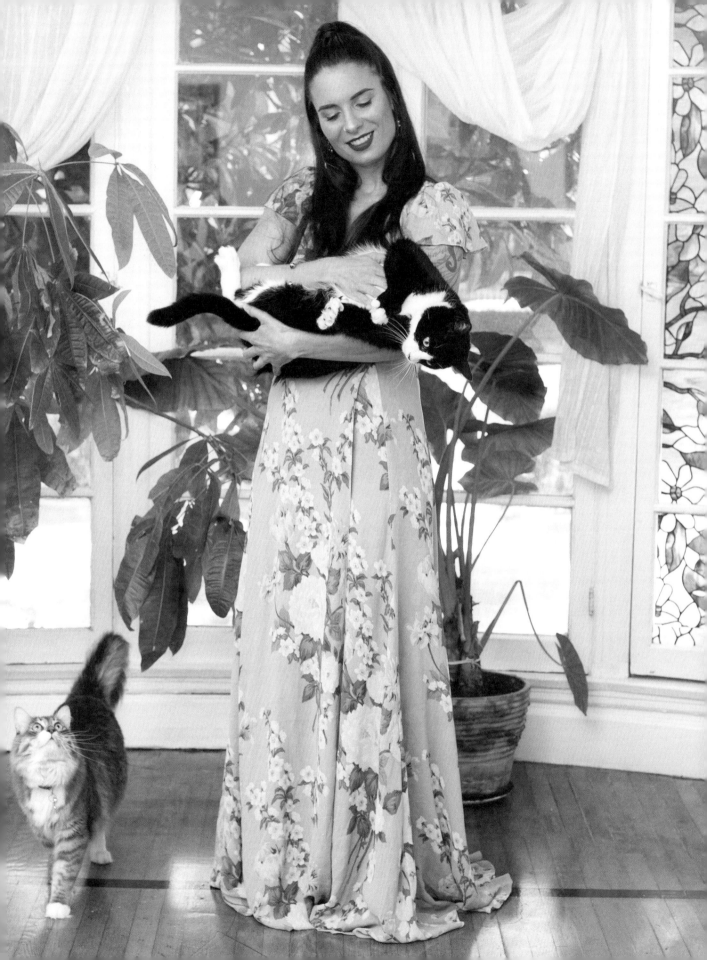

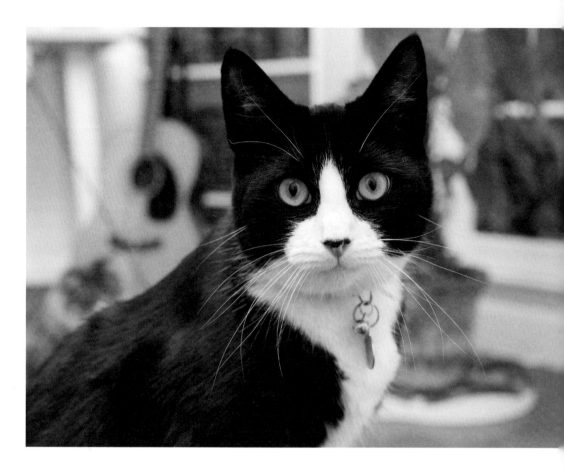

together, and Weetzie Cat (named after the titular character from the *Weetzie Bat* books, which hold a special place in my heart) came home with me. Weetzie fit into our little family right away, although he was very sick and malnourished and needed special care. Mister and Weetzie bonded like it was meant to be, and I feel like my home is finally complete.

These two fluffy boys may test my patience at times, but they have given my days a sparkle that I didn't know was missing before. It's such a joy to come home to them and know that I will be giving them amazing lives full of love and affection.

LIKES

Mister » Ear and chin scritches, looking at himself in the mirror, being told he's handsome, squirrels, crawling under the sheets when Mom makes the bed and "hiding," batting paper bags to make crinkly sounds

Weetzie » Tummy rubs, being brushed, all kinds of scratches and petting, taking up the whole bed, birds, saving Mom from bugs by catching them, any toys involving feathers, cuddles on the couch—but no holding or restraining, please

DISLIKES

Mister » Tummy rubs, dogs, loud air conditioners, being told what to do

Weetzie » Baths, brooms, vacuum cleaners, the noise that trash bags make when Mom snaps them

HUMAN ALTER EGO

Mister » Dr. Ian Malcolm from the *Jurassic Park* series

Weetzie » None—he's a Weetzie

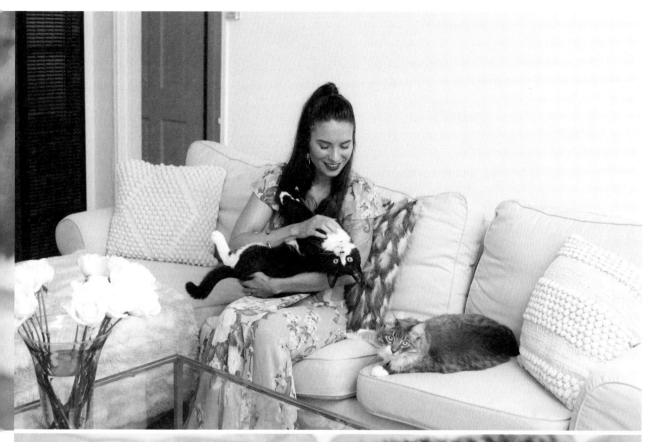

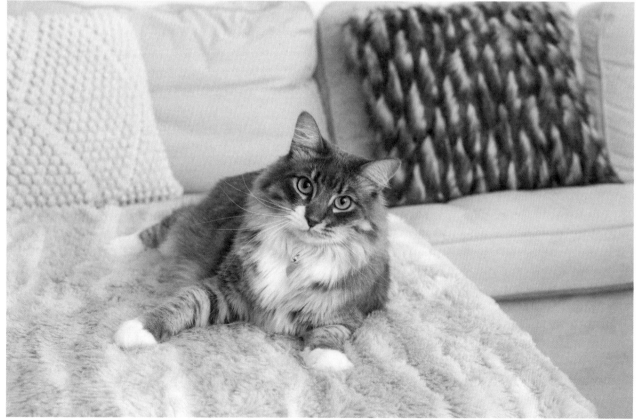

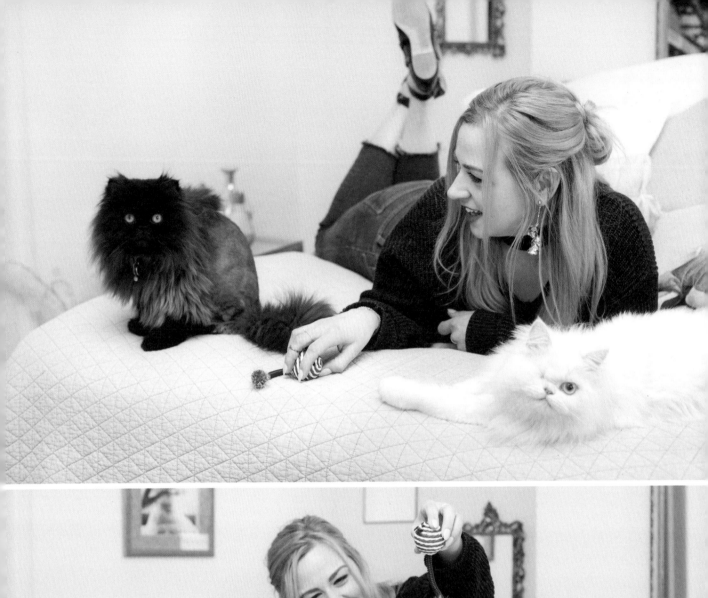
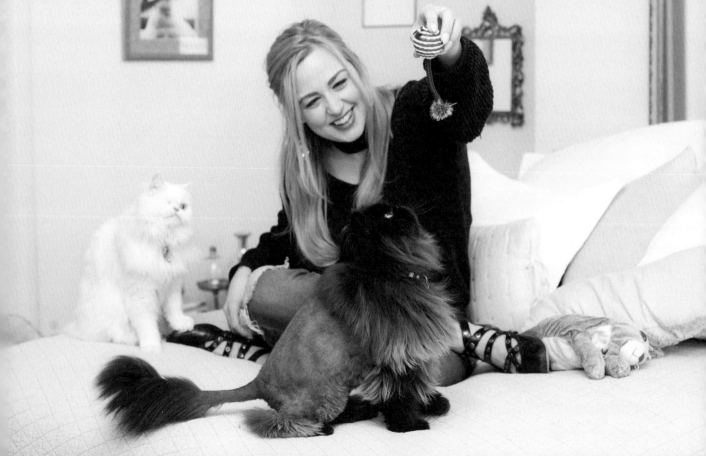

"Empathetic and loving enough to earn an animal's trust,
and patient enough to relish that quiet, sweet process."

Bethany Watson

ACTOR, PRODUCER, AND VOICE-OVER ARTIST
NEW YORK, NEW YORK

In 2016, I lost my beloved soul-mate cat, Oliver, when he was only seven. It was sudden and devastating, as Oliver had seen me through many hard transitions in my life and I wasn't prepared to lose my constant companion.

After that, I said I wouldn't adopt again. I didn't want to let myself get that attached to another innocent animal.

My downfall, however, came when my friend Danielle adopted two cats from Happy Homes Animal Rescue, in New Jersey. I started following their Instagram account, and pretty quickly fell in love with a one-eyed white Persian. I've always had a thing for one-eyed cats, and here was one literally staring me in the face. Minerva (or Poppy, as she was called back then) had been rescued from the streets of Cairo, Egypt. A woman there found her and posted a pic of her on Facebook. One of the Happy Homes women saw it and contacted an incredible man she knew in Cairo named Ahmed, who agreed to foster Minerva until she could be sent to Happy Homes. She was motherless and so small. He took her in and nursed her around the clock until she was strong and healthy enough to make the journey. Thanks to Happy Homes's Instagram account, I also quickly fell in love with a black Persian cat who just looked spooked. I felt like he needed someone to tell him that everything was going to be okay. That's how Minerva Purr (full name Minerva Angela Lansbury Purr-Watson) and Loki (Loki Sherlock Watson) came to live with me. They're the sweetest kittens you could ever hope to meet.

Minerva is a feisty barn cat who loves to race and climb. She sees me only as a tall tree that she can scale to get up higher. (I have many leg and torso scratches to prove this.)

Loki is my little soft-hearted boy. If he were a high school student, he'd be the goth poet who sits alone at lunch and writes sad songs with a quill pen while listening to Modest Mouse. He just wants to be held against my chest all the time, and is definitely the kitten who soothes my heart after a long day.

I'm so grateful we all found each other.

Minerva & Loki

TYPE

Minerva »	Persian/Ragdoll mix
Loki »	Persian

NICKNAMES

Minerva »	Kitty Wap (like Fetty Wap, due to her one eye), Little Girl, My Love, or just Hey Girl Hey
Loki »	Loke, Tone Loc, Little Boy, Sweet Baby Boy, Guyliner (because my sister pointed out that he looks like he's wearing eyeliner like the little emo boy he is)

FAVORITE SNACK

Both »	Oven Roasted Chicken Feline Greenies

LIKES

Both »	Attacking bed sheets, playing with the plastic wrappers from kombucha bottles

DISLIKES

Both »	Having their bellies touched, being groomed, visitors

HUMAN ALTER EGO

Minerva »	Selina Meyer from *Veep*
Loki »	Paul Dano's character in *Little Miss Sunshine*

CAT LADIES ARE...

—

"Uniquely in tune with their cats, and with other people's thoughts and feelings."

Imaan Khan

CLINICAL RESEARCH COORDINATOR
SILVER SPRING, MARYLAND

In February 2017, our senior cat, JJ, died. My husband and I had had him for only eleven months and were devastated. I'm part of a Facebook group for declawed cats in New York and New Jersey—group members post and share pictures of declawed cats to help find them homes and raise awareness; many of them have special needs—and one day a picture of Hedwig and Panda popped up. They were three years old and about to go to a shelter. I messaged the group right away and asked if they would consider a family in Maryland. We shot a quick home video for them the next day, and the next weekend we drove to New Jersey to get them.

Hedwig's original name was J.Lo, because her previous owners said she was a diva, and Panda's was Jumper (she moves fast). Panda had a gimpy leg that we hadn't known about, but we didn't care. They were too cute, even though Panda was hissing like a maniac and Hedwig was too scared to react. We asked some questions about the leg; apparently Panda's previous owners had gotten her from Craigslist as a kitten, and when they brought her home her leg was weird. They tried to contact the Craigslist person, but he or she had disappeared. They had the vet do scans and tests, and she's fine—she just walks a little funny and puts her leg in weird positions. (Seriously, sometimes it's freaky, and I have to move her leg to stop the terror in my heart.) Anyway, we took them home. They were very well-behaved in the car and didn't make a peep the whole time in their crate. When we let them out in our apartment, they hid under the bed, and our mattress growled for a couple of days.

What was weird is that I didn't love them when we got them. I was very upset. I liked them, but I didn't love them as much as I loved JJ when we got him; I loved him the minute I saw his Petfinder profile. But these cats . . . I was so disappointed with myself and thought I was

Hedwig & Panda

TYPE

Both » Domestic shorthair

NICKNAMES

Hedwig » Heddiwigs, Heddipigs, Heddipigs Heddipigs Let Me In (said in the voice of Negan from *The Walking Dead*)

Panda » Panda Poo, Pandaass

FAVORITE SNACKS

Hedwig » Sheba Sticks, string (but not treats in the shape of string)

Panda » Everything

LIKES

Hedwig » The couch, the fancy chairs, rubs, whining, playing while we make the bed, showing you her butthole, getting petted in that one spot that makes her lift her butt

Panda » Her box, the dining chairs, sitting on new things that come into the house, anything edible, lying down in the way, rubbing against the catnip scratcher

DISLIKES

Hedwig » Being held, windows that are open just a little bit

Panda » Being held, getting her claws trimmed, being loved

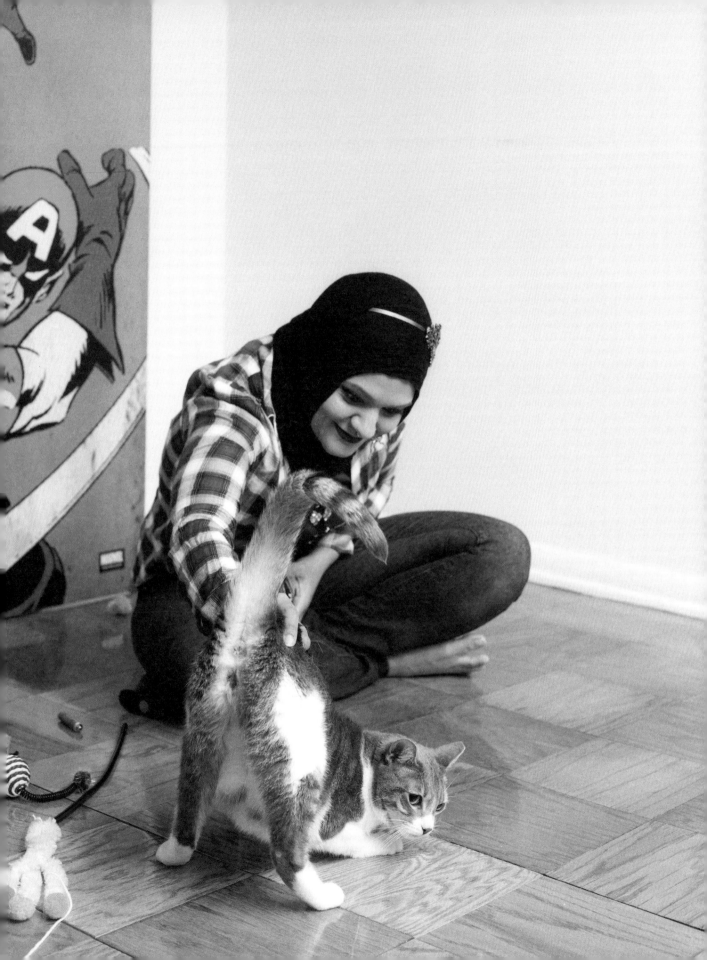

a terrible person. After a few weeks with them, though, it was all different. I threw myself a cat shower, which shows how crazy in love I am with them.

Hedwig isn't actually a diva, though she is kind of whiny. We named her after Harry Potter's owl, and I swear the next person who says, "But she's not all white like the owl," is going to get it. Jumper became Panda. (Guess what colors she is?)

Hedwig is wary of strangers, hates large parties, and loves to eat string. She ate an arm's length of string once. Thankfully she pooped it out, and now we hide any string-like material—even threads off a bed sheet. She is very affectionate, and I am getting her used to being held. When I take a shower, she sits on the closed toilet seat and waits for me to come out so I can pet her. One time I made the mistake of sitting on the edge of the tub, and she sat in my lap and cuddled with me. I didn't move until she got off. My cats are not lap cats, so it takes a lot for them to sit on your lap. Hedwig also sleeps with us. Did I say sleep? I mean she walks on my bladder at 4 a.m.

Panda is friendlier with strangers and will sit on her chair even if there are fifty people around. She doesn't give an F. She's not as affectionate as Hedwig, though, so when she does rub against us, it is a very revered action. If she's purring, we make sure to keep doing whatever is making her purr. She's most loving at night. When we're asleep, she head-butts us for pets, and we oblige her because we don't want her to stop.

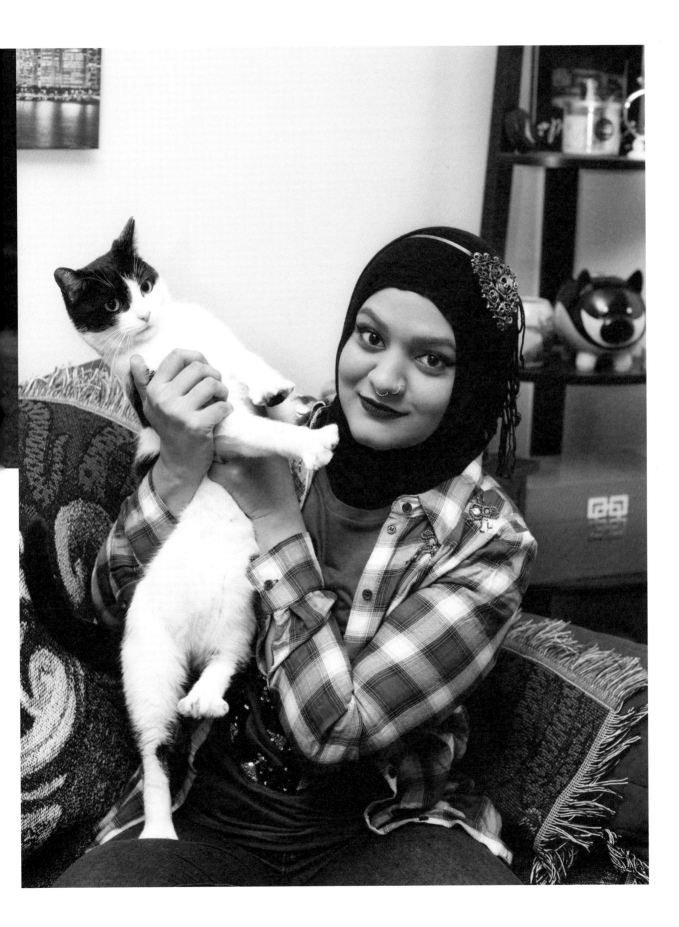

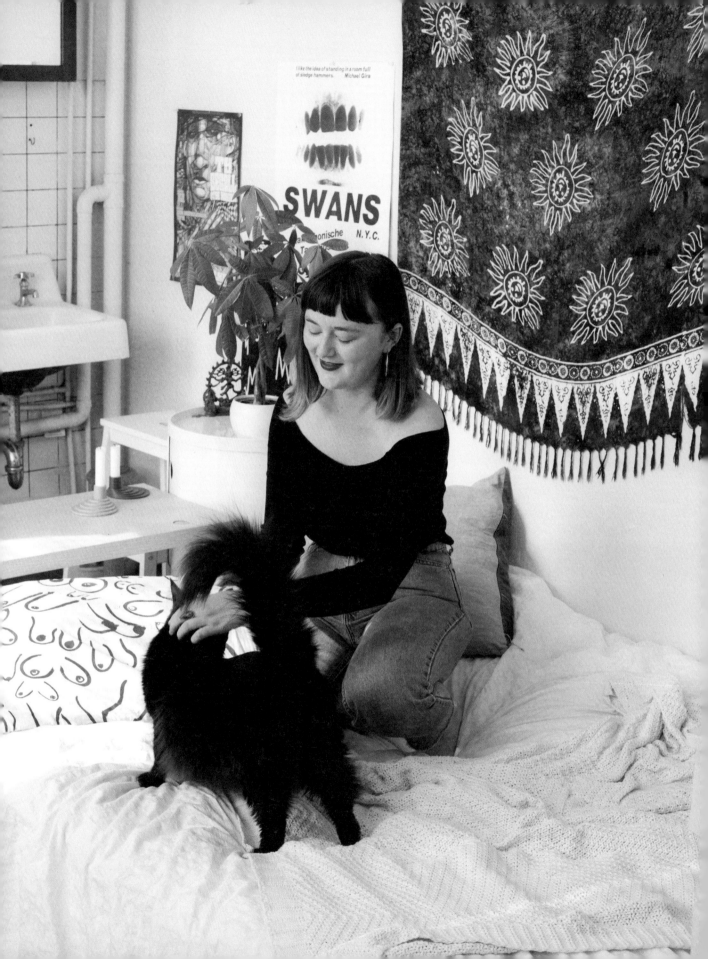

Ariana Bindman

PHOTOGRAPHER
SAN FRANCISCO, CALIFORNIA

I'm convinced that Mona is basically Posh Spice. She's dismissive to other cats, her black-to-gray ombré is nicer than mine, and her facial expression wavers between annoyed and unimpressed. Much like Victoria Beckham, she's a misunderstood diva, and for that I love her.

I also admire Mona's staunch independence and natural ability to make life go her way. She needed those traits to survive. Since she was a kitten, the odds have been stacked against her: As a black cat, she had the lowest chances of getting adopted at a shelter, and even once she was adopted, she was neglected by her original owner. It still amazes me that such a small, vulnerable creature—albeit one who jumped out of a moving car in East Oakland and scaled thirty-foot-tall power lines in Sacramento—finagled her way into my life.

We joined up because we were both trying to escape from the same person: her original owner and my then boyfriend. Based on what I've heard, Mona often ran away from my ex (thus the death-defying stunts). His living situation was always dysfunctional, and he was very neglectful and rarely took proper care of her. As a result, she hid in closets or nooks and crannies or disappeared altogether. Shortly after all three of us moved in together, the relationship took its natural course and imploded. Finally, I confronted him about never feeding Mona like he promised he would. He replied, "It's okay, cats can survive for days without food." I knew then what had to be done. I started looking for a new, pet-friendly apartment right away, just big enough for Mona and me.

Despite the unsavory circumstances at the beginning of my relationship with Mona, I view it as a gift. When I made the decision to break up with my ex and keep her, I felt surprisingly empowered. The urgency of the situation also made me realize that my connection with her was more meaningful than the one I had with my ex, and her presence helped me cope with the trauma moving forward. She and I comforted each other during a chaotic period of time, and we bonded quickly as a result.

Mona

TYPE
Siberian mix

FAVORITE SNACK
Inaba Churu purée

LIKES
Quality belly rubs, clean laundry, taking eight-hour naps in the sun

DISLIKES
Large men, loud noises, getting woken up from said eight-hour naps

HUMAN ALTER EGO
Definitely Posh Spice

I love doting on her, and proudly embrace being a full-blown cat mom. I let her sleep on the whites even though she sheds massive amounts of black fur, and if she happens to be lying on my jacket, I settle for a cardigan instead. Even when she does a wet sneeze right on my laptop as I'm working, I can't get angry—I live to spoil her.

Just like the scene in *Spice World* where Posh, Ginger, Baby, Scary, and Sporty come together to form Army Spice, Mona and I joined forces to fabulously overcome the proverbial obstacle course. I wouldn't have it any other way: "Just Girl Power is all we need."

CAT LADIES ARE...

"Tapped into the special enchantedness only felines possess, and under their cats' spell, they are rewarded by a life that is more glamorous, inquisitive, graceful, eccentric, sassy, clever, and perfect."

Holly Andres

FINE ART AND COMMERCIAL PHOTOGRAPHER
PORTLAND, OREGON

I have always loved Siamese cats. I secretly rooted for all the naughty ones in the Disney films, and my childhood cat, Vivian, who was my best friend, was part Siamese. Vivian followed me everywhere I went and let me dress her in doll clothes and push her around in a toy stroller. She died at age seventeen, when I was in my last year of graduate school. About a year after that, I adopted Sophia from a farm in Oregon City, Oregon. The litter she was born into was a twelve-year-old girl's 4-H project; the family had converted their '70s-style plant atrium into a cat room, fully equipped with carpeted ramps and steps. When I crept into the room and sat cross-legged on the floor to pet her mother, Sophia scurried down from the highest vantage point and crawled into my lap as though she owned it. Fifteen years later, I spend most of my time packing her around like a baby.

Nine years ago I split up with my husband, and Sophia and I moved into a small apartment on the other side of town, where she was removed from the company of her dad and two little cat brothers. In those days, she was devastated by loneliness. I would come home and her voice would be hoarse from crying. While the thought of introducing another cat into my tiny apartment did not sound appealing, I knew I needed to find her a companion, and fast. And so I hopped on good ol' Craigslist and found the one-and-only posting for a Siamese cat—two hours away. I drove out to Lincoln City on the Oregon coast, where I met an elderly couple in a Dairy Queen parking lot. I was with a friend, and we took a wrong turn, which made us over an hour late. They sat in the car, waiting and chain smoking, until we arrived.

Sophia & Sylvia

TYPE

Both » Siamese

NICKNAMES

Sophia » Monkey Face, Babycita, Chocolate Buffalo, Platipussy, Bumble Bee, Sosaphina, Swiss Miss, Monster

Sylvia » The Baby, Li'l One, Twinkle Toes, Angel Face, Li'l Girl

FAVORITE SNACKS

Both » Tuna from the can, water from the fishbowl

LIKES

Sophia » Holding onto my arm like it's a tree branch, eye contact, sunshine, affirmation

Sylvia » Being kissed on the head, playing fetch, riding on my shoulders, fighting with the printer, gazing into the fishbowl

DISLIKES

Sophia » Being ignored, being held like a baby, getting left behind

Sylvia » Loud noises, scary people, being too hot, being under the covers

HUMAN ALTER EGO

Sophia » Mrs. Robinson
Sylvia » Jerry Hall

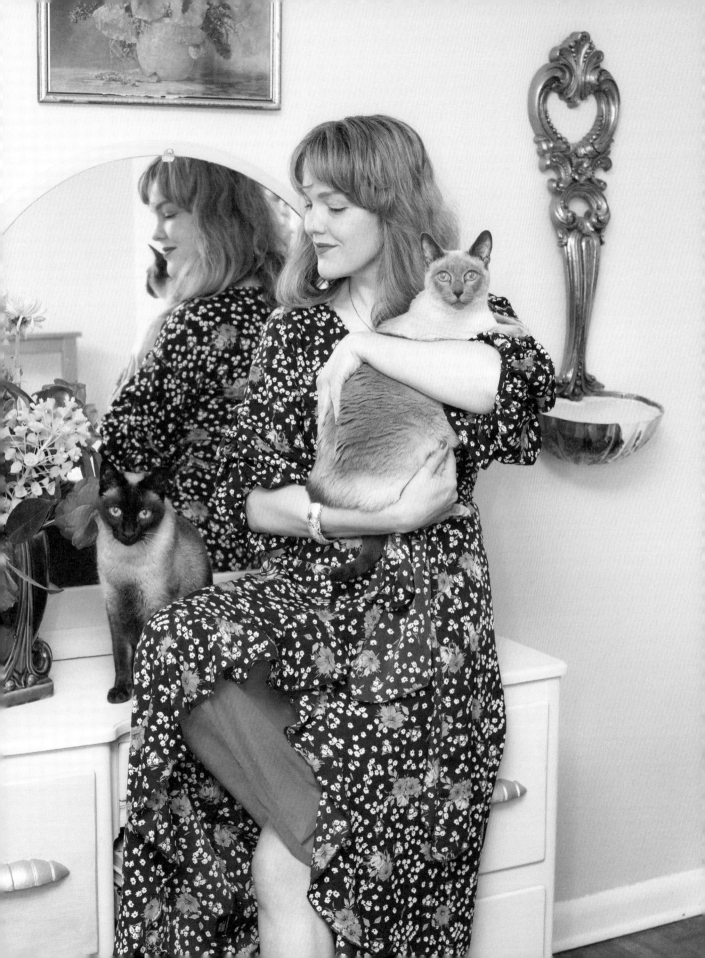

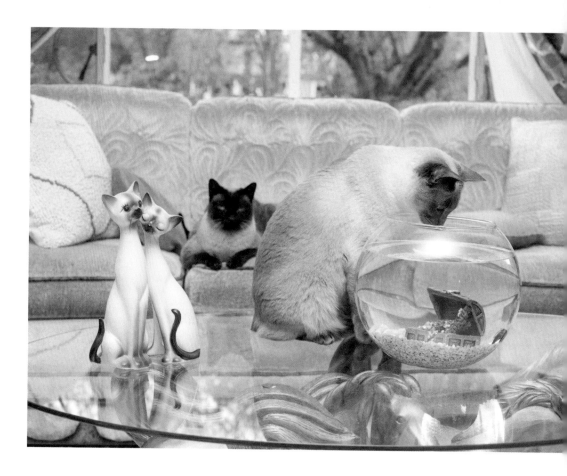

Baby Sylvia's introduction did not go well. For the first week, she lived under my bed like a feral cat. One morning I found her curled up in my underwear drawer; she had crawled up the back of the dresser and into the top drawer, apparently thinking she'd be safer there. I felt awful. Sophia was mad, and this new baby was traumatized. Then one day, about a week in, I came home to the most miraculous sight: the two of them spooning on the bed. I'm not sure what happened in those few hours while I was away, but they fell in love to the extent that they still pile on top of each other in a single cat bed, and if one of them is shut in another room, they both scratch and cry at the door until they are reunited.

Adopting Sylvia represented a new chapter for me. I thought of her as a metaphor for my new life—which explains why I was so anxious when she almost died twice in the first six months I had her. First, she got a severe uterine infection as a complication of being spayed, and then she had to be cut open again to fetch a little clown nose she chewed off her favorite doll, creating a major obstruction in her intestines.

Those were some dark days, and it seemed like a monumental task just keeping that little kitten alive. I now look back and realize my determination to keep her healthy mirrored my own efforts to rebuild a life that then felt shattered from divorce. At times their presence is Zen-like. Sometimes they perch like Ming Dynasty statues on either side of my desk. Other times they relentlessly use their voice until I pick them up, sit down, and acknowledge them. It's as though they know I'm stressed, and that what I need most in the moment is to chill. They are my feline therapists.

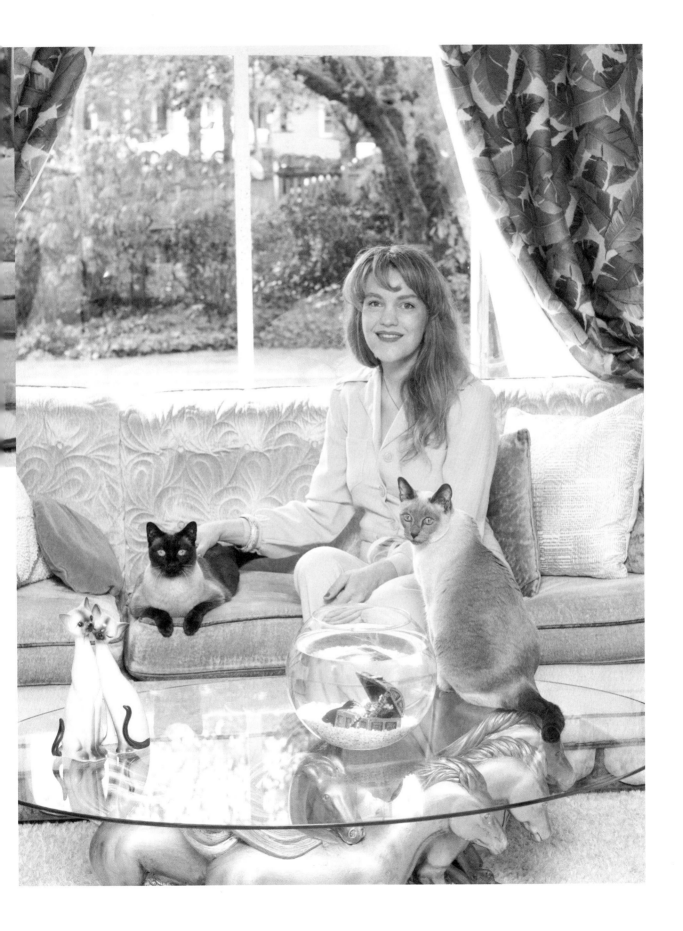

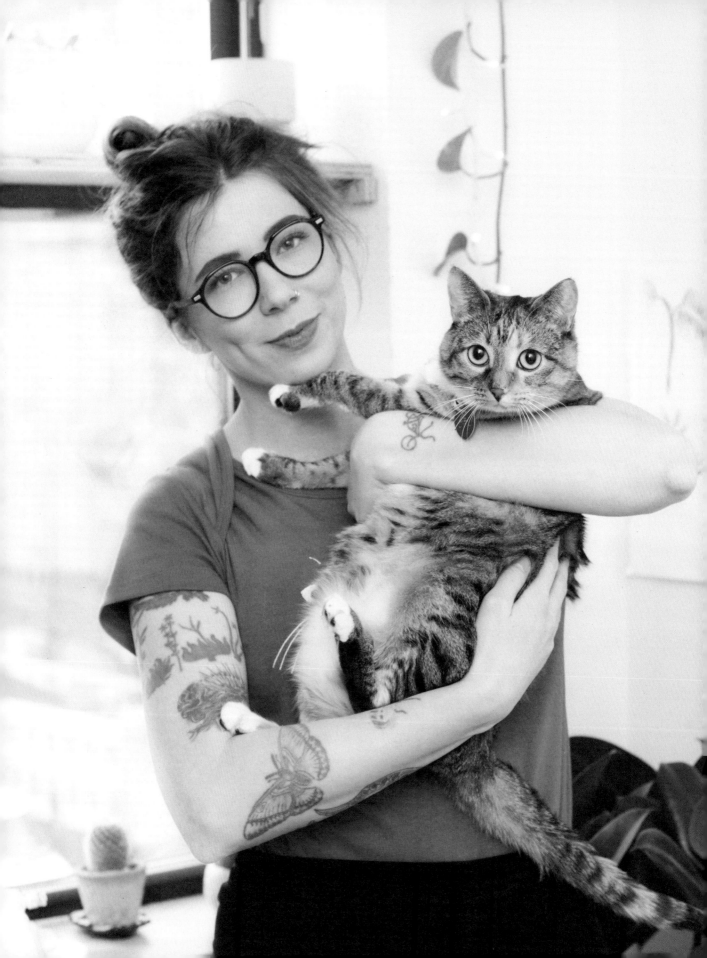

Athena Wisotsky

WRITER, EDITOR, AND ARTIST
BROOKLYN, NEW YORK

Before Frikki, I had wanted a cat of my own for so long. But I moved a lot in the past few years, and there was always something in the way. I never felt settled enough, or the apartment was too small, or my housemates weren't on board. There are three bodega cats that I visit as often as I can, but it isn't the same as coming home to a little creature of my own.

When my mother, Donna, passed away suddenly in 2016, I had the responsibility of rehoming her cats in the middle of everything else going on. She had five: two ladies we got when I was in high school, and three siblings from one of them. They were her joy and companions, and it was so important to me to find safe, stable homes for them. She would always send me photos of them curled in her lap or hamming it up, and tell me whatever antics they were getting up to. We joked that she would have to mail one to NYC. When she passed away, it felt like the right thing to do to adopt one of them.

My decidedly-not-a-cat-person boyfriend, Max, and I didn't choose Frikki at first. Her brother is a lot more social, happy, and almost comically beautiful. But I realized that with her skittish temperament, she'd need a lot of patience and love. And Max took to her right away—it was her giant cartoon eyes—so little Frik flew with us from Oregon to New York.

She warmed up to us a lot in the first month, and so did the household. Max initially didn't want her on the bed, but he caved within three days when he realized the power of a cat snug. I often catch them cuddling in bed, and he texts me, "How are my girls?" when I am working at home, sometimes with her in my lap. They bonded quickly, and it warms my heart.

That wasn't the way I imagined getting my first cat, but having Frikki around was a major comfort in my grief. Sometimes I just sit and pet her and imagine my mom doing the same thing. She's a living piece of my mother's life. I'm so happy to have her in my home.

Frikki

TYPE
Domestic shorthair

NICKNAMES
Frik, Friklet, Kweet, Baby Chicken Girl, Talky Good Girl

FAVORITE SNACK
Freeze-dried salmon

LIKES
String, pouched meats, chin scratches

DISLIKES
Dry food

HUMAN ALTER EGO
Uncle Fester from *The Addams Family*

Channing McKindra

ACTOR
LOS ANGELES, CALIFORNIA

I have always been a cat person. Nine years ago, when I lived in New York, I had a musing that I'd like to adopt an all-white cat and name her Sailor (after my favorite childhood show, *Sailor Moon*). Cut to June 2012. I had moved to Los Angeles two months prior to pursue acting. I had just started a hostess job at a restaurant that paid pretty terribly and was renting a room from a woman who had three cats and four dogs. One day, my housemate told me about an abandoned cat her sister had found outside their local preschool in San Diego. Apparently, her sister's husband was adamant that they couldn't have a second pet, and my housemate already had her hands full, so she said I should adopt the cat. At the time, I was trying to get settled in a new city and start a career, so taking on the responsibility of a pet was the last of my priorities, but my housemate talked me into it, saying that she would care for the new cat along with hers. Plus, I would never want any animal to be sent to a shelter, even if only for a few days.

I saw a picture of the cat before I drove an hour to pick her up early one morning. She was completely white, with a delicate build and green eyes—just as I had envisioned back in New York—so I already knew her name was going to be Sailor. She softly mewed most of the way home. I think she instantly knew I was going to be her mom.

The first couple months were rocky. Sailor had a serious attitude problem. She was nice enough some of the time but would just as often hiss or run at me, trying to scratch at my ankles. I definitely questioned my decision to adopt her at first. My housemate never

Sailor

TYPE
Domestic shorthair

NICKNAMES
Baby, Angelcake Babyface, Little Honey, Sweet Thing, Little Girl, Princessface, Angel

FAVORITE SNACK
Feline Greenies

LIKES
Sleeping in her cat tower, hiding in small spaces, Indian food, ice cream, popcorn, behind-the-ear scratches, drinking out of the toilet

DISLIKES
Hunting anything for more than a few minutes, other cats, closed doors

ended up fulfilling her promise to help out because Sailor could not stand her—or any of the other animals in the house—and rarely wanted to venture out of my room.

Eventually, Sailor learned to stop being aggressive toward me, and we began to bond. That first year in L.A. pretty much sucked, but she was my anchor and my comfort. I honestly don't know if I would have stayed had she not serendipitously arrived. Neither of us was at all happy with our living situation, but we had each other. A lot of the motivation to get my own place and a better-paying

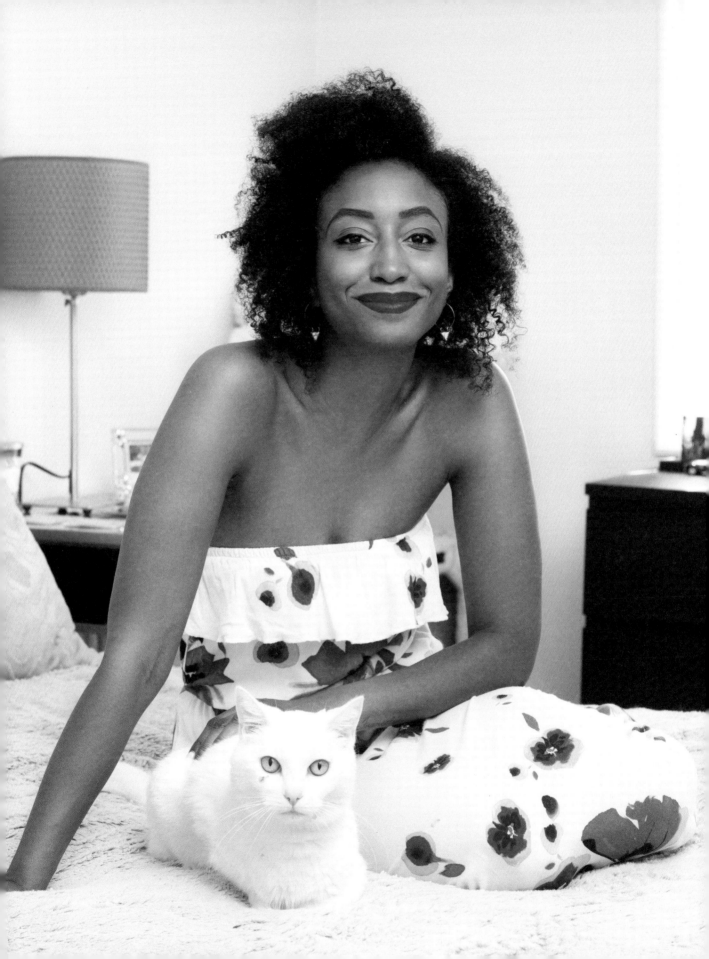

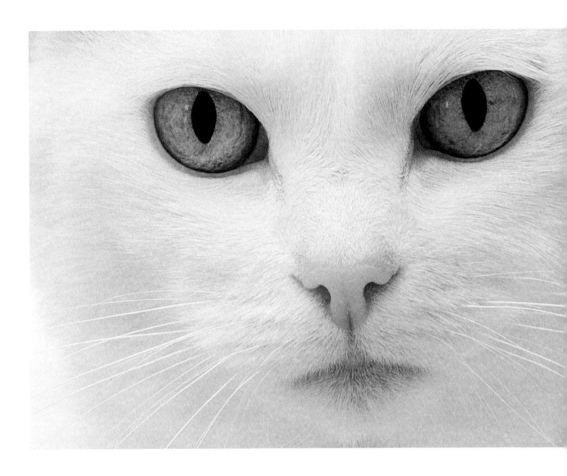

job came from wanting to take care of her and make sure she was in a comfortable environment.

As soon as we moved, she transformed into an entirely different cat. Bit by bit, she became very sweet and loving. She used to only tolerate being held. Now she melts in my arms and purrs. Whereas before she'd sleep only at the foot of my bed, she now curls up right next to me and lets me cuddle her as I fall asleep. For a long time, she was very skittish and didn't care to be around anyone but me, but she's become way more social. Now that we live with my boyfriend (her stepfather, as I like to say), she's affectionate with him, too.

When I come home, Sailor likes for me to lean down to her so she can sniff my face, which I'm guessing is so she can figure out what I've been up to all day. If I talk to her, nine times out of ten she responds. She is very vocal, and I've learned all of her different meows' meanings, if you will.

Sailor was diagnosed with a heart condition a few years ago, and she has hyperthyroidism as well. She is by far the most expensive pet I've ever had, with very

fancy doctors' appointments. I mean, she literally has a cardiologist. Even though I couldn't always afford it, I've always found a way to pay for her medical treatment. She is my baby and the first pet that is solely my responsibility. I want to do everything I can to make sure she has a long, happy life.

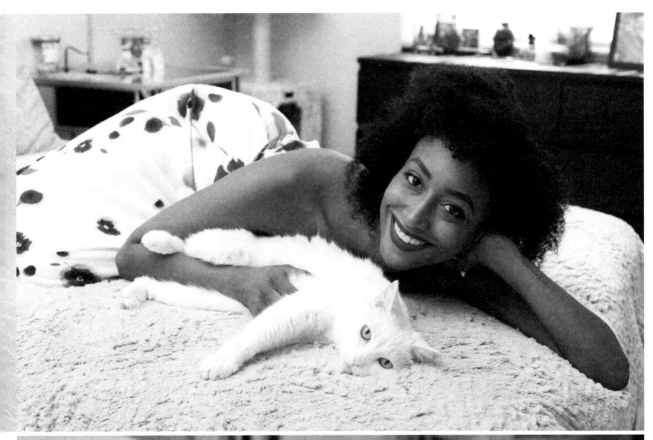
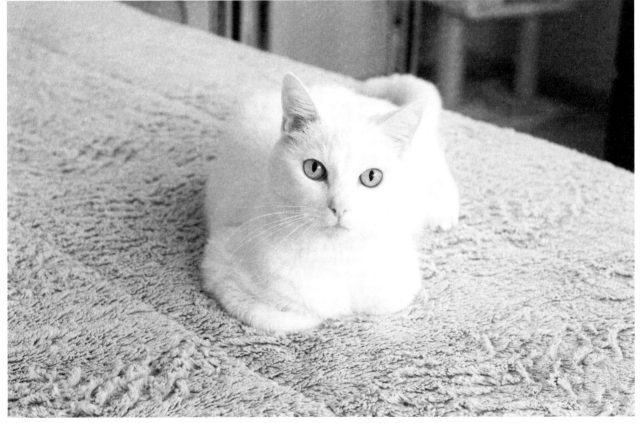

Because You Have a Cat

1. **SELF-CARE.** A roommate who spends approximately 95 percent of her waking life either sleeping or grooming knows what she needs and how to get it. That attitude is bound to rub off.

2. **SELF-RESPECT.** Cats know that everyone won't love you—and that you don't have to love everyone. They model how to get and give love on their own terms, the way all of us want to.

3. **PERSUASION.** That being said, cats know that sometimes all it can take to win a person over is an unexpected outpouring of pure, unbridled affection, which, when given sparingly, can be 100 percent addictive.

4. **TYPING.** Who needs to look at the keyboard? There is a furry body on top of your fingers, between you and the screen, yawning and stretching and kneading the keys, but you can finish that email, no problem.

5. **STAYING WARM.** If you burrow all the way under the blankets, your body heat will work just like a tiny furnace. Always leave the tip of your nose sticking out. Always choose the fuzziest dry-clean-only blanket.

6. **IDENTIFYING THE FAINTEST SOUNDS.** No, that clicking isn't the air conditioner shutting off or a mouse in the walls. It's just the cat running across the top of the refrigerator.

7. **INVESTING IN HIGH-QUALITY HOME GOODS.** That tufted headboard will never survive; ditto the jute rug. You've learned to choose velvet and canvas (aka "performance fabrics"). You know that beautiful alpaca throw wouldn't last a week.

8. **WAKING UP EARLY.** There's nothing like paws in your hair or a whiskery nose in your face to make you spring out of bed, set out the kibble, and start the coffee.

9. **ACCEPTING CHEESY GIFTS WITH GRACE.** One day, you just might get the Taj Mahal–shaped cardboard cat scratcher you've always wanted.

10. **DEALING WITH POOP.** You don't shudder when you see your cat waddling away from her litter box anymore. You just grab a paper towel and take care of business.

11. **ADULTING.** Anyone who has ever administered a cat's medication, tried brushing her teeth, or given her a bath knows exactly how their parents felt when they said "it's for your own good."

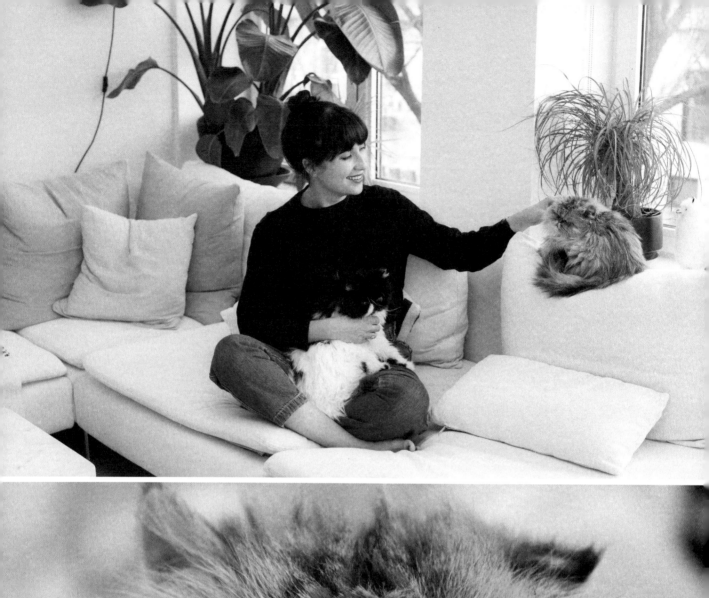
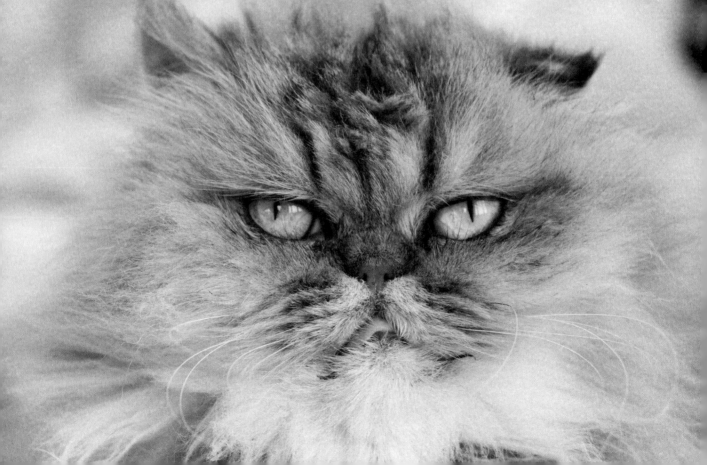

Éva Goicochea

COFOUNDER OF TINKER WATCHES AND CEO/COFOUNDER OF MODERN SEX PRODUCT LINE MAUDE
BROOKLYN, NEW YORK

In 2013, our Persian cat Olive passed away from polycystic kidney disease, which is pretty common in the breed. Our adopted Himalayan, Mr. Miyagi, was left as an only feline child. We took a weekend trip without him, checked our Nest Cam on the way home, and saw him crying his head off. He was lonely! So I got on PetFinder, found a cat available for adoption, and made my husband turn the car around to go thirty miles to meet that cat.

The woman who had posted the Petfinder ad was like, "The one you came to see is friendly, but I have this other shy orphan Persian cat who doesn't really like people, so I'll give her to you for free." Sold.

We put tiny little Bea in her carrier and raced down the freeway to introduce Mr. Miyagi to his new sister. Needless to say, they became best friends, and he did his best to get Bea to be less shy. At first, she'd hide under the bed or scurry around the house, afraid of anyone coming near. But Mr. Miyagi soon taught her how to snuggle next to our arms when we were sleeping as a way to be close without too much activity. Bea now sits next to me every morning and nudges my arm until I wake up and pet her. She has learned how to be social on her terms.

When Mr. Miyagi passed away, I was heartbroken. Not knowing if we wanted another cat, I randomly got on Craigslist, and there was Winnie. Her owner was an older man who couldn't keep her. I asked his son to drop Winnie off for a weekend visit. That was more than four years ago.

Winnie was absolutely the best medicine for heartbreak. She truly knows how to entertain herself—and everyone else. She eats treats like a squirrel, standing up on her legs and using her front paws to hold her snack. If we're eating at the table, she sits down next to us and waits as if she's going to be served. And then there was the time she jumped on it while we were eating by candlelight and lit her tail on fire like a

Bea & Winnie

TYPE

Both »	Persian

NICKNAMES

Bea »	Beatle, Bio Bea
Winnie »	Winnie the Pooh, Panda Cat

FAVORITE SNACKS

Bea »	Dog food stolen from her canine sisters
Winnie »	All snacks, but especially noodles and bread

LIKES

Bea »	Her parents
Winnie »	Everything

DISLIKES

Bea »	Loud noises
Winnie »	Nothing

HUMAN ALTER EGO

Bea »	Puss 'n' Boots's daughter
Winnie »	Rebel Wilson

complete rascal. (She was fine. Didn't even faze her.)

Bea and Winnie are very yin and yang. Bea is shy and quiet with a grumpy streak, while Winnie is absolutely a ham, always happy and up for playing. Together, they are balanced, and we imagine Winnie encouraging Bea not to take life so seriously. Every now and then, they cuddle.

Christina Loff

MARKETING DIRECTOR AT CHRONICLE BOOKS
SAN FRANCISCO, CALIFORNIA

My cat Jack passed away from cancer in 2017. I didn't think I could ever bond with another cat the way I did with Jack, who was in my life for eleven years. I always worried that he was lonely as an only cat, even though I'm sure he was fine. So when my boyfriend and I talked about adopting a new one about four months later, I convinced him that we should get two. I trolled local shelter sites for months and shortly after Christmas saw two adorable gray kittens who needed to be ours. I rushed to San Francisco Animal Care & Control with a friend to meet them and bring them home. They were cute and playful and everything you could want three-month-old kittens to be, but something was missing for me. I asked the volunteer to meet the other cats available for adoption.

One of our first stops was an eleven-month-old named Furrito who had been found on the freeway. I suspect they called him that because the shelter is in the Mission, where taquerias are abundant, and because he is just a big bundle of love. I picked him up (which I later found out you're never supposed to do the first time you meet a cat; you don't know what their temperament is or how they'll react to you), and he immediately put his face in mine and gave me kisses. My friend took a video of all this, and on it you can hear her and the volunteer cooing and saying, "Well, look at that, that's an instant connection." And it was. All thoughts of two kittens were forgotten. I brought him home, and we named him George.

For the four months we lived without a cat, our house had felt so empty. There was just this sadness left behind after we lost Jack. George has a big personality—goofy and attentive and loving—and he filled our home with the kind of joy only an animal can bring. I think we were both surprised at how easy it was to bond. George is cautious when he meets new people, but with us it's all trust. I'm pretty sure he thinks I'm a cat.

George is particularly entertaining in the mornings and evenings when he has what we call "the zooms." He runs into the bathroom as soon as he hears the shower stop and waits on the bath mat for your wet legs to emerge, then rubs himself all over them and plops down on top of your wet feet. My friend says this

George

TYPE
Tabby mix

NICKNAMES
Georgie, Peanut, Peanut Butter, Georgina, Buster

FAVORITE SNACKS
Cheese popcorn, dried salmon

LIKES
Belly rubs, drinking fresh water from the sink

DISLIKES
The neighborhood cat who taunts him, bananas

HUMAN ALTER EGO
A bouncer or security guard

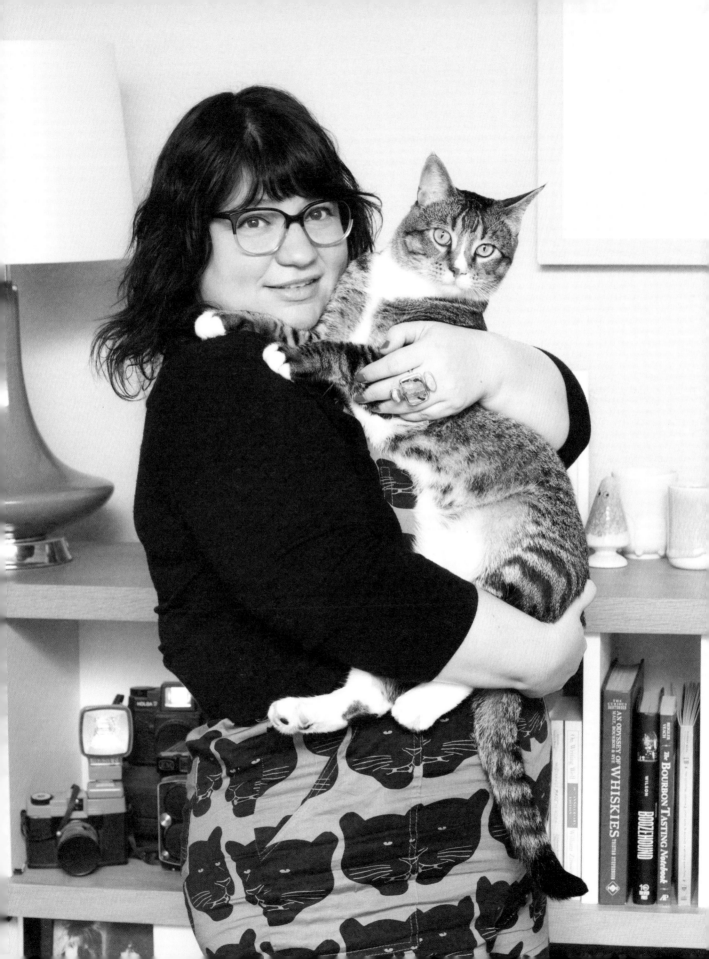

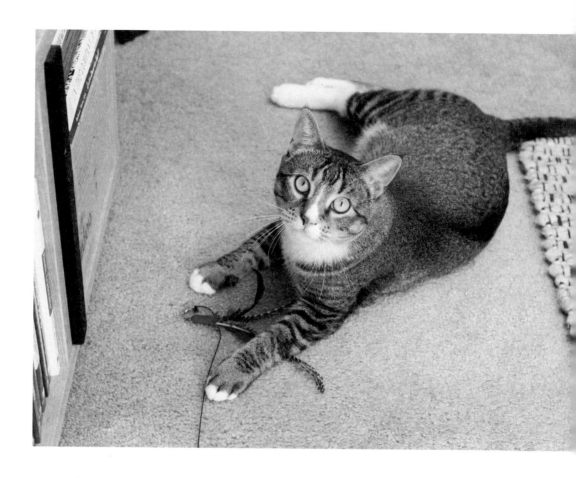

is his way of marking us after we're freshly clean, but I think he just likes the hot water and snuggles.

He helps me put things into perspective and not take life too seriously. After a bad day there's nothing like playing or cuddling with a cat to take your mind off whatever is bothering you. George does this thing when he wants to play where he jumps up at my legs when I'm walking down the hall as if he's going to attack me, and then runs and hides behind his box of toys in the living room. That's my cue to pull out his fake bird on a stick and whirl it around. He does crazy jumps and flips trying to catch it, and when he's done playing he takes the feathers in his mouth and struts off with the giant stick trailing behind him and tucks the toy in one of our shoes. We joke that he walks like a fashion model—he really swings his butt and sashays down the hall.

It was so heartbreaking watching Jack get sick, and because of it I've become an overprotective mom, always worried something is going to happen

to George. Sometimes I feel like he can sense my worry. Every night he follows me to bed and hops in, makes biscuits on our faux-fur blanket, and settles into the same spot next to me. Some nights George puts one paw on my arm before he falls asleep. It's as if he's saying, "Hey, don't worry so much, everything will be fine—I got you."

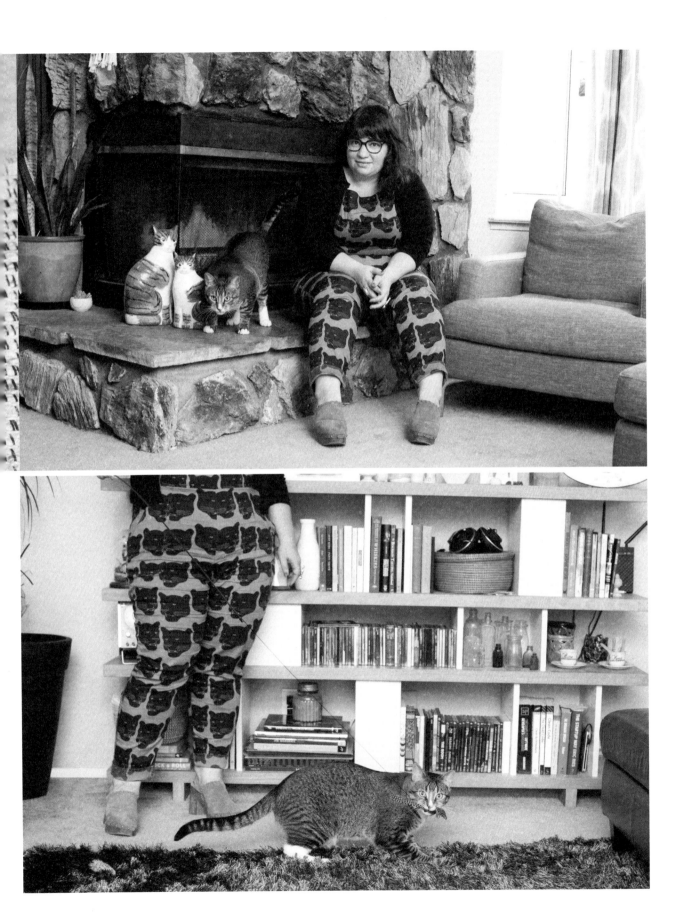

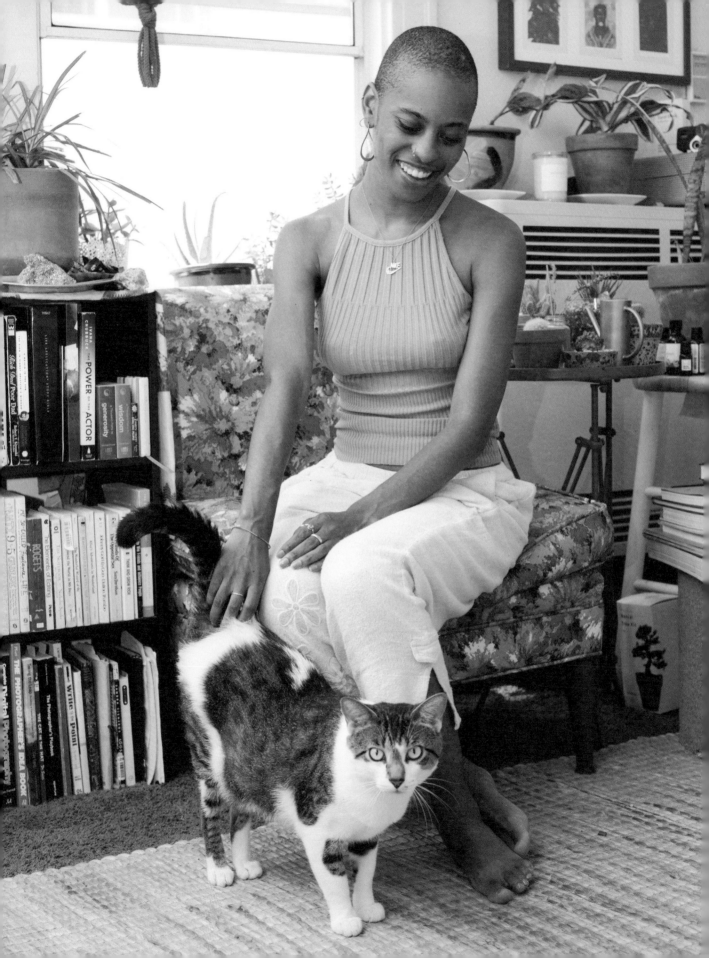

Rikki Wright

PHOTOGRAPHER
LOS ANGELES, CALIFORNIA

Cairo

TYPE
Tabby

NICKNAME
Cai

FAVORITE SNACK
Tuna

LIKES
A good scratch session

DISLIKES
When I put the toilet seat down

One day in 2013, a friend of mine posted a photo of her cat on Instagram, saying she was giving him away. I fell in love with that photo and instantly sent her a message to tell her I wanted him. We met up outside a Books-A-Million near where I went to school at Alabama A&M University, in Huntsville, and she brought Cairo to my car. My first thought was, *Wow, he's much bigger than I thought.* He was scared but warmed up pretty quickly.

I moved to Atlanta for work after I graduated, then I quit that job and moved to Miami so I could try to freelance for the first time. I really didn't enjoy living in Miami, so my then boyfriend and I moved to Los Angeles in 2016. Cairo made all those moves with me. He adjusted very quickly to each new environment, practically after one day.

I may not have liked Miami, but I think Cairo was happiest there. He's an indoor cat but loves watching all the action that goes down outside. There are so many stray cats on South Beach—the alleys are filled with them. Cairo had the time of his life running back and forth from window to window, talking to the stray cats and chasing birds.

There aren't as many stray cats in Hollywood, but I spend as much time as I can keeping Cairo busy and happy. He loves any game that involves hunting, and will play the mouse-on-a-string game for a good ten to fifteen minutes every other day or so. But he catches on after a while that it's a fake and loses interest.

He's definitely a cat who likes his space. I think moving around a lot, the way we have done, isn't the typical life of your average tabby. Luckily, most of my jobs are based in L.A. so I don't have to be away from home too often. But in the summer of 2017 I was away for two months and had a friend stay with him, and when I returned he honestly ran to me. I could tell he missed me.

We always greet each other when I leave and come back. Like, "Hey, what's been up with you?" And he lets out the cutest crybaby meow to make sure that his meals are right on time.

Cairo also pees in the toilet. I didn't actually train him to do it; he just started on his own. I was home alone one day and heard water running in the bathroom. I was so scared, thinking, *Who turned the water on?* Then I saw Cairo run out of the bathroom really fast. I went in after him, looked in the toilet, and saw pee in there. It surprised me at first. I didn't totally believe it until I witnessed it for myself. After that I became obsessed with YouTube videos of cats peeing in the toilet. There are a lot of special cats out there.

Cairo is my muse and my comforter. He's been with me during some very intense moments in life: graduating from college, transitioning into adulthood and real life, a lot of tears and relationships. He knows when to be right there.

Alyssa Mastromonaco

AUTHOR, CROOKED MEDIA PODCAST HOST, AND REPRODUCTIVE RIGHTS ACTIVIST
NEW YORK, NEW YORK

In 2005, I got my first cat: a Hurricane Katrina rescue named Shrummie. Shrum was a calico Persian, weighing in at twenty-three pounds. The first few days with Shrum were like living with a giant raccoon. I thought he was going to eat my face off. But he didn't. He became everyone's best friend, and he was with me until he was almost seventeen.

He got quite sick at fifteen, while I was working for President Obama in the White House. Everyone knew how much I loved Shrum, so they made sure to schedule meetings so that I could take an hour a day to go home and give him his meds. When he finally passed, people knew how devastated I was—even the president, who immediately called me from Air Force One. My phone rang, and it was a weird, long number. I thought it was a lawyer I was dealing with at work at the time, so I picked up. The Air Force One operator said, "Ms. Mastromonaco, this is Air Force One. We miss you up here. Do you have time for the president?" Then President Obama told me that as he was flying over Denali peak in Alaska, he was pretty sure he saw Shrummie's spirit float by.

I never thought I could replace Shrum. There is no replacing him. But those days after he passed were among the loneliest I have ever known. It was only about four weeks later that I asked my hubs to meet me at Bideawee Animal Rescue, because I saw this fuzzy guy online and thought he might need our help.

And that's when we got Petey. He had been rescued from a dog-hoarding situation, and was very scared. He was about six or seven years old. He slept and ate under the bed for months. When we moved into our condo, he lived behind the tub. But every night I would sit on the bathroom floor and hang out with him.

He's a special guy who had to have some teeth pulled and makes this cat fang face that rips us up every time he does it. We don't

Petey, Bunny & Midge

TYPE

All »	Persian

NICKNAMES

Petey »	Magoo, Bulgogi
Bunny »	Queen, Bun, Bundella (when she was an asshole)
Midge »	Midgie

FAVORITE SNACKS

Petey »	Any of my plants
Bunny »	Temptations
Midge »	Anything

LIKES

Petey »	Chin rubs and affection against his will
Bunny »	Her rainbow catnip kicker
Midge »	Everything, especially sitting on the windowsill

DISLIKES

Petey »	Noise
Bunny »	Not getting attention
Midge »	Being picked up

HUMAN ALTER EGO

Petey »	Bob Mueller
Bunny »	Zsa Zsa Gabor
Midge »	Michelle Wolf

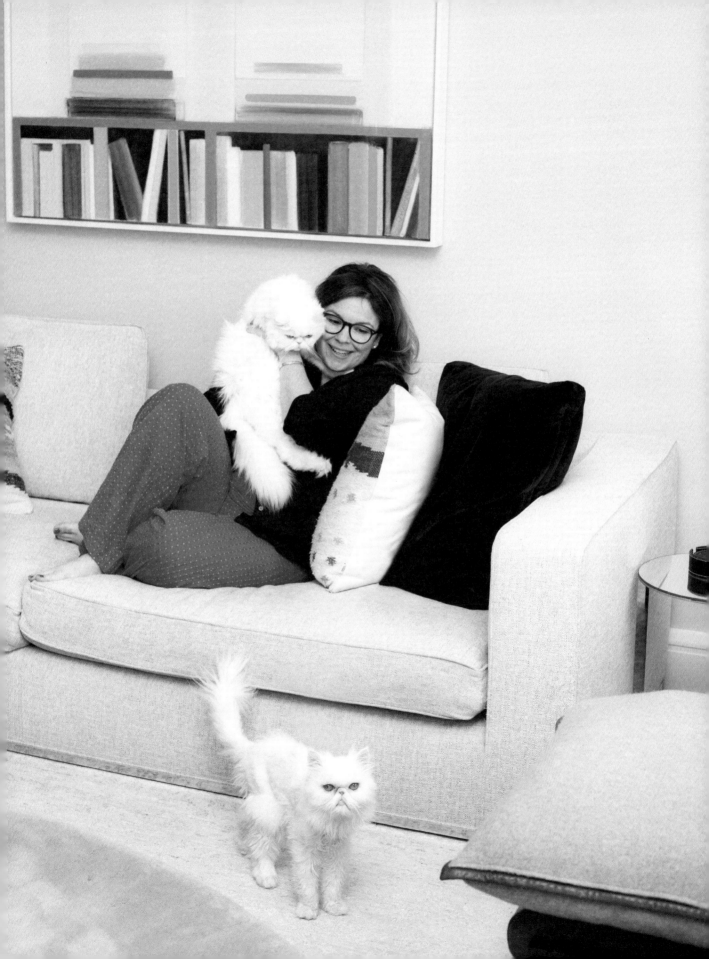

know if he knows he's doing it, but it's fun to think he's registering an opinion by showing the fang. He's a regal Q-Tip—his fur is like a white, round halo. One day I saw him on the windowsill, looking out the window and listening to a jackhammer, as calm and cool as can be, and I got teary thinking about how far he has come. He likes to get into cat-loaf position on our stomachs when we're trying to sleep, and lets me pick him up and smoosh his face. He runs like Secretariat.

When I was poking around online and found Petey, there was another kitty who caught my attention. Also a white Persian. Also one blue eye and one yellow-green eye. But Golden Paw Society said they didn't think she was ready to be adopted. Months later I got an email from them, asking if we were still interested. I had never had two cats but thought it was fate: Her name was Bunny, and it was Easter weekend when we brought her home.

Bunny is the Queen. She immediately took to Petey and all of the spots he had claimed for himself around the house. And he graciously yielded to his new little sis. She likes to sit close to you and stare at you upside-down to get a chin rub. She makes eye contact, and I am convinced that I can talk to her and she understands me. As soon as my alarm goes off (which is either "I Am Woman" or "Shut Up and Dance"), Bun jumps up on the bed and purrs in my face. And when Petey runs and Bun tries to follow, it's like an actual hopping bunny trying to keep up with Secretariat.

In 2018, we met Midge. She was a hot-ass mess. Again, rescued from an extremely bad situation. She weighed about four pounds, had no fur, and had a fang like Petey's because, as near as the vets could tell, someone had broken her jaw and it healed crooked. (She's not in any pain.) Midge is a lunatic. She's somewhere between three and five years old, and loves to play and follow Bun and Petey around. She's not unlike an eager middle schooler who wants to sit at the cool table. She grunts and snorts so loudly because of her jaw and smooshed nose. We all had to get used to it. It woke me up in the middle of the night for weeks. You cannot so much as open the fridge without turning around and finding her behind you. If she ever gets fat, I don't know how we will put her on a diet. She likes to head butt people. You will just be sitting on the couch, and she will get up on the arm and head-butt you. It's hilarious. She's named Midge after *The Marvelous Mrs.*

Maisel, because Midge Maisel took a lickin' and kept on ticking better than before.

I don't know what I would do without them. No matter how bad the day, when you see those Fuzzy Butts you can't help but laugh. And they are appreciative in their own way.

|||

A few days after these pictures were taken, Bunny passed away. She had been diagnosed with lung cancer a few months before. She also got pancreatitis. In the average animal it will clear up with a bland diet, but since she had just had chemo, we couldn't chance her becoming weak. That's why she's wearing a Kitty Kollar, to keep her feeding tube in place. She charmed all the doctors at Animal Medical Center, and handled her chemo like a goddamn dame. But Bun wasn't herself, and we promised she would go out the way she came in. So our vet came over, and Bun went to sleep on her favorite blanket on our bed, which was her favorite spot. I know she shared a roasted turkey leg with Shrum up in the sky when she got there.

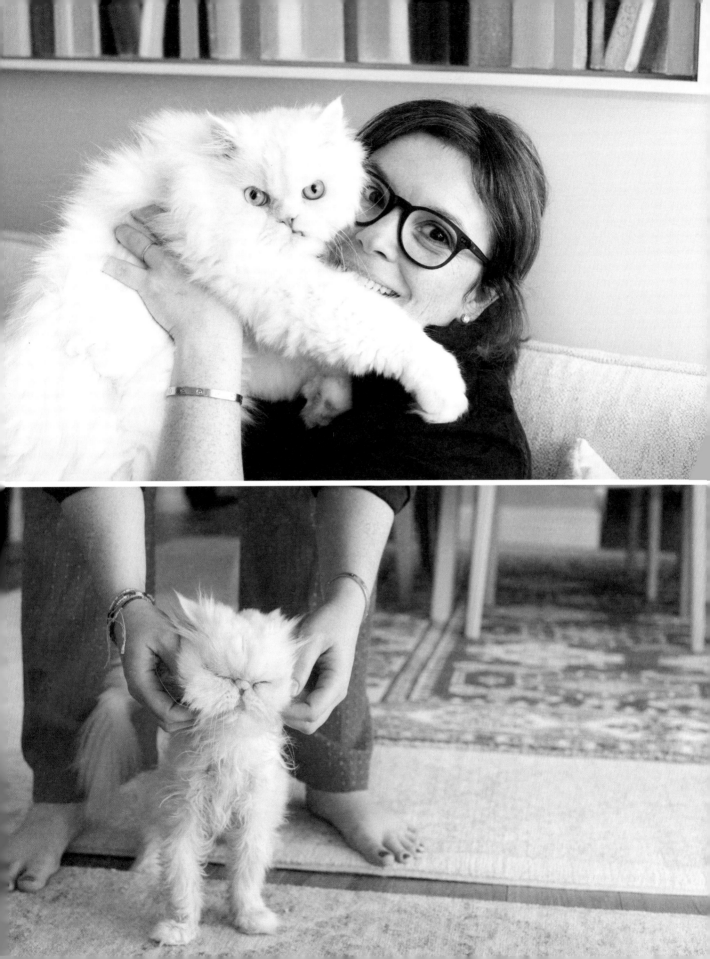

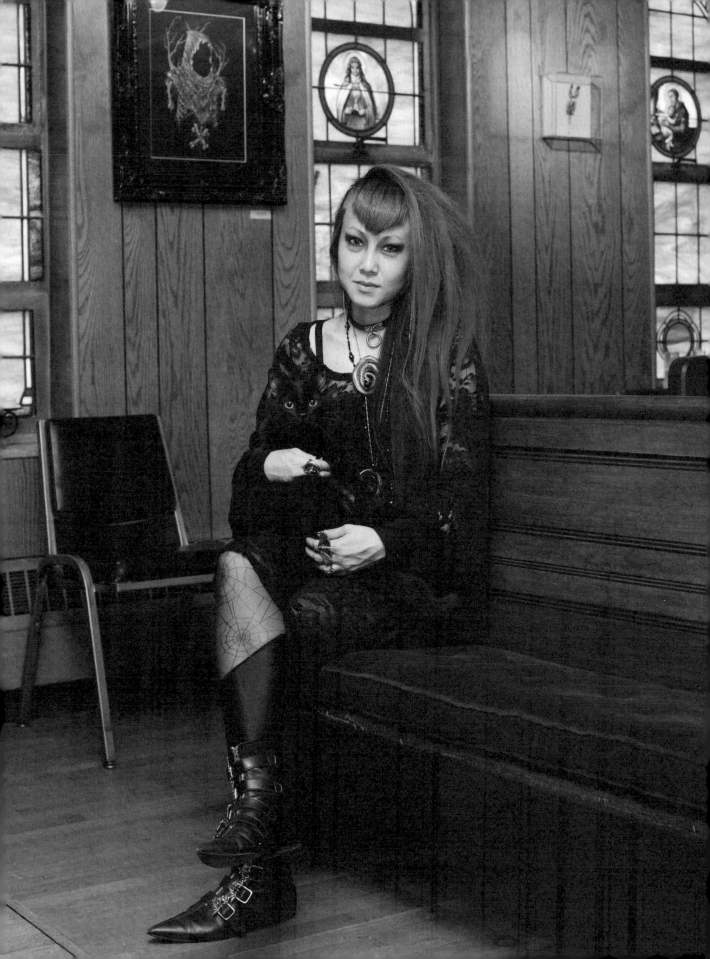

CAT LADIES ARE...

III

"Just ladies who prefer to stay home and hang out with their cats."

Sophi Reaptress

CLOTHING DESIGNER
PHILADELPHIA, PENNSYLVANIA

My partner, Jeremy, got Pogo for me as a surprise. We had just adopted our dog, Rocket, but Jeremy knew that I also wanted a cat. When some of his friends who live in Pittsburgh were passing through Philly, they secretly dropped off Pogo with him. I was working in my studio downstairs, where I do all my sewing, and Jeremy asked me to come upstairs. I saw a cat crate and some cat food but didn't suspect anything—I was convinced that we were not going to get a cat since we already had Rocket. I didn't even see the kitten inside the crate at first. Jeremy told me to look again, and I saw the cutest tiny kitten all the way in the back, looking a little scared. I couldn't believe it. I was so happy I cried.

I remember how cute it was when we introduced our pup to our kitten. Rocket had left his favorite gross toy, Mr. Squirrel (RIP), in the same room where we put Pogo. Of course, Mr. Squirrel also became Pogo's favorite toy. Rocket and Pogo sniffed each other under the door, and Pogo reached his claws underneath it, trying to play with Rocket. Eventually, we got comfortable enough to open up the door and let them run around together. Now they love each other like brothers. The funny thing is, Pogo is the tough one. He likes to hide by the door, so he can grab Rocket's butt when he comes into the house. But I've also caught them sleeping next to each other, and it melts my heart.

We live and work in a huge space called the Convent, where Jeremy curates art shows and events in a little chapel upstairs and I make clothing in my studio downstairs. Pogo comes down to hang out with me, and will either sit with me on top of my chair or sleep on the couch. He also loves to creep around and hide in the long fabrics on my clothing rack. It's all black, so he blends right in—you just see his two eyes staring out. He likes to hang out in the chapel, too. The old walnut pews have fancy red velvet cushions, and he stretches out on them like a king.

Pogo loves to make me jealous. He purposely loves Jeremy more than he loves me. When Jeremy is working on an illustration, Pogo finds a way to be on his lap or at least sit nearby. When we go to bed, Pogo sleeps on Jeremy's left arm, far away from me. Every once in a while, when Jeremy is away, Pogo may decide that it is okay to love me. I always tell him, "Oh, now you love me?" I still squeeze and kiss his cute face anyway.

Pogo

TYPE

Black domestic shorthair

NICKNAMES

Little Monster, Baby Vampire,
Little Jerk

FAVORITE SNACK

Anything

LIKES

Sunbathing, treats, face scratches

DISLIKES

Too much cuddling

Bonney Johnson

INTERIORS AND PRODUCT STYLIST
PORTLAND, OREGON

My husband, Lou, and I found Dora as a stray on the street near my mom's house in Hemet, California. She was malnourished and had mange, but she pranced right up to us. She knew she belonged with us. The vet told us her birthday was probably sometime in early July, so she and I celebrate together on mine, July 8. The way I see it, we're just a pair of scrappy Cancers from the same weird small town, tryin' to make it in the world.

When we first got her home, she didn't realize that we were going to keep feeding her every day, so she pounced on all of our meals. She once leapt over a laptop to try to eat some of my sandwich. She was able to drag a container of fries halfway across the room before I noticed.

Once she settled in, it became clear what a queen she is. She has taken over entire areas of the apartment. Shelves that used to house sweaters are now her afternoon nap spots. When we watch a movie, she sits in front of the TV and preens so we can better admire her beauty. She is very particular and never shy about showing us her feelings when things aren't up to her specifications.

Dora has been an indoor gal the entire time we've had her, but she still likes to hunt. She'll creep down to the basement and pull old socks out of Goodwill bags and display them at the bottom of the stairs. Sometimes we come down in the morning to find clothes we haven't seen in years scattered around our living room, and Dora, who could not be prouder.

In a lot of ways, Dora is the type of woman I admire. She is regal, but takes no shit. Earn her affection, and she goes all in. When I was pregnant with my son, she slept on my belly every night; sometimes she meowed to him. I was alone when I went into labor, and she refused to leave my side. Every time I moved, she followed me, and when I changed positions, she repositioned herself next to me. Just having her with me, showing that kind of blind compassion, made me feel so much calmer. I couldn't have done it without her.

We happened upon Abe at an adoption event. He was so playful and had the loudest purr I had ever heard. That's all it took. When he came home, he settled in right away. He spared no time letting us know he is a risk-taker. Once,

Dora & Abe

TYPE

Dora	»	Longhair tuxedo
Abe	»	Tabby

NICKNAMES

Dora	»	Dora Doll, Queen
Abe	»	Abey Baby (or, if our impressionable child is out of earshot, Big Fat Abe)

FAVORITE SNACK

Both	»	Any houseplant they can reach

LIKES

Dora	»	Milk-bottle caps, leaky faucets
Abe	»	Sunbeams, heating vents

DISLIKES

Dora	»	Most things
Abe	»	Closed doors

HUMAN ALTER EGO

Dora	»	Elizabeth Taylor in the White Diamonds commercials
Abe	»	Jimmy Buffett

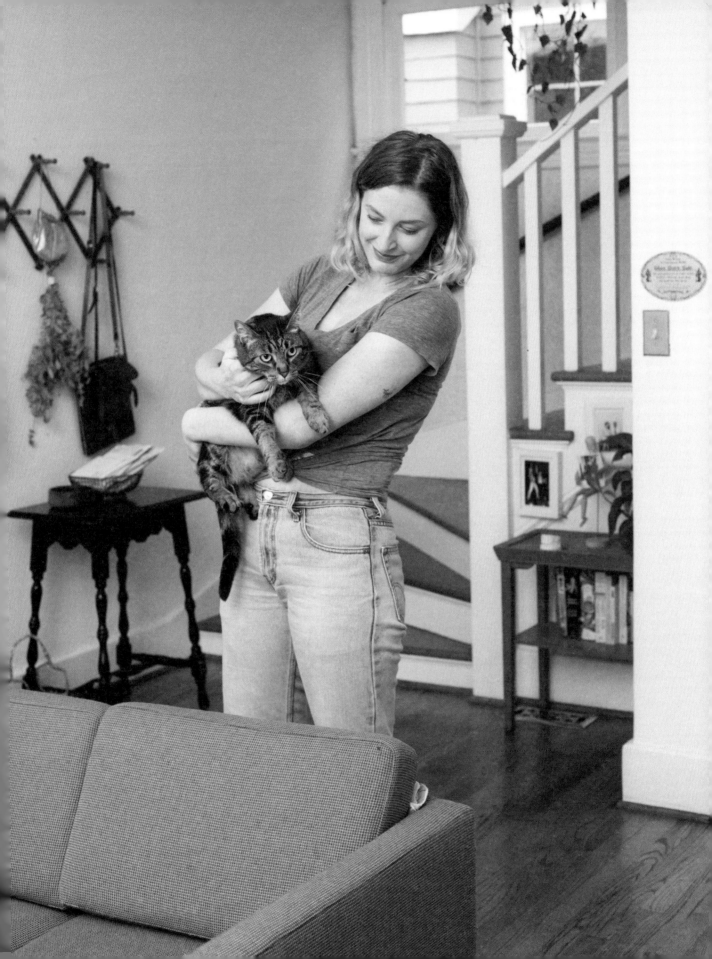

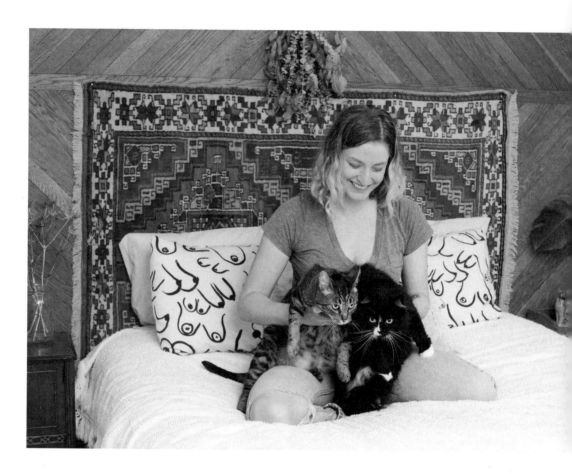

in a hotel room somewhere between San Francisco and Portland, he managed to (briefly) get stuck in the wall. One year we had to cut him out of our Christmas tree. He's got such an air of nonchalance and confidence; he seems as surprised as we do when he finds himself in these jams.

After our son was born, it was so interesting to watch Abe's personality shift. It was as if he knew this little human needed him. Abe is so patient with him. He never loses his cool when he gets hugged too hard. Our son calls him Abey Baby, and their bond is really clear. Seeing them together has made all the tomfoolery of Abe's younger days completely worth it.

Abe sleeps between Lou and me every night. Most nights he loudly meows in our ears to check if we want to wake up and play with him. He nibbles on our toes when the sun rises so we know it's time to feed him. He's a big guy, and he uses his weight to bust through any closed door.

Dora and Abe are both such troupers. They have gone through multiple long-distance moves and a new human addition to our family, and handled it all better than I could have asked them to. They are mostly roommates, not exactly friends. But they do have breakfast and dinner together every day, and eating is their shared hobby, so here's hoping.

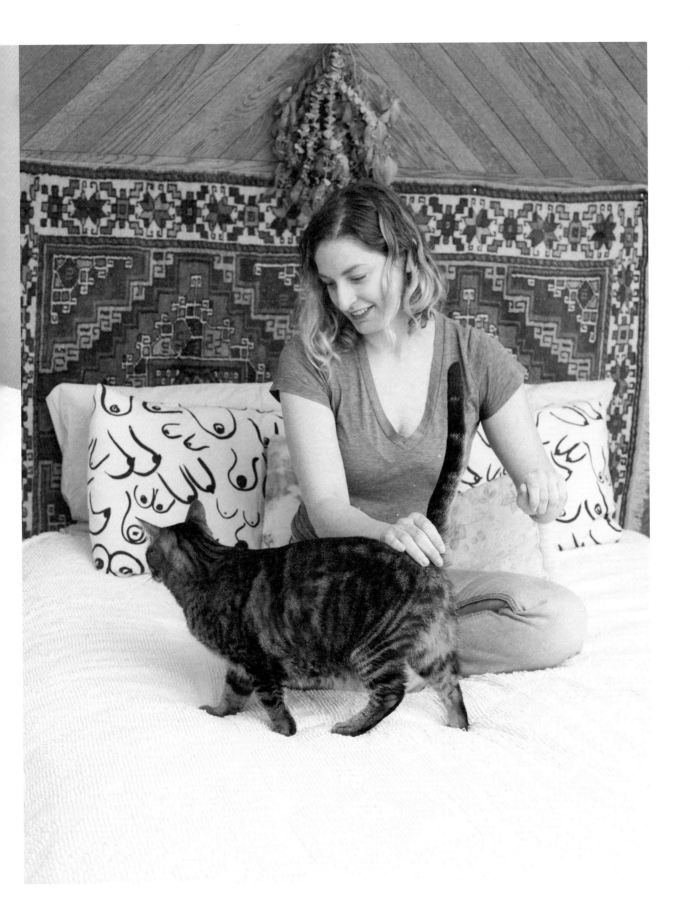

Jacqueline Mansky

JOURNALIST
WASHINGTON, DC

Buffy has big, doleful cat eyes that make her seem like she knows the world's troubles. She's a nervous cat, something I immediately softened to when I first saw her hunched in the back of a kennel on a snowy Valentine's Day three years ago. The local shelter was running a promotion for the holiday: Take home a cat for $14.

I had never had a cat before, but I had just moved to Washington, DC, into an apartment that allowed pets. If I didn't yet understand the particular mannerisms of cats, I rationalized that we were two lonely hearts who spoke a shared language of anxiety.

Buffy gets her name from the cult '90s TV show. It suits her well. She can be a scaredy-cat, but she knows how to defend herself if pressed, which strikes me as very brave. Sometimes I call her Cat, pronounced the way Audrey Hepburn does when she stretches out the syllables in that scene in the rain in *Breakfast at Tiffany's*. She also answers to Fluffy, which is what most strangers think I'm saying when I call her name, based on her coat, which has somehow found its way onto every single item in my wardrobe.

Before I got a cat, I assumed from my years of reading *Garfield* comic books that they spent most of their days napping and eating lasagna. While Buffy does enjoy napping the day away and has a strange penchant for spinach (which, if anyone understands, please let me know), one of her favorite things to do is snuggle on the couch with me. Coming in at a close second is jumping for string.

When I adopted Buffy, I didn't expect her to need me so much. When I come home, she waits for me at the door with an expectant "Meow," which I take to mean Where-is-my-food-scratch-me-behind-my-ears-where-have-you-been?

The longer I have her, the more confident I notice she becomes in her space. That has been the most gratifying thing to watch. She's still my worried cat, but she's not as quick to flee anymore—she'll just stand there and pant nervously instead. Now she mostly asserts her needs. If I'm on my laptop working and she wants my attention, she head-butts me or walks over the keyboard, which is exactly what a cat should do.

Buffy

TYPE

Unclear, potentially part Maine coon

NICKNAMES

Cat, Buff, Fluff, Princess, Puppy, Rabbit, Otter, Owl, Pig, Wolf, Baby (Bb)

FAVORITE SNACK

The occasional lox trimming—she's a good Jewish cat

LIKES

String, flowers, dipping her paws into cups of water

DISLIKES

Baths, blue jays

HUMAN ALTER EGO

Sarah Michelle Gellar

Laura O'Neill

**COFOUNDER OF VAN LEEUWEN ARTISAN
ICE CREAM AND CO-OWNER OF THE
BROOKLYN RESTAURANT SELAMAT PAGI**
LOS ANGELES, CALIFORNIA

Gypsy arrived unexpectedly in the winter of 2008, a year after I moved from Melbourne, Australia, to New York City. I was living with my then boyfriend, Ben Van Leeuwen, and his brother, Pete—my business partners—in Greenpoint, Brooklyn. Pete's girlfriend at the time found a tiny kitten walking around Chinatown in the snow, scooped her up, and brought her home. She really wanted to keep the kitten, but her roommate was allergic, so she brought her over to our apartment.

Gypsy was so tiny and sweet. Back then she would sleep on my pillow next to my face, and I would zip her into my jacket and bring her on walks to McCarren Park. I remember choosing to stay in and play with her many nights rather than go out. From almost day one she was obsessed with the outdoors and would stare out the window, meowing to be let out. Eventually we gave in and let her have supervised playtime in the backyard. She liked nestling in piles of leaves and stretching out in the sun.

She was the house cat, but Ben and I were very much her parents, so when we got married and moved out later that year, she moved with us a few blocks over. We had a backyard there, too, and we spent an entire day putting up a bamboo fence so that she wouldn't be able to go too far. The minute we opened the door, she ran right out and scaled it. There was an indoor-only cat in the apartment next door, and Gypsy was infatuated with him. Once, when we opened our apartment doors at the same time, Gypsy ran in the neighbors' door to get him. Our apartment also acted as the Van Leeuwen office for many years, and Gypsy really honed her secretarial skills there. If the file cabinet was ever left open, she'd jump up on the drawer and frantically rummage through the files. Anything coming out of the printer was equally fascinating to her.

Gypsy

TYPE
Tabby

NICKNAMES
Chimpin, Chimpy, The Chimp, Chimpin Zelda, Zelda, Chimpioto, Champagne

FAVORITE SNACKS
Vegemite, the almond milk left at the bottom of a cereal bowl

LIKES
Having her ears rubbed, sleeping in a drawer

DISLIKES
Pâté-style wet food, unless it's hand fed; vacuums

HUMAN ALTER EGO
We joke that she wishes she were a dog.

When Ben and I split up in 2011, I thought leaving her with him would be the best thing—rehoming her again seemed mean. But after talking to a friend who said, "Fuck that, she's your only family here—you gotta take her with you," Gypsy and I moved into a new home in Greenpoint, just the two of us. She slept on the bed every night, sometimes under the covers with her head on the pillow.

I met my current partner, Greg, in 2013, and he pretty much moved in

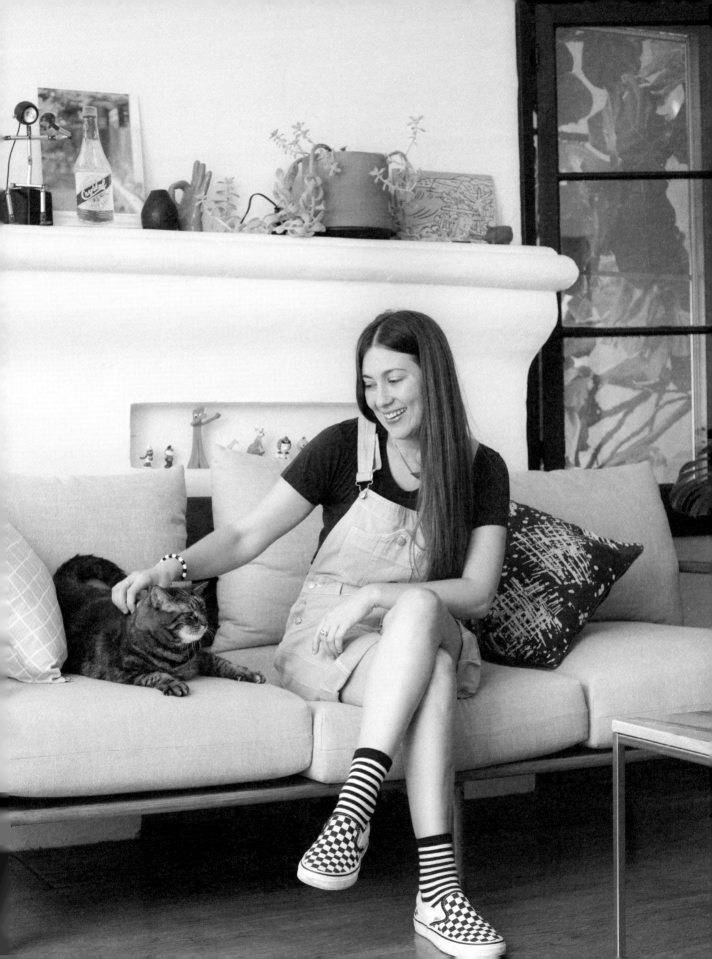

right away. He loves Gypsy—she probably contributed to my allure. We started calling her Chimpin for some reason, and it really stuck. We almost never call her Gypsy anymore, and most of our friends now know her as Chimpin or Chimpy. Greg is an animator and works from home, so he and Gypsy became really close. Gypsy started to get pretty plump having someone around all the time to spoil her. And Greg got a huge heart tattoo with "CHIMPIN" written inside.

In 2017, we moved to L.A. Gypsy had to become an indoor-only cat since it's too risky here with coyotes. We tried walking her with a harness and lead, but she didn't really like it. I thought she might be miserable indoors, but she's really happy. We have tons of plants and big windows to look out and lots of great, sunny spots where she can nap the day away, and, most important, she's with her favorite humans who love her so much. Ben sees her when he comes out to L.A., and I send him lots of pictures.

Gypsy is the first cat I've ever had. I never knew how obsessed I could become with a pet. She's so affectionate and funny and weird. When we lived in Greenpoint, we had a watercooler and she learned how to stand up, hold the spigot, and drink from the stream. Now she drinks only from a glass in the hallway that she thinks is Greg's. I have a special, high-pitched call that makes Gypsy stop what she's doing, race over to me, and push her head into my face. I don't know if she thinks I'm in distress when I do it or what, but it's really sweet. Greg has tried the call, but he can't quite get the pitch. Gypsy has definitely mellowed over the years, but she still goes wild sometimes and races around the house. We also play a game where we walk around calling her name and pretending we can't see her. She follows us and jumps up on the tables, attempting to get in our line of sight. One time she went and looked in the mirror, I think to see if she was still there.

Greg and I talk about getting another kitten sometimes, but we are worried it might change Gypsy. I also fear we may never have another cat as awesome as she is. She has been the most constant thing in my life in America, and I am so grateful for all her love and for being by my side through some of the hardest times and some of the most wonderful.

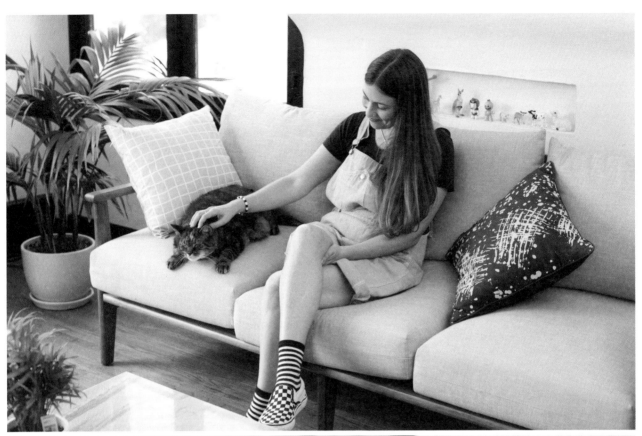
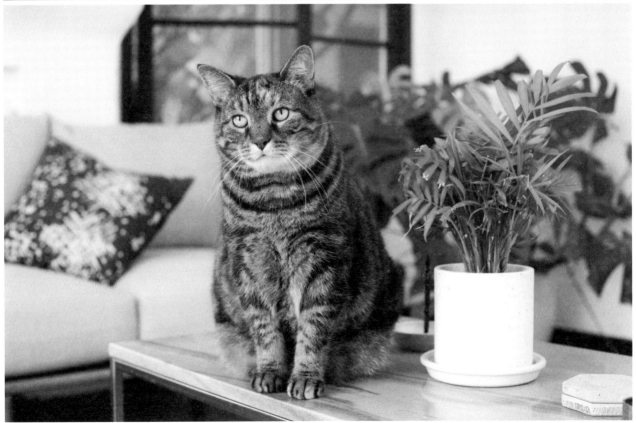

YOU KNOW

YOU'RE
A CAT LADY
WHEN...

1. Your cat has her own Instagram account—and **MORE FOLLOWERS** than you do.

2. You've **REARRANGED** your living room to give her better bird- and people-watching perches.

3. You've been **LATE** to work, skipped the gym, or canceled plans because your cat decided she wanted to cuddle and you couldn't pull yourself away.

4. You hear a great name and add it to your list of potential **FUTURE CAT NAMES**.

5. When your **FAVORITE SONG** comes on Spotify, your cat comes out of hiding, tail held high.

6. You've "favorited" all **THE BEST** cat-collar, bed, and custom pet furniture vendors on Etsy.

7. You have **LINT ROLLERS** in your dresser drawer, by the front door, on your desk, and in your purse.

8. You've **HUDDLED** through more than one blizzard/blackout/breakup together.

9. Everyone who visits you—even the takeout guy—**KNOWS HER NAME**.

10. Your relationship has **INSPIRED** one (or more) friends to adopt one (or more), too.

CAT LADIES ARE...
✳

"People who have a cosmic relationship with the animal world
and aren't afraid to cross into that space."

Maria Hinojosa

**ANCHOR AND EXECUTIVE
PRODUCER OF NPR'S *LATINO USA*
NEW YORK, NEW YORK**

There is such a profound joy in the human-animal connection, and it goes into the spirit world. The way I see my cats is that they are almost like little spiritual beings in my midst.

Miko is the playful boy of the family. He's four, and he's always jumping around and chasing things. His favorite thing is to be a baseball catcher: He likes to catch rolled-up pieces of paper or little snacks. If he doesn't catch them, he's not interested, which I think is very funny. He makes me laugh because he's so ridiculously silly. Miko barely has a voice—he barely meows—but when he does, it's such a little thing, which is adorable since he's so big. He's my sleeping partner. He sleeps right next to me or at the foot of my bed. People usually move around when we sleep, but once Miko gets into position, he will sleep in that position for eight hours and not move until I wake up at five.

At thirteen years old, Safiya is the older girl of the family. She's really my husband's cat. They have a very deep, profound, loving relationship. When I'm away on travel, she's his trusty partner. Although she never had kittens, she is like a mom because she's more predictable. I have a little bit of an allergy to Safiya, so I have to be very careful as to when I pet her. But she meets me at the door when I come in, and has actually learned to do a few tricks for me. She kisses me on the nose when I say, "*Beso, beso.*" She also gives me high fives, and she shakes hands. I've never had another cat who was trained to do anything, but Safiya actually does those things.

Now that my husband and I are empty nesters, our cats play a much more important part in our lives. They're our break from regular life. We play with them and set up things to keep them entertained. It feels like a release, taking us back to a simpler time when we had small children running around the house. It's a very real dynamic that keeps us feeling like we're the parents of toddlers.

I feel like my cats keep me connected to this world, and to a world beyond.

Miko & Safiya

TYPE

Miko »	Tuxedo
Safiya »	Calico

NICKNAMES

Miko »	Mikolin, Mikos
Safiya »	Safi

FAVORITE SNACKS

Both »	Anything that rolls, catnip

LIKES

Miko »	Generally everything
Safiya »	Getting brushed, pretending she's catching birds on our fire-escape bird feeder

DISLIKES

Miko »	Nothing
Safiya »	Being seen, having to show her face to company, generally everything

HUMAN ALTER EGO

Miko »	Brad Pitt
Safiya »	A lonely drama queen who is in love with her father

CAT LADIES ARE...

✳

"As unique as their cats and without fail love
to talk about their cats with other cat ladies."

Nikki Garcia

**OWNER AND DESIGNER OF
THE CLOTHING LINE FIRST RITE
SAN FRANCISCO, CALIFORNIA**

Bill

TYPE
Mix

FAVORITE SNACK
Yogurt, cheese, ice cream

LIKES
Head rubs, catnip, rugs, men,
birdwatching, watching the panda
cam, paper bags

DISLIKES
Babies and small children, vacuum
cleaners, aluminum foil

I found Bill at a neighbor's outdoor party while I was in college in Missoula, Montana. Another friend's dog was chasing this tiny, scraggly kitten. She kept coming back, and we were finally able to grab her and take her to my apartment—more in an attempt to rescue her from the dog than as part of a plan to keep her. She was so tiny and sad looking, with infections in both eyes. Truthfully, I had wanted a cat but thought she was in bad shape and maybe was not the one to keep. I held onto her while we figured out if anyone wanted to adopt her, and brought her to the vet a couple of days later to treat her eyes. Over the course of the week, as she healed and became more comfortable with me, I decided that I loved her.

I have had Bill for fifteen years now, and she has moved with me into nine different apartments and homes, in Montana, Portland, and, for the past twelve years, San Francisco. She has had very different parameters in each of these places that have brought out different parts of her personality, and she has always been very adaptable to change. In Montana, she roamed the wilderness that bordered our home and came inside only to eat and sleep. A friend claims to have seen her jump off the roof of my two-story house and land on her feet, even though I once had to recruit another friend to rescue her from a very tall tree in the front yard. We now live in a pretty dense area, so getting outdoors is not quite as easy. Becoming an indoor cat brought out her grumpier side for sure. It was really hard to see her beg to go out at first, and it must have been a huge, confusing shock after so much freedom. Eventually she eased into lots of window-ledge and sunny-spot lounging and birdwatching. For a couple of years, there was a neighborhood cat who climbed onto our window ledge every day so that they could just sit and gaze at each other, face to face. I think they were in love, but every time I opened the door the other cat ran away. Now that Bill is older and can't jump over the fence anymore, she goes in and out every day for very short periods of time when she chooses, and it seems to make her a happier cat.

I moved my studio into my home a couple of years ago, so our lives and routines have definitely been more synched up lately. I feed her before I do anything else each morning. After my morning workout, she rolls around alongside me while I stretch on my mat. She's pretty good about boundaries and knows she cannot come into my studio,

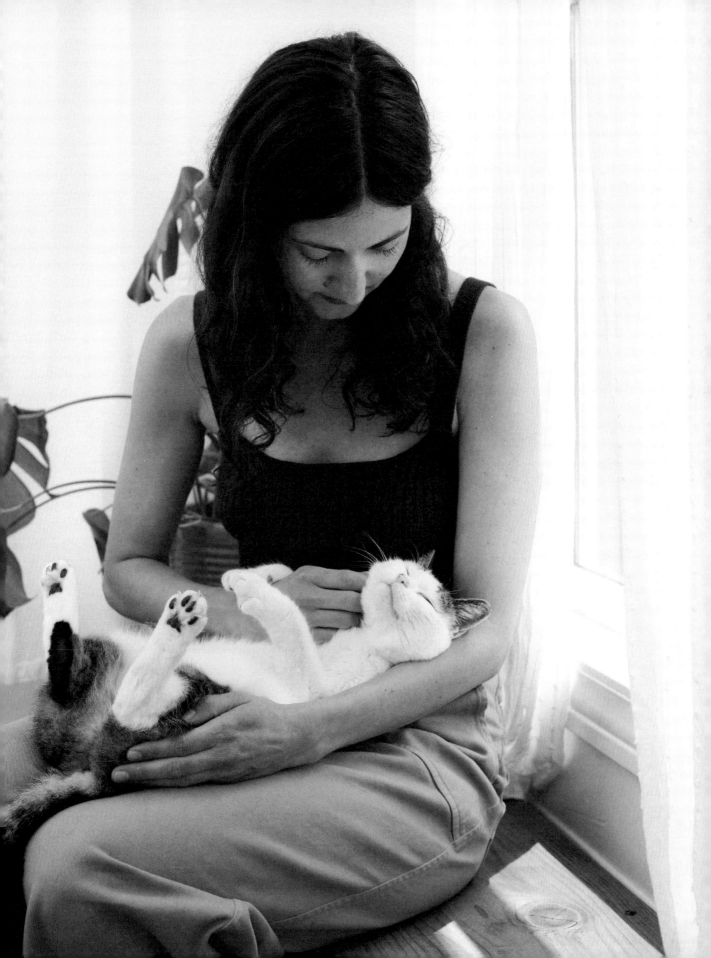

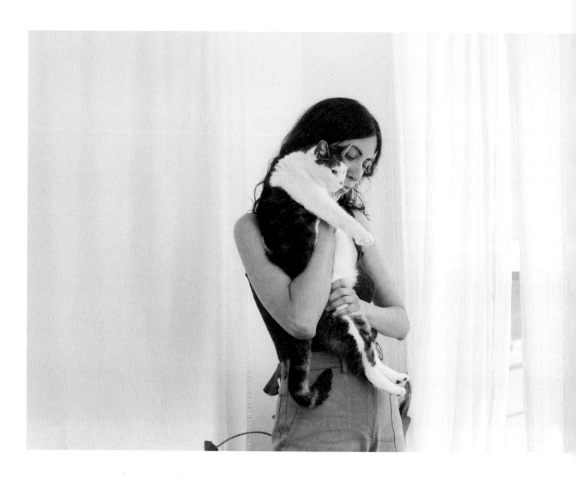

but she lies at the door to watch me while I work. If she's not snoozing deeply somewhere, she follows me from room to room and cozies up by me in the office while I am at the computer. She has her favorite spots around the house, but they change every few weeks or so. She will live in an armchair every day for a month, then won't jump on it again for the next month.

Bill can be very social with people she senses are into her, but she is good at feeling out her audience to know who is going to want to pet her. (My boyfriend is the exception. He's not a cat person, but she just never gives up on him.) She does this funny thing when people are around where she acts really interested in something she has never seemed to care about, like exploring a cupboard or dragging out some long-ignored toy. We have a joke that she's trying to impress guests by saying, "Look how interesting my life is— look at all my things." She seems to be more drawn to men than women, something I believe is related to an old college boyfriend of mine who showered her with attention.

Bill knows exactly when it's mealtime and will not let you forget it. She hangs in the kitchen like a dog when you are cooking and stands under the cutting board, waiting for bits to drop.

Sometimes you won't see her for a while, and then, out of nowhere, she will tear through the room at full speed. I think she does it just for the element of surprise.

I had cats as a kid and have always loved cats in general (I had subscriptions to *Cat Fancy* and *Cat*), but Bill and I have really grown up together. She has been with me since I was twenty, as I tried to figure out and navigate adulthood. I once heard a researcher present a hypothesis on an NPR show about how cats see us in relation to themselves, and one of the theories was that cats think we are just other, much larger cats. Of all the suggestions, I liked that one best. Bill definitely knows I am the boss, but I like to picture her looking at me, thinking that we are the same.

CAT LADIES ARE...

*

"Playful and dreamy."

Emily Katz

ARTIST AND FOUNDER OF MODERN MACRAMÉ
PORTLAND, OREGON

Cowbear is an ancient love bug. My sweetie, Adam, adopted her from our friend Melanie. One day in the late 1990s, Melanie spotted her hanging out on the street in inner Northeast Portland. A scrawny tuxedo cat, Cowbear followed Melanie home three days in a row. On the third day, Melanie took her in, fed her, and gave her some love. Over the course of three more days, Cowbear ate all the cat food in the house (there were three other cats living there), and when Melanie came home from work one night, she discovered that Cowbear had given birth to kittens on a pile of laundry in the closet.

That was at least sixteen years ago. We always get the year Adam brought her home mixed up. Cowbear might be eighteen, sometimes we say twenty—we don't know for sure. But she is a fierce outdoor-indoor cat who likes to stay out all night and patrol the neighborhood.

One of my favorite things about her is she knows just where to curl up. She purrs loudly on my chest or climbs up on my back—it feels like a mini massage. She also joins in when we take our dog, Donut, for a nightly walk around the block. And she comes when she is called, more so than the dog sometimes.

We host people in our home via Airbnb, and Cowbear is the best greeter. One guest laughed and joked that she was actually the host, because she showed them where the bedroom was, where her food bowl was, and how best to scratch her behind the ears. She can often be found curled up on the guest bed.

People always ask me about how it works being a fiber artist, mainly working with rope and string, and having a cat. "Doesn't she play with the rope all the time?" When I first started my business, I worked out of a guest room in our home. But Cowbear really isn't interested in toys or string, so I'm lucky—my macramé gets off unharmed. I have an office

Cowbear

TYPE

Tuxedo

NICKNAMES

Meowbear, Meowsatron9000

FAVORITE SNACK

Catnip

LIKES

Letting us know that she wants to come into the room and then going right back out again, eating wet food, getting her head scratched

DISLIKES

Too much attention, getting picked up

now, but when I come home from a long day, she is always waiting at the front door with a mouthful of meows, ready to be fed and loved.

Sam Ushiro

FOUNDER OF THE DIY/LIFESTYLE WEBSITE AWW SAM
BROOKLYN, NEW YORK

Let me tell you about my cat, Sabbath. Sabbath is one of my best friends, and a total character. She's as black as the sky on a moonless winter night, with deep yellow-green eyes that remind me of lush forest ferns. She is a total sass pants, and can be as feisty and hot-headed as a jalapeño pepper. She knows how to strut her stuff, and she is packing in the booty department.

Sabbath came into my life when I met my fiancé, Kyle, for the first time. He shared a room with her in an apartment with four other guys in Brooklyn. She was one of a litter of five that Kyle's roommate's friend's cat had given birth to, and one of the last to be adopted. I generally don't enjoy being around animals, as it upsets my allergies and I used to be more of a fish person than a dog or cat person, but that didn't bother Sabbath at all. She immediately took to ruining my shoes and showing me that she was in charge. Normally I am the one in charge, as I run my own business. I was shocked to be bossed around by her, but I quickly realized she was like that with everyone.

After a little bit of time getting to know me, she started to warm up to me. Our first real bonding experience was when I had to take her to the vet for her first checkup. She wasn't too happy to be there. I'd never seen a cat hiss so much, at everything in the vet's office: dogs, other cats, staff. After that harrowing experience, I think we really got closer, and it wasn't much later that she moved in with me. We spent all day writing emails and watching trashy reality TV until Kyle got home, and I think that was when I started to really love her company. Up until that point, it had been a struggle to get her to acclimate to the new living situation, and for me to handle my allergies being terrible 24/7. Despite the fact that she has her own room in our apartment, she still likes everyone to know that she is what's most important.

I had never considered having a cat before and, honestly, I still wouldn't, because the only cat for me is Sabbath. Nowadays she's an integral part of my daily routine, which includes five minutes of petting

Sabbath

TYPE
Unknown/tabby mix

NICKNAMES
Sabby, Babushka

FAVORITE SNACKS
Almond milk, chicken-flavored dental treats

LIKES
Being left alone, ear scratches, neck massages

DISLIKES
Being left alone, being touched or held, loud noises

HUMAN ALTER EGO
Danny DeVito

in the morning before breakfast and at least fifteen minutes of playtime before bed. We like to spend at least ten minutes during the day watching birds outside the window, and, when we get our way, at least eighteen hours a day asleep.

Sabbath started off being quite sassy, constantly scratching the couch; jumping on the fridge, counters, and tables; and generally just being in the way all the time, the way cats are. She has gradually settled down, but at any time she is likely to be hiding behind a chair, waiting to ambush her true enemies: your ankles

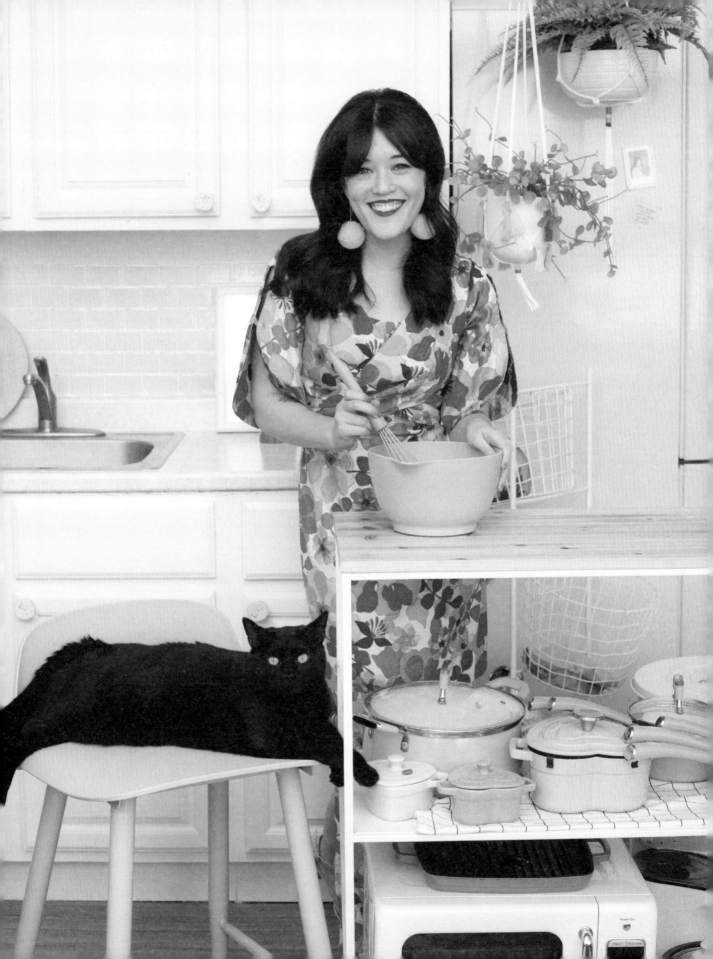

and the vacuum cleaner. We have trained her not to be quite so harmful to our belongings, but she sometimes likes to scratch the couch just to remind us that she's the boss.

Her personality and antics can be truly bizarre. One of her favorite ways to exercise is to use her scratching post as a pole that she swings around on. Then there's the fact that she doesn't meow or purr; instead she makes what we call goblin noises. She talks back when she is being scolded, like a rebellious teenager, and will sometimes say "Sorry" when she has been bad, in an attempt to avoid being sent to time-out.

I think I see a lot of my own traits in Sabbath. We are both determined to get what we want, bold when we need to be, and coy when it's necessary. She isn't a big socialite, and neither am I. We both prefer a rainy day indoors watching Netflix and napping to a party where we have to interact with more than two people. My favorite thing to tell people is how she has her own special chair in the living room where she sits and watches everything, like a queen on her throne, keeping the court in order.

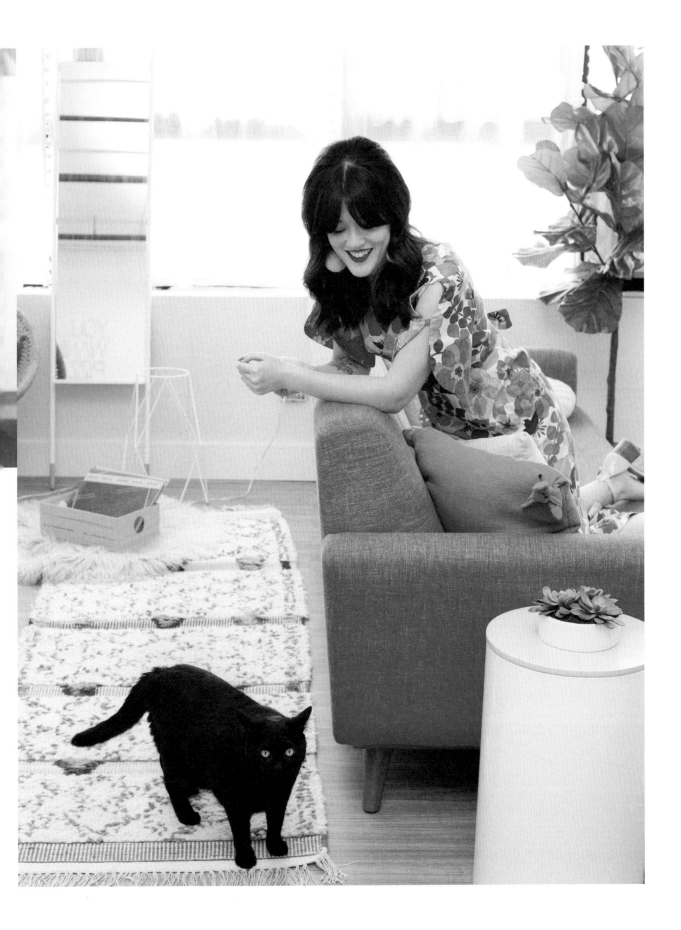

Lauren Leavell

BARRE INSTRUCTOR, EVENT COORDINATOR, AND NANNY
PHILADELPHIA, PENNSYLVANIA

Doo Doo and I met in the summer of 2013. I had just moved from Los Angeles to Philadelphia to be with my long-distance boyfriend. Aside from him, I did not know a soul on the East Coast. At my college transfer student orientation, I sat next to a girl who told me about two kittens she was fostering for the Animal Care & Control Team of Philadelphia (ACCT Philly). She invited me over, and I jumped at the chance to make a friend and see kittens. (Duh.)

When we got to her apartment, only one kitten was out and playing. The other was shy and hiding under the bed. My boyfriend came to pick me up, and I begged him to come up and see the cats. He is severely allergic, but he obliged. When he sat down, the shy one came out from under the bed and crawled into his lap. We left without talking about getting a cat because his allergies made it impossible. Two days later was our one-year anniversary and the adoption day for the kittens. I woke up and all I wanted was that cat. So he did what any amazing partner would do: He drove me to the animal shelter to pick her up.

Doo Doo is the first cat who has ever been mine, and I feel like a first-time mother. Doo Doo is short and stout, and has a small head for her body (but I would never tell her that). She is extremely vocal, especially when it comes to birdwatching and whenever someone sneezes. Everything she does is the funniest and cutest and smartest. She sleeps with a T-Rex Pillow Pet my grandmother gave me in her bed—a giant Power Greens box from Costco—and licks his head often. Doodie is the perfect alarm clock. She jumps on the bed and starts her motor to wake me up. We cuddle for about twenty minutes every morning.

Doo Doo has that keen emotional sensor most cats have. I don't think I have ever had to be sick or sad by myself since we met. She always finds me and curls up on my lap or sits close to me, even if that

Doo Doo

TYPE
Tabby mix, potentially part Bengal

NICKNAMES
Doodie, Doo Berry Pie, Paprika

FAVORITE SNACK
Ben & Jerry's Chunky Monkey ice cream

LIKES
String, darting between feet, sunning herself, being stretched

DISLIKES
The vacuum, being touched with a foot, a closed box

means she comes into the bathroom. She helped me through finals, wedding planning, a job I hated, the decision to quit the job I hated, multiple bouts of the stomach flu, you name it.

Lately, she has been having some skin issues. We took her to the vet, and they told us it is anxiety, which I can totally relate to. It is funny that the one who has helped me manage my anxiety and adjust to life on the other side of the country now has anxiety. I will do just about anything to make her feel safe and secure. She is my baby, my Doo Doo. She is my pride and joy.

Jess Hannah

JEWELRY DESIGNER
LOS ANGELES, CALIFORNIA

My two kitties are the jewels of my life. Like most cat people, I struggle to keep a lid on how much I talk about my pets, because I tend to bubble over. Until Olive, aka Ollie, I was a dog person. I grew up with a corgi named Corky and an Australian shepherd/Lab/who-knows mix named Wishbone (RIP). My parents still have three dogs, and I have one, Ruby, a husky mix—my other jewel. I wouldn't say that becoming a cat owner has completely converted me, but I definitely fell in love with the feline way.

Olive is my sweet baby angel, my firstborn, the apple of my eye. When I was in college, I begged my partner, Tyler, to let me get a kitten. He and my roommates adamantly refused. Little did I know this was part of a scheme. I had a birthday coming up, and on the day of I was just hanging out at home since I'm not really a birthday person. Tyler came in with baby Ollie, and I started crying. She was wearing a ribbon around her neck. Two years ago on our anniversary we were just watching TV in bed, and Tyler brought Ollie in with a ribbon around her neck. Tied to it was the engagement ring he had adamantly refused to buy me.

As for Remy, she was one of a bunch of kitties found in an alley next to a friend's partner's former work building. The company was going to "get rid of them." This couple saved them and found homes for all of them. Remy was the last one, and we adopted her.

Each of our animals has her own distinct voice. We joke that Ollie has a comprehension problem, so she often mispronounces things. We have a speaker called an Aether Cone, but Ollie thinks it's a person named Ethan Cohen. She also thinks that filet mignon is Phillip Mig-Non, and that the name Jacques is pronounced "*jah-kwess.*" She is also very confused about her species, since her best friend in kittenhood was my college roommate's pitbull. Now Ollie talks to Ruby as though they are both dogs, especially when she's making fun of Remy.

Olive & Remington

TYPE

Olive »	Tabby
Remy »	Black cat

NICKNAMES

Olive »	Ollie, Trolley, Polly, Pauline, Olaf, Squanch, Olive Newton-John
Remy »	Remberly, Rem Koolhaus, Crème Brûlée, Kremlin, Crumb, Rembert, Remulous, Remy Revesz

FAVORITE SNACK

Olive »	Canned tuna
Remy »	Dog treats

LIKES

Olive »	Meowing at me when I'm on the phone because she thinks I'm talking to her
Remy »	Exploring the yard, hunting insects, spending time in the closet among my sweaters

DISLIKES

Olive »	Being left out
Remy »	Uninvited cuddles

HUMAN ALTER EGO

Olive »	The Childlike Empress from *The NeverEnding Story*
Remy »	Tara Reid

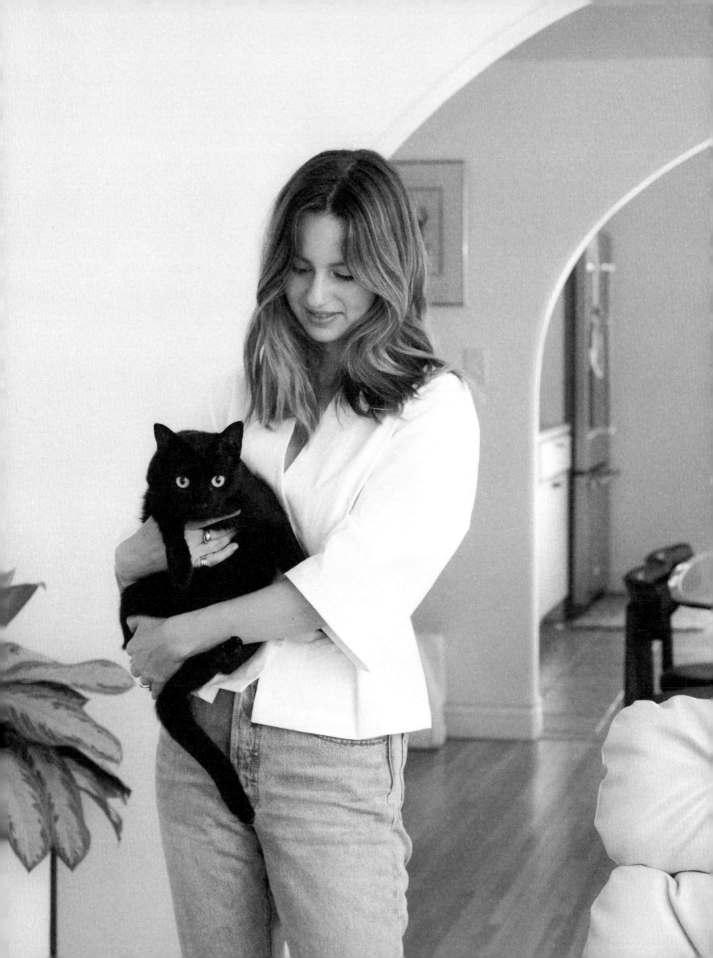

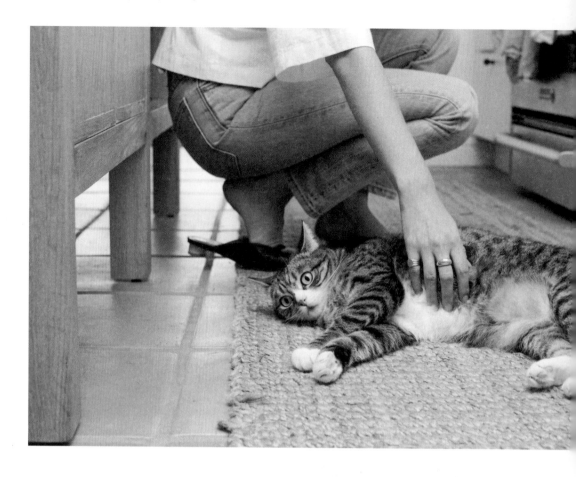

"Us dogs . . ." or "Maybe we should do something just us dogs." She is highly intelligent and trainable like a dog, though. We taught her to sit and shake.

Remy is your more catlike cat: autonomous and, in the rare moment when she does decide to cuddle, very aggressive, throwing her butthole in your face. The only things Remy ever says are "I love trash" and "Make it look sexy." We joke about how she leaves at night; she recently realized that she can hop over the backyard wall, and we are pretty sure she has a boyfriend. She's kind of like your typical rebellious teen who prefers being alone and refuses to shower. "Make it look sexy" comes from the Kendrick Lamar song "Element." When Remy is lounging, she assumes a paint-me-like-one-of-your-French-girls pose and often flashes a nipple or arranges her legs just so. She'll be on the kitchen island (where she is not allowed) and justifies it by cooing, "Make it look sexy."

The cats aren't allowed to sleep in the bed anymore because I'm allergic to them. My allergist thought I was crazy when I told her that I didn't want to sacrifice this simple pleasure, but she won the battle in the end. Every morning I wake to them meowing at my door, and when I open it we scream, "Kitty Stoorrm!" and they bust in, fiending for attention.

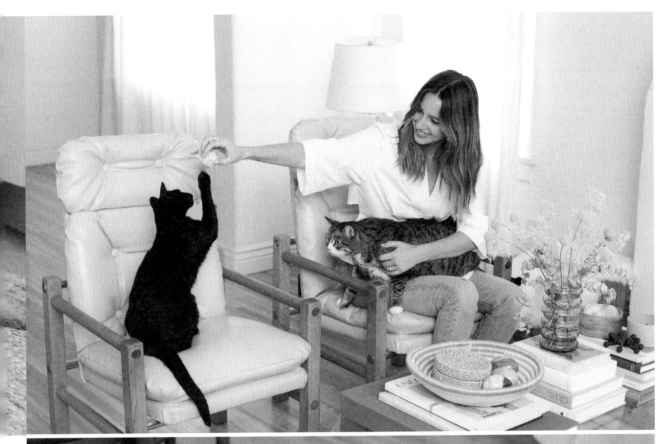
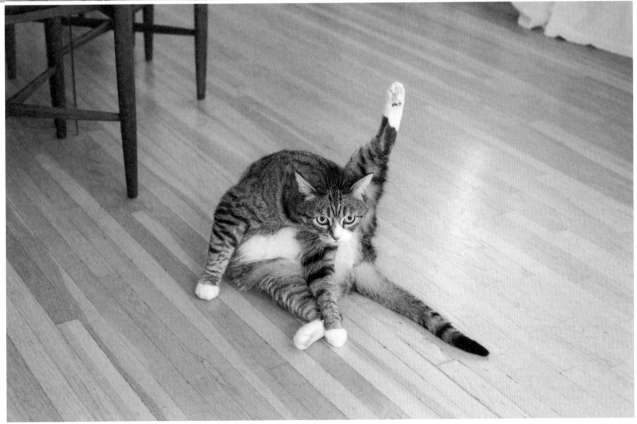

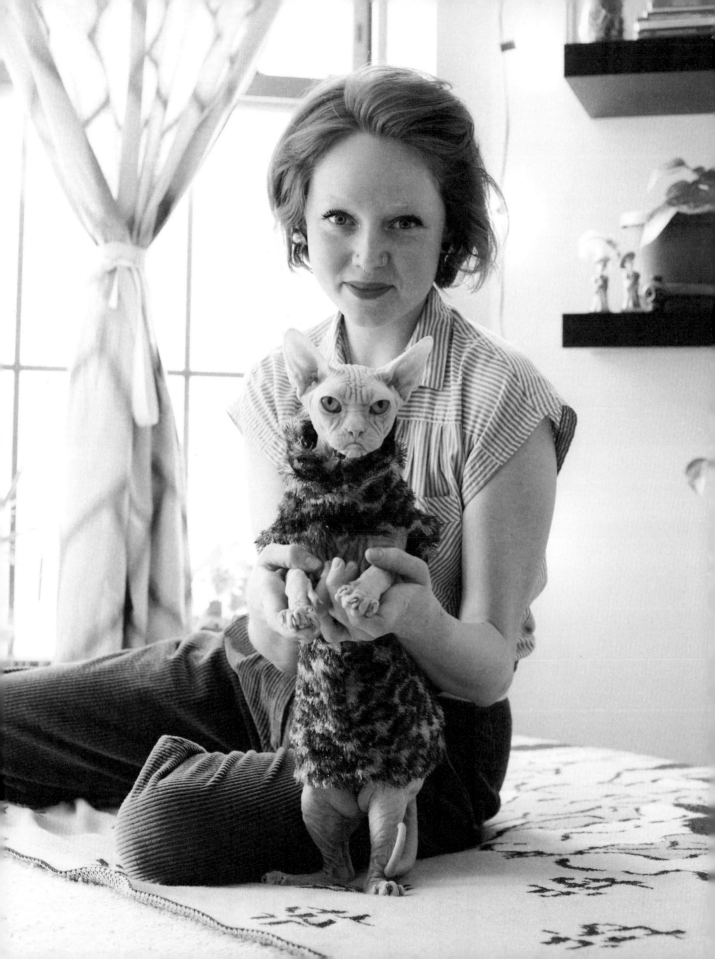

"Some of the most compassionate and understanding people in the world.
And their cats always return the sentiment."

Sara Anderson

FULL-TIME CAT MOM
BROOKLYN, NEW YORK

I met Loki shortly after I moved to Syracuse, New York, with my boyfriend, Brent, who was working on completing a graduate program at the time. We are both from Minnesota and moved to New York together. I had always wanted a hairless cat but never thought it was a realistic possibility since the breed can be hard to find and can sometimes be pretty expensive. Brent, unfortunately, is also allergic to cats, so I ruled out the idea of owning a cat for some time—until I found myself feeling a little depressed from the move to Syracuse and decided I wanted a pet. I started researching hypoallergenic cat breeds and poring over Craigslist for any possible leads. I looked for about three months before I came across Loki's ad on Craigslist, and the rest is basically history.

Brent and I adopted Loki in 2014, and happily accepted him as an integral part of our lives. Loki is incredibly affectionate, cuddly, and chatty. He loves napping on our bellies, eating chicken and scrambled eggs, and receiving hearty head scratches. Brent and I are completely and wholeheartedly enamored with him. Soon after we adopted him, I started an Instagram page (@loki_the_sphynx) dedicated solely to Loki. It quickly picked up a following thanks to his seemingly grumpy demeanor and unique look. It has been really fun cultivating posts to share and interacting with the community on Instagram. Loki has helped me return to creative and optimistic parts of myself that were misplaced while I was feeling unmotivated and sad. Animals are incredible healers, and I am eternally grateful for Loki's companionship and generous loyalty. He is truly one of a kind.

Loki

TYPE
Sphynx

NICKNAMES
Lokus, Loku, Buddy, Hot Cat, Night Cat

FAVORITE SNACKS
Feline Greenies, scrambled eggs

LIKES
Cuddling, waking up early, making blanket biscuits, sleeping with Mom and Dad, running laps around the apartment at dusk

DISLIKES
Not receiving attention

HUMAN ALTER EGO
Yoda, Dobby the House Elf

Shortly after these photographs were taken, Loki passed away after complications during a routine dental visit to the vet. An underlying heart condition was ultimately the cause. It was unexpected and incredibly heartbreaking. Although this has been very hard, we have found so much hope and joy through the healing process. Sharing photos of Loki was an endeavor that brought together so many people. Without their love and support, it would have been even harder. Loki, thank you. We love you forever.

Puno

**FOUNDER OF THE ONLINE PLATFORM
FOR CREATIVES ILOVECREATIVES**
LOS ANGELES, CALIFORNIA

Well, I actually hated cats. (I cringe saying that now.) It all started when I was young and adorable. I got swiped on the face by my Lolo's cat, Pierre. My body probably had PTCD (post-traumatic cat disorder) because the older I got, the more allergic to cats I became. I'm talking swollen eyes, hives, endless sneezing—not cute. I even got an allergy test, and the doctor wrote "5+++, stay away from cats!"

I believed I would be a dog person forever. I had a dog, Rufus (RIP), for eighteen years. He was a great dog, and that didn't help the cat cause. Then a series of events unfolded that made me the cat lady I am today.

My BFF, Mark Bonus, had similar cat allergies. While on his *Eat Pray Love* quest in Hawaii, he had the option to stay in a bungalow next to the beach. The only problem was there were two cats living there. He wanted that bungalow. Every day he rubbed a cat on his face and screamed, "I love cats! I LOVE CATS!!!" And then one day my homie was cured! He now owns a Maine coon.

At the time, I thought the story was cute. There wasn't a beach bungalow in my immediate future, so I had no reason to change. Then I went on a trip to South Africa. For five days we went out and looked for big cats. It was incredible! I thought, *Who knew it would be so fun to just sit around and watch cats?* They weren't doing much, but it was fascinating. That was the first time I realized I enjoy being in the proximity of cats.

I was *still* skeptical of domesticated felines until I met my gateway cat, Winnie, who belongs to my great friend Éva and her partner (pg. 121). Winnie is this adorable, tiny, cow-print Persian, but she also fetches *and* eats with her hands. WTF?! Winnie changed the game for me—along with Bea, their other cat; my friend Jess Hannah's cats, Ollie and Remy (pg. 160); and a few other felines: shout-out to

Muad'Dib

TYPE
Peke-Faced Persian

NICKNAMES
EmDee, Mobb Deep

FAVORITE SNACK
Coconut oil

LIKES
When I shape the fur around her paws into perfect puffs

DISLIKES
Having dingleberries wiped off her butt (she doesn't get them anymore, thank the cat gods!)

Bob, Kevin, Eero, and Eames. Kitty plug! Even crazier, I wasn't allergic to any of these cats.

I started reading about different cat breeds, and it seemed like a Peke-Faced Persian's temperament and flat face matched my vibes. Just to see what was out there, I started hitting up Helping Persian Cats, a local nonprofit organization that holds adoption events on the weekends. The first time I went, there was Nyla. She was a gray exotic shorthair. (I would have renamed her Beyoncé.) Daniel, the husband, was skeptical about getting a cat because of my allergies. To test them, I started

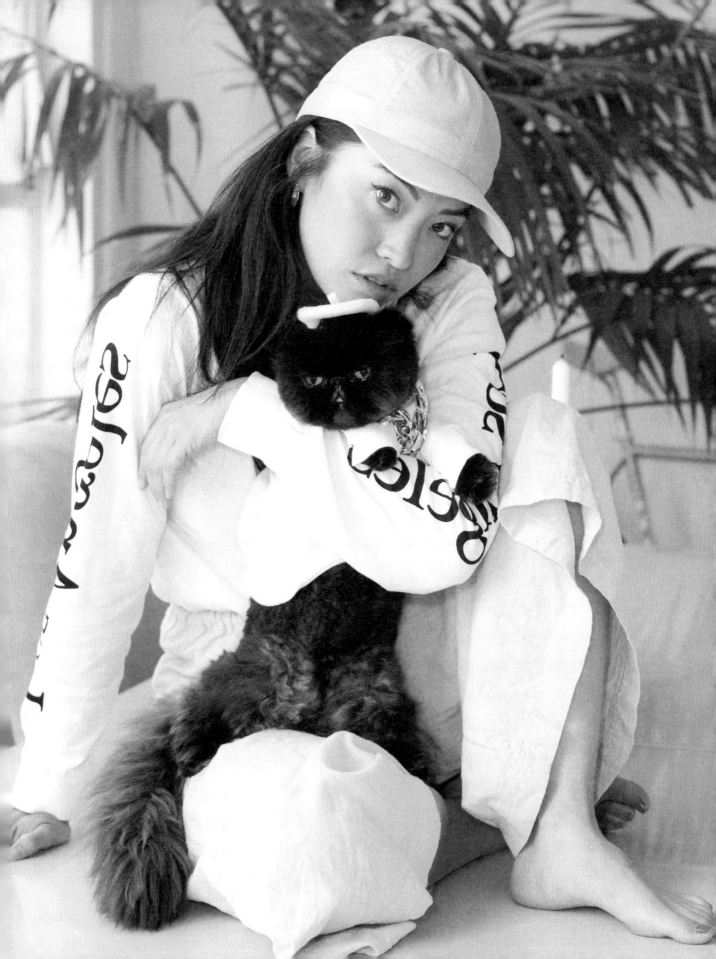

rubbing Nyla's hair all over my neck and even under my shirt. The adoption ladies didn't really mind it. Immediately though, hives. Everywhere. Sadly, I had to leave without Nyla.

It didn't make sense. How was I allergic to Nyla but not any of the other cats? Maybe it was dust? I also read that some cats have more of the allergen protein called Fel d 1. It made me question what I was actually allergic to.

The next time I went to one of the adoption events, there were two adorable Persian sisters—and a similarly adorable couple was walking away with them. Damn!

It wasn't until the third time that I saw Muad'Dib, formerly known as Stormy. I picked her up and instantly felt the love. We had a connection. I secretly checked my compact for any hives and saw one on my neck. I was so sad. I don't know why, but I started whispering, "I love cats. I love cats." I brought her home, took Claritin for a week, and haven't seen another hive since. MIRACLE.

I think my body knew Muad'Dib was worth fighting for. First of all, she's crazy cute but also very strange looking. She has these huge yellow eyes, an almost inverted nose, and labia-shaped lips. Every time I look at her I'm overwhelmed with emotions: laughter, confusion, love, and that "OMG that's so cute" feeling.

In the *Dune* series, Muad'Dib is the name of the human leader and a mouse who is wise in the ways of the desert, so we named our cat after a mouse. It works, because she's cute like a mouse, but slower. An unexpected plus is that people often mistake her name for Mobb Deep, the American hip-hop duo from Queensbridge Houses, New York. We've got all our bases covered.

Maybe it's because I was a dog person, but I was able to teach Muad'Dib tricks. This cat loves canned meat. She can sit, shake, lay down, and do a bear pose when she stands up on her hind legs for a treat. I even got her to walk on a leash.

She's also very photogenic. I found out that she really takes to the camera. Anytime there's a camera on, she's there. And she doesn't mind wearing clothes. Six-month baby clothes are the perfect size for her. Once I realized that, it was on. I knew this was rare, so I immediately made a cat calendar.

Like Winnie, Muad'Dib is a gateway cat. She's turned hundreds of people into cat people. She's

one of the best things that has ever happened to me, and it has snowballed into all sorts of new spaces I'm exploring. Now I question every preconceived notion I have about myself.

These days, when the ol' cat versus dog debate comes up and I'm hit with, "I hate cats! I'm a dog person," it hurts. I'm sorry to anyone I have said this to, but I get it. I used to be that dog person. Dogs have more than five thousand years of domestication over cats. Who knows! Maybe cats will reach a domestication tipping point and end up wagging their tails when you come home. You never know. Don't you want to be part of that history?

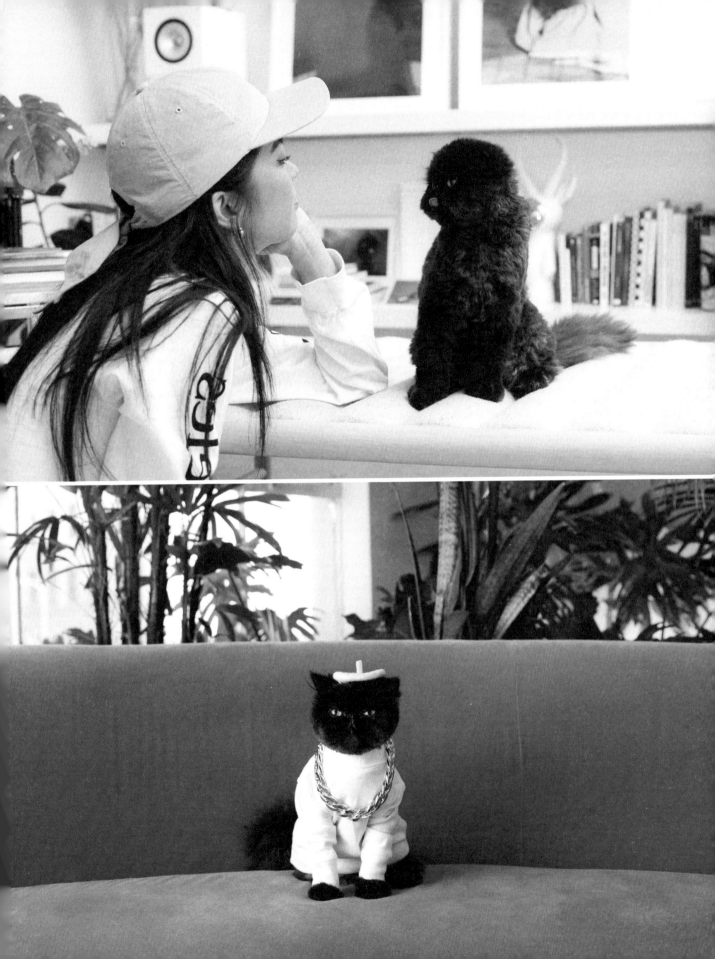

What to Expect When You're Expecting a New Cat

Reading about these cats may have you feeling inspired to adopt one of your own or to add another to your family. If so, we love it! Your new feline soul mate is out there, and we want to help match you up. All of the girls in this book adopted or rescued their furry best friends—some off the street, others from bad living situations, and many from animal shelters—and that's what we encourage you to do. In 2017 alone, more than 1.5 million cats entered shelters in the United States. It's up to all of us to give them loving homes.

Like felines themselves, rescue organizations come in all stripes: There are municipal ones, run by the local government; private ones, run by nonprofits; hybrids of the two, where a nonprofit runs a shelter for the government; and foster-based ones, where the kitties live in volunteers' homes. Each one is bound to be a little different, but there are certain steps you'll encounter everywhere, and things you should think about before you stop by. Danielle Bays, community cat program manager for the Humane Society of the United States, lays it all out:

Before You Visit

Think about your day-to-day routine. Consider the amount of time you spend at home and how much of it you can realistically dedicate to playing with a new cat. Those factors will determine the age and number of cats that's right for you. It's important to do this before you visit and fall for an animal who might not be the best fit.

» **KITTENS** want and need a lot more attention than adult cats do. That's why shelters often recommend that only people who spend their days at home adopt kittens—and that they adopt a pair. "It's for social development," says Bays. "If you have another cat who is young and willing to interact with a kitten,

that *might* be okay. But kittens need enrichment. We humans can't be kittens." If you have a nine-to-five, think going from zero to two cats sounds like a lot, or already have an older cat who might not adapt easily to life with a new kitten (or kittens), plan to adopt a new cat who is a year old or older.

» **MULTIPLE CATS** may sound like a dream, but if you don't have the bandwidth for kittens, make a mental note to ask the shelter staff about any older cats who came in from the same household. "They'll already be bonded to each other," says Bays.

» **A SOLO CAT** is also an option. Plan to ask which shelter residents would like to have the house all to themselves before you start looking around and set your heart on anyone. There may be prospects who didn't get along with their fellow fosters, or who came in from a household where they were the only cat. These guys would love to be your one-and-only.

If you feel torn as to whether you're ready for a cat of your own, offer to foster or volunteer. Shelters need help with plenty more than caring for the animals, too. Your photography, graphic design, event planning, carpentry, or organization skills, or simply your presence, might be exactly what they need most.

Then, factor in the cost. First there's the adoption fee: zero to $200, typically. The amount shelters ask adopters to pay up front varies widely, for lots of reasons.

» **GEOGRAPHY:** There are just more cats in some parts of the country than in others. "Some shelters, particularly in the Northeast—Maine, for instance—don't have enough cats to keep up with demand. They may partner with shelters in areas that are overrun," says Bays. A higher fee may include transporta-

tion costs as well as funds to help support a partner shelter. On the other hand, shelters with a surplus of felines may charge less.

» **TIME OF YEAR:** You may see promotions such as fee waivers, pay-what-you-can rates, or buy-one, get-one offers at peak times, such as during kitten season (late spring through fall) and Adopt a Shelter Cat Month (June).

» **AGE:** Some shelters may charge more for kittens, especially in nonpeak season; they may charge less for senior cats.

» **DISCOUNTS:** Reduced fees may be offered for certain adopters, such as seniors and members of the military.

After the adoption fee, expect to spend somewhere between $500 and just over $1,000 a year on average in basic care and keeping—including around $180 for a routine vet exam. To help anticipate your expenses, call a few vets near you to find out if their exam and vaccination fees are lower or higher than average.

The Application

You'll need to fill one out—it's just a matter of when, and how long it will take. Some shelters have you complete it before you visit and meet a single animal; others have you apply for a specific animal after you've met and made up your mind. You may find that busier shelters with more animals to manage have laxer processes, while foster-based shelters dive deeper, since they're less worried about overcrowding. Regardless, you'll be asked to provide the same basic information. There are a couple of common supplemental questions, too.

» **ALL APPLICATIONS** will want to know your contact information: physical address, phone number, email. Also on the form: questions about any animals that you currently own or have owned in the past; who lives in your home with you, people-wise; and who your veterinarian is, if you have one.

» **AN IN-DEPTH APPLICATION** may have you list contact information for your landlord, if you have one, and provide references, the way you would on a job application. They may require a home visit as well.

» **YOU MAY SEE QUESTIONS** such as "Do you plan to let your cat outside?" and "Would you consider declawing your cat?" on the form. These aren't intended as gotchas, says Bays. (In case you're completely new to cats, the answer they're looking for to both is no.) It's more about starting a conversation with new potential pet parents and educating them on what cats need and what is best for them.

An interview is the usual next step. It may be a casual conversation, or it could entail speaking with a nonprofit's board of directors. If questions about declawing and outdoor time didn't come up on the application form, they may come up here. Declawing is unhealthy and painful for cats, and the Humane Society and its partners are staunchly against it. Likewise, they discourage letting your cat outdoors, since it can be unsafe for them and for wildlife populations. If you find a cat on the street or in your yard, though, it may be tough to persuade her that a luxurious, air-conditioned life is what her heart truly desires. The great indoors may not agree with her, as some of our girls have found. By and large, the best thing you can do for your cat is keep her inside your home with you.

Choosing a Cat

"When you meet a cat and feel good about the connection, go ahead and adopt her," says Bays. "There aren't any rules about how many times you should visit a cat first." Here, a few pointers to help you find your new playmate or fellow couch potato.

» **A CAT MAY NOT** be her usual confident self at a busy pop-up adoption event or noisy shelter. Those who seem shy and reserved may be warm and loving at home. And you can pretty much bet that cats who are very confident in a shelter environment will be even more so in a more relaxed setting.

» **ASK THE SHELTER STAFF** to tell you about the cats they know best. "They'll have a clearer idea of what a cat's personality and activity level really are like, and can give you a sense of whether she will be a good match for your lifestyle, versus you thinking, *Oh, that's a really pretty cat,* and getting her home and realizing she's going to drive you nuts," says Bays.

» **DO YOU DREAM OF SNUGGLING WITH A SPHYNX?** Shelters often have purebred cats or cats with mixed but fancy ancestry, too. Persians, Ragdolls, Russian Blues, and Siamese are not uncommon. When you visit in person, tell the shelter staff what you're looking for. Browsing online via a site like Petfinder is another quick way to narrow your search.

You may encounter cats with unique conditions or special needs. Cats with these three common conditions can live long, healthy lives.

» **CEREBELLAR HYPOPLASIA (CH).** In cats with this condition, the part of the brain that controls the fine motor skills did not develop completely before they were born. That's why they're sometimes called wobbly or shaky cats. They may not be super coordinated, but CH doesn't require any ongoing medical care, and it definitely doesn't stand between them and exploring the world in their own slightly off-kilter way.

» **FELINE IMMUNODEFICIENCY VIRUS (FIV).** This autoimmune disorder is often symptom-free, though it may eventually progress and make an infected cat more susceptible to illness. In the past, it has been thought that FIV-positive cats should be solo cats. "But the research on FIV is actually changing quite a bit," says Bays. "Studies out in the past year or so have shown that cats who test positive for FIV can cohabitate with other cats without transmission." As long as cats with FIV are symptom-free, they don't require any special medication or treatment.

» **A MISSING EYE OR LEG.** Lack of a limb is no match for feline agility. "Cats are incredibly adaptable," says Bays. A kitten may come into a shelter with such a severe infection that an eye needs to be removed, or she may have been in an accident that irreparably damaged a leg. But, says Bays, "pirate cats and the rest of them get around just fine."

If you already have a cat or cats and want to add another, you need to take your role as matchmaker pretty seriously. (Just ask Bays, whose cats have decided they're not huge fans of her boisterous Maine coon foster.) Make sure these characteristics are complementary:

» **ENERGY LEVEL AND PLAY STYLE.** When you're observing a potential adoptee, pay attention to how active and playful she is, and what kind of behaviors she exhibits. For example: "Does she like to wrestle?" asks Bays. "If so, she might not be a good match for an older cat, or a cat who likes to play quietly."

» **AGE.** Older cats may be slower moving and a little more set in their ways, so you need to be extra conscientious about not disrupting their routine.

» **DESIRE FOR ATTENTION.** "If you have a cat who really likes all of your attention, and you get another cat who wants all of your attention, there might be some unhappiness over that," says Bays. That's especially true if there are older cats involved.

Bringing Your Cat Home

You can usually take your new cat with you as soon as the ink is dry on your paperwork, but don't tuck her into her carrier until you have her complete medical records in hand and have gotten straight answers on these next steps.

» **SPAYING OR NEUTERING.** Most cats you meet will already have had this done. Kittens may be an exception, says Bays, since shelters sometimes make them available for adoption while they're waiting in line for surgery. Some shelters also arrange to have adopters take their new young cat to be spayed or neutered within a certain amount of time and return paperwork to them showing that it has been completed. Make sure you know what you need to do.

» **VACCINATIONS.** Clarify when she's due for her next round. For a kitten, it may be soon, since kittens need several shots early in life but must be a certain age before some of them (such as rabies, required in many states) can be administered. Adult cats need boosters once a year.

» **MICROCHIPPING.** Some shelters get their cats microchipped pre-adoption. If that's the case, ensure you have her identification number, and stash it somewhere safe with her other health records. If not, plan to have it done ASAP. The procedure, which entails implanting a radio-frequency identification (RFID) chip between her shoulder blades, feels like getting a shot and typically costs $45, a onetime fee that includes registering her in a pet-recovery database.

» **FLEA PREVENTIVES.** Find out if she's been given any. Many shelters give cats flea preventives due to the constant influx of new animals. Your cat won't necessarily need them if she's a solo cat or if all your animals stay inside. But if you have a dog as well, or if you plan to let her out on a "catio" or take her for walks on a lead, you may want to continue giving her one. Says Bays: "It doesn't take very much to get fleas." Ask shelter staff what they've been using, how much, and when she'll need the next dose.

While you've got these vet questions on the brain, Bays says now is the right time to make a first appointment, even if your cat couldn't be healthier. "You want to build a relationship with your veterinarian, and for him or her to see your cat when she's healthy," she says. "That will give your vet a basis for comparison if and when your cat doesn't feel well."

At home, your job is to give your new cat a safe, enriching cocoon. Let her investigate the smells, hiding spots, and prime scratching and playing places at her own pace, beginning in a quiet, small room of her own. It's best to let her adjust slowly by confining her to a spare bedroom, laundry room, or extra bathroom outfitted with all the necessary creature comforts. Here are the basic supplies you need to get her settled in:

» **CARRIER**

» **BREAKAWAY COLLAR** (these have a safety clasp that releases under pressure, to keep animals from getting stuck)

» **IDENTIFICATION TAG**

» **FOOD AND WATER BOWLS**

» **FOOD** (the specifics will be up to you and your vet)

» **LITTER, BOX, AND SCOOP**

» **TOYS**

» **SCRATCHING ACCESSORIES**

You might even rearrange the furniture in her abode a bit to give her access to higher points, like a windowsill, a dresser, or sturdy shelves. (Cats, of course, love a view.) Then, let her broaden her horizons, bit by bit.

If this means relocating her litter box, remember that cats appreciate having them in a low-traffic area, and you'll ideally need one box per cat plus one additional box. She may also revolt if you don't scoop it daily, or if she doesn't like going in it. Luckily, there are different styles of boxes (open, lidded, top-entry) and types of litter (clay, pine) to suit any cat's preference. It may be a matter of trial and error.

All of these logistics are especially important if you already live with a cat or cats. Typically, you want to keep your new cat separated from your existing ones for about a week, gradually introducing them to each other. You can help smooth the process by placing objects with their scent in each other's territory (e.g., switch up one or two of their toys or their bedding). Eventually, you can try giving them dinner on opposite sides of a door; it's important to ensure they feel comfortable eating near each other. You'll know they're ready to share a habitat by carefully watching how they behave. "They don't know the one-week formula—it could take more time, or less," Bays says. "You've got to really pay attention to how they react." If they start trying to play with each other underneath the door, or if they couldn't care less, it's all good. Hissing or swatting? Take it slow.

Depending on your situation, bringing home baby could take a mere afternoon, a week, or a few months. We hope this explains everything you need to know about becoming a cat mom. It's a life-changing decision, definitely for the better. Just flip back through these pages and see how many of our ladies consider their front-door greeter/alarm clock/take-a-break reminder/outfit preheater/snack buddy essential to their well-being, not to mention daily life. Trust us, you'll be falling for her—and she'll be confidently exploring all of your closets, claiming her spot on the sofa, and snoozing on your head—in no time.

Rescue Organizations We Love

NATIONWIDE

ASPCA @aspca

The Humane Society @humanesociety

Petfinder @petfinder

ATLANTA

Java Cats @javacatscafe

AUSTIN

Austin Siamese Rescue @austin.siamese.rescue

CHICAGO

The Catcade @thecatcade

Paws Chicago @pawschicago

The Windy Kitty Cat Lounge @windykittycatcafe

Tree House Humane Society @treehousehumanesociety

LOS ANGELES

Helping Persian Cats helpingpersiancats.org, facebook.com/helpingpersiancats

Stray Cat Alliance @straycatalliance

MINNEAPOLIS

The Cafe Meow @thecafemeow

NASHVILLE

Nashville Cat Rescue @nashvillecatrescue

NEW YORK CITY/NEW JERSEY

Animal Care Centers of NYC @nycacc

Animal Haven @animalhaven

BARC Shelter @barcshelter

Bideawee @bideawee

Brooklyn Animal Action @brooklynanimalaction

City Critters @citycritters

Empty Cages Collective @emptycagescollective

Golden Paw Society @goldenpawsociety

Happy Homes Animal Rescue @hh_animal_rescue

Kitty Kind @kittykindcats

North Brooklyn Cats @northbrooklyncats

TLC Animal Rescue tlcarescue.com, facebook.com/tlcarescue

PHILADELPHIA

Animal Care & Control Team of Philadelphia (ACCT Philly) @acctphilly

Kawaii Kitty Café @thekawaiikittycafe

Morris Animal Refuge @morrisanimalrefuge

Philadelphia Animal Welfare Society (PAWS) @phillypaws

PORTLAND

Oregon Humane Society @oregonhumane

The Pixie Project @thepixieproject

SALT LAKE CITY

Tinker's Cat Cafe @tinkerscatcafe

SAN DIEGO

The Kitten Lady @kittenxlady

Orphan Kitten Club orphankittenclub.org

SAN FRANCISCO

San Francisco Animal Care & Control @sfanimalcareandcontrol

San Francisco SPCA @sfspca

TORONTO

Annex Cat Rescue @annexcatrescue

TUCSON

The Hermitage Cat Shelter @hermitagecatshelter

WASHINGTON, DC

Humane Rescue Alliance @humanerescue

Last Chance Animal Rescue lastchanceanimalrescue.org, facebook.com/lcarmd

PetMAC DC petmac.org, facebook.com/petmacdc

About the Author and Acknowledgments

BRIANNE WILLS is a fashion and beauty photographer and the creator of *Girls and Their Cats*. Her work has been published in *Teen Vogue*, *Nylon*, *Spin*, and *ELLE*, and her clients include Refinery29, Wildfang, Milk Makeup, Samantha Pleet, Ilana Kohn, Bare Minerals, Shiseido, and The Coveteur. Originally from Oregon, she now lives in Brooklyn with her husband, Chris, and their two cats, Liza and Tuck.

A huge thank you to Elyse Moody, my right-hand woman. I could not have asked for a better partner throughout this process. You have made this whole experience wonderful and fun.

Molly Young, for contributing her beautifully written foreword.

Olivia Roberts at Chronicle, for believing in *Girls and Their Cats* and for allowing me to create the book of my dreams.

Lizzie Vaughan at Chronicle, for your design and making this book better than I could have hoped.

Lori Galvin, my agent, for seeing something special in the project and for holding my hand every step of the way.

Emily Theobald, my first girl and her cat.

Janine Fredrickson, whose endless generosity helped kick-start the book. Thank you for flying me out to Portland.

Meredith Hattam, for designing my website and the beautiful proposal that helped get me here.

My sister Jackie, for helping me edit images and for being the best sounding board a girl could ask for. I don't know what I would have done without you.

Thank you to my Mom and Dad, for your enduring support. Dad, thank you for continuing to inspire and challenge me as a photographer and for instilling in me a love for animals. Mom, you have never not been there for me. Thanks for keeping me company in L.A.; you saved my sanity and made that trip a memorable experience.

Thank you to my in-laws, for cheering me on since the beginning. And a special thanks to Cindy, for meeting me in San Francisco and for going to all the vegan restaurants with me.

Thank you to my husband, Chris, whose unwavering support and encouragement has meant everything. I love you.

Thank you to all the cat ladies who welcomed me into their homes and shared their stories with me.

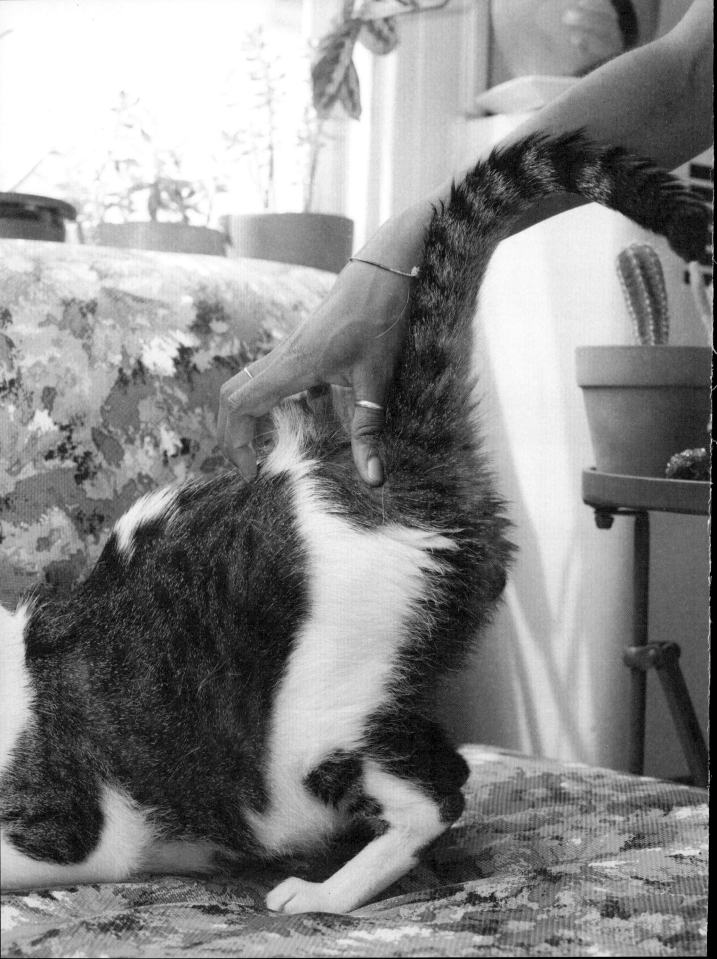